MADE FOR
MUGHAL
EMPERORS

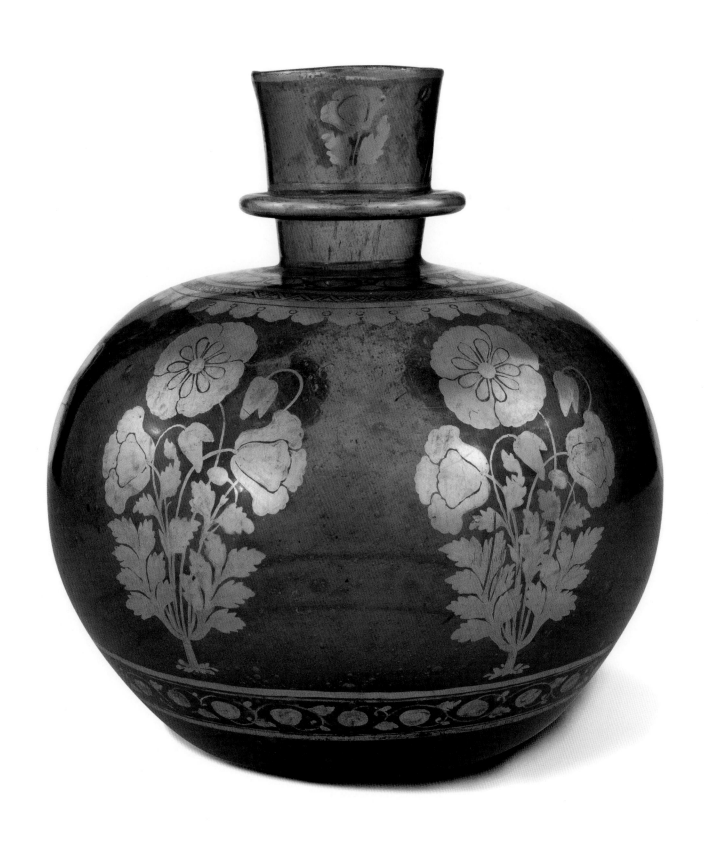

MADE FOR
MUGHAL
EMPERORS

ROYAL TREASURES FROM HINDUSTAN

SUSAN STRONGE

Lustre Press
·
Roli Books

GENEALOGY OF THE MUGHAL EMPERORS

TIMUR
1336–1405

RULED 1370–1405

BABUR
1483–1530

RULED 1526–30

Wives include Maham Begum (Humayun's mother), Gulrukh Begum (mother of Kamran and Askari)

AKBAR
1542–1605

RULED 1556–1605

Sons include Salim, Murad and Daniyal

JAHANGIR (PRINCE SALIM)
1569 –1627

RULED 1605-27

Wives include Nur Jahan (daughter of I'tmad ad-Daula, and sister of Asaf Khan, whose daughter Mumtaz Mahal married Shah Jahan); sons include Khurram, Khusrow, Parwiz and Shahriyar

HUMAYUN
1508-1556

RULED FROM 1530-40,

AND 1555-56

Wives include Hamida Banu Begum
(Akbar's mother)

SUR INTERREGNUM
1540-1555

SHER SHAH SURI

RULED 1540-45

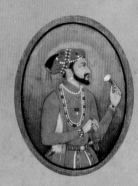

SHAH JAHAN
(PRINCE KHURRAM)
1592-1660

RULED 1628-1658

Wives include Mumtaz Mahal; sons
include Dara Shokuh, Shah Shuja',
Murad Bakhsh and Aurangzeb;
daughters include Jahan Ara Begum

ʿALAMGIR
(PRINCE AURANGZEB)
1618-1707

RULED 1658-1707

EXTENT OF THE MUGHAL EMPIRE
AT THE DEATH OF AKBAR

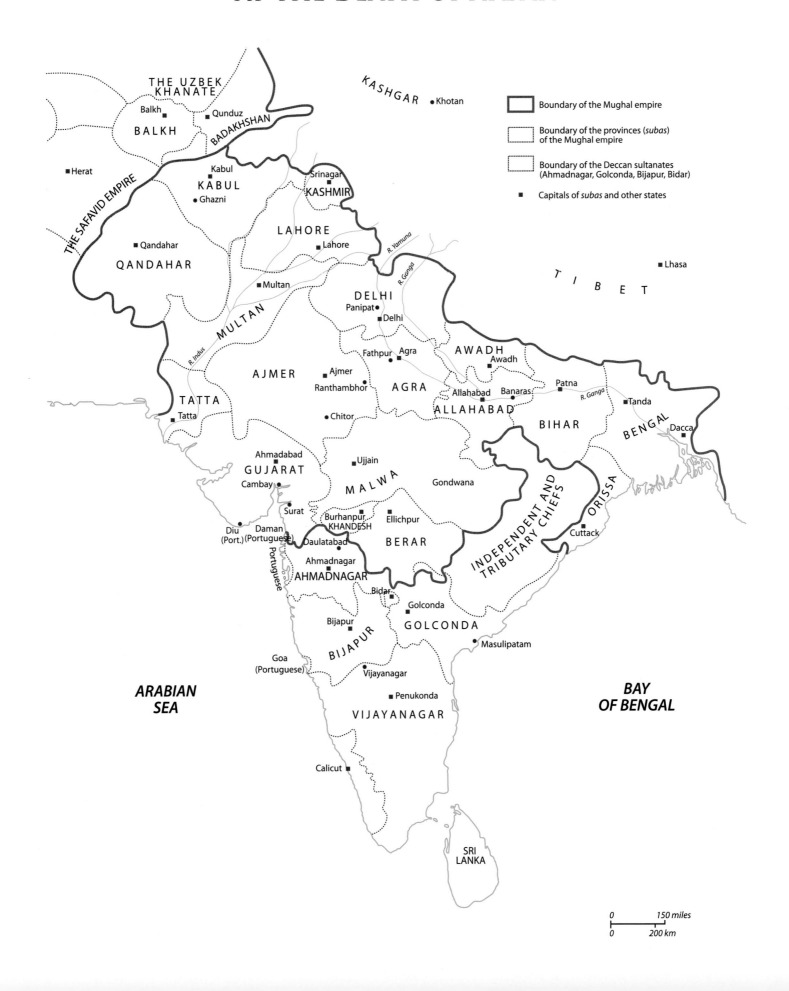

THE UZBEK KHANATE

Balkh

Qunduz

BALKH

BADAKHSHAN

KASHGAR

Khotan

Herat

THE SAFAVID EMPIRE

Kabul

KABUL

Ghazni

Srinagar

KASHMIR

LAHORE

Lahore

R. Yamuna

T I B E T

Lhasa

Qandahar

QANDAHAR

Multan

R. Indus

MULTAN

DELHI

Panipat

Delhi

R. Ganga

Fathpur Agra

AWADH

Awadh

AJMER

Ajmer

AGRA

Patna

TATTA

Ranthambhor

Allahabad Banaras

R. Ganga

Tanda

Tatta

Chitor

ALLAHABAD

BIHAR

BENGAL

Dacca

Ahmadabad

Ujjain

GUJARAT

Cambay

MALWA

Gondwana

ORISSA

INDEPENDENT AND TRIBUTARY CHIEFS

Surat

Burhanpur
KHANDESH Ellichpur

Cuttack

Diu
(Port.)

Daman
(Portuguese)

Daulatabad

BERAR

Portuguese

Ahmadnagar

AHMADNAGAR

Bidar

Golconda

Bijapur

GOLCONDA

Goa
(Portuguese)

BIJAPUR

Masulipatam

Vijayanagar

ARABIAN
SEA

Penukonda

BAY
OF BENGAL

VIJAYANAGAR

Calicut

SRI
LANKA

Boundary of the Mughal empire

Boundary of the provinces (subas)
of the Mughal empire

Boundary of the Deccan sultanates
(Ahmadnagar, Golconda, Bijapur, Bidar)

■ Capitals of subas and other states

0 150 miles

0 200 km

ACKNOWLEDGEMENTS

Many friends and colleagues have been generous in providing me with advice and comments relating to their own areas of expertise: in particular I would like to thank Rosemary Crill, Steven Cohen, Joanna Whalley, Alan Hart, Nigel Israel, Benjamin Zucker, Derek Content, Asok Kumar Das, Robert Skelton, Elaine Wright, Masumeh Farhad, Zahra Faridany-Akhavan, Yves Porter, Laura Parodi, Andrew Topsfield, Reino Liefkes, Luisa Mengoni, Antonia Brodie and Henry Noltie. I am, of course, responsible for any mistakes that remain. Nuno Vassallo e Silva and Roger Foligot provided valuable references, and I also thank Divia Patel, Nick Barnard, Ken Jackson, Andrea Stern, Fiona Grimer, Richard Davis, Clare Johnson and Melissa Appel for their help or advice. I am especially grateful to my friends Liz Langford, Gam Milner, Marian Campbell and Eric Turner for their support.

More than anyone, I thank A.S. Melikian-Chirvani for reading the complete text and providing invaluable suggestions, corrections, Persian translations and editorial advice.

I am also extremely grateful to Sheikh Nasser and Sheikha Hussah al-Sabah for graciously supplying images from their exceptional collection in Kuwait, and to Katherine C. Baker for facilitating this. Parvin Seghatoleslami, Director of the Golestan Palace Library in Tehran, gave permission for me to reproduce folios from the Golshan album, and I owe a special debt to Shima Gholami, former chief conservator, for arranging the photography.

At Roli Books, I warmly thank Priya Kapoor for bringing everything together, and Sneha Pamneja for her splendid design.

Note: Because the provinces of the Mughal empire extended beyond the borders of the modern nation state of India to include parts of present-day Pakistan, Afghanistan and Bangladesh, 'Hindustan' is used in preference to 'India'.

Most of the paintings and artefacts illustrated in the book were made within the empire. A place of production is therefore given only for artefacts made outside the empire, or within the empire when the precise location is known or seems probable. For the dimensions, height is followed by width or diameter. Geographical names are given according to standard contemporary English usage; Islamic era dates are preceded by the abbreviation AH. Diacritical marks have not been used for transliterated words in this book which is intended for a general readership.

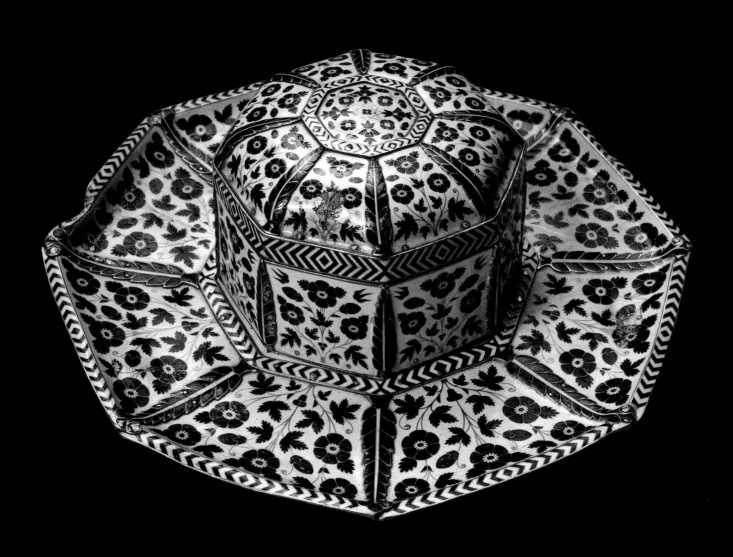

CONTENTS

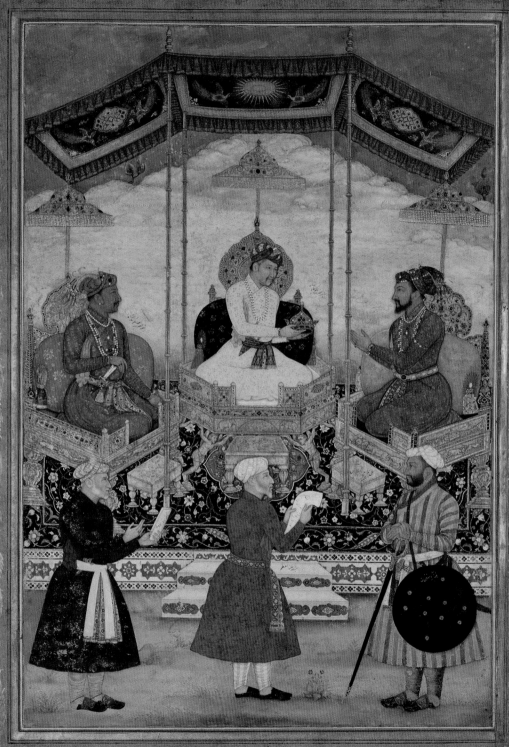

INTRODUCTION

Radically new styles of court art and architecture appeared under the three emperors Akbar, Jahangir and Shah Jahan in the land the Mughals knew as Hindustan. Fortified palaces were built, even entire cities, and legendary monuments like the Taj Mahal were created and may still be seen. But their equally legendary artefacts have almost entirely disappeared or have been irrevocably altered: Shah Jahan's jewelled throne known later as the 'Peacock Throne' was destroyed, the Koh-i nur diamond recut, and the vast quantities of sumptuous silk and velvet, embroidered and other cloths made for the court have long since perished. Many of the exquisite manuscripts that were created survive, but more often have been broken up, their pages scattered in collections all over the world. However, their paintings depict the lost splendour of the court, while rare jewelled vessels and weapons and carved or inscribed precious stones bring to life the contemporary descriptions by historians and travellers of the arts made for the Mughals.

The emperor dominated a milieu whose ceremonies required beautiful buildings and gardens, and workshops to produce the furnishings and objects. When he was in residence, the palaces provided a grand setting for the emperor's public and private assemblies and for the court's annual cycle of rituals and festivities. The backdrop was only slightly less elaborate when the ruler moved in formal progress round his domains,

Facing page | Plate 1 | AKBAR, JAHANGIR AND SHAH JAHAN WITH THEIR MINISTERS
By Bichitr, dated regnal year 3 [January 18, 1630-January 7, 1631] Opaque watercolour and gold on paper
29.7 cm. x 20.5 cm. Chester Beatty Library, Dublin: In 07A.19

because the court was deemed to be wherever he happened to be, and much of his daily routine continued as he travelled. Huge encampments were set up like small cities with the crimson tents of the royal family always at the centre, and canopied enclosures replacing the marble or stone halls of the palaces.

All the finest products of the subcontinent were found at the Mughal court and the treasuries were filled with African gold, diamonds from Golconda, rubies from Burma, and even the brilliant green emeralds of Colombia which were brought by Portuguese traders. Merchants also brought silver gilt artefacts from Nuremberg and Augsburg, porcelain from China, cameos and glass from Italy, while textiles came from Europe, Iran and China. Many of the foreigners in the royal ateliers were Iranians, but the Europeans who arrived at different times included enamellers, diamond cutters and occasionally painters.

The Mughal dynasty was founded in 1526 by Babur, an invader from Central Asia who would not have used this Persian word meaning 'Mongol' to describe himself. His family was distantly related to the Mongol ruler Chinghiz Khan but they more often emphasized their direct descent from Timur, the fourteenth-century conqueror whose capital was the resplendent city of Samarkand. Babur tried and failed to capture this ancestral prize but lost his own small kingdom in the process. He then turned his attention to Hindustan, which Timur had briefly occupied in 1398, giving Babur a spurious reason to seize the Sultanate of Delhi.

Babur's first language was eastern Turkish, but he belonged to the sophisticated culture of the Persian-speaking Iranian world and was familiar with the work of its greatest writers and calligraphers, architects and artists. His son Humayun who succeeded him in 1530 shared his cultivated interests but not his military genius. By 1542 he had lost most of Babur's conquests and was forced to flee to the refuge of Shah Tahmasp's court in Iran. With the shah's support, Humayun was able to capture Kabul, and from there launched a series of attacks on Delhi. In 1555 he reconquered the city and regained his sovereignty, but within a year was dead and his fourteen-year old son Akbar succeeded him.

Under the guidance of Humayun's aristocratic general Bayram Khan, Akbar and his army won spectacular victories that secured the family's fragile rule, but Akbar soon made his own dramatic conquests, and by the end of his extraordinary reign the Mughals were a great power (see map on Page 6). Efficient administration of the empire generated enormous revenues, to which the wealth of defeated kingdoms was added. When an English ambassador arrived at the court in 1616, he called it 'the treasury of the world'.

The culture of these Muslim emperors who ruled a predominantly Hindu population was overwhelmingly shaped by Iran. Persian, which had long been the language of the educated elite, became the administrative language of the empire. Kingship was expressed in art and literature through Iranian concepts and Akbar adopted Iran's lunar calendar and its major New Year, or Nowruz, celebration. At the same time, he borrowed elements of Hindu royal ritual that remained equally central to the reigns of Jahangir and Shah Jahan. Every day, the emperor appeared to the populace from a high *jharoka*, or balcony, in the manner of Hindu kings and followed their ancient practice of being weighed on solar and lunar birthdays against gold and silver.

The complex traditions of Iran and Hindustan were also brought together in art and architecture to create innovative styles that evolved rapidly. Artists, craftsmen and literati came from Iran to the imperial capitals where they often built beautiful mansions in the latest Mughal style. But the subcontinent had its own remarkable artists and craftsmen. Akbar's energetic patronage drew Hindu and Muslim practitioners from all over the empire to the royal workshops and to construct his monuments. In architecture, the techniques, forms and designs of Iran and Hindustan at first existed side by side. Stonemasons built fortified palaces at major strategic points and created the new city of Fatehpur using indigenous styles, but at the same time an Iranian architect designed Humayun's tomb in the

manner of monuments in Timurid Herat. Increasingly, however, the multiple traditions merged.

In the royal *Kitab Khana*, or 'House of Books', the conventions of the Safavid and Timurid courts prevailed as a result of the supervision of two Iranian masters inherited by Akbar from his father. However, its character was radically different because most of the artists were from the subcontinent. Contact with Europe introduced additional complexity. Akbar's delegation to the Portuguese colony of Goa in 1575 paved the way for three Jesuit missions who arrived at the court between 1580 and 1595. They brought paintings and engravings which swiftly influenced the work of the Mughal artists – the Jesuits' artefacts must have had a similar impact, but the evidence has virtually disappeared. Later waves of European art arrived when merchants brought their exotic wares to the courts of Jahangir and Shah Jahan, providing a different inspiration that subtly modified decorative motifs on objects and also produced new architectural forms.

Many of the royal artists and craftsmen were extremely versatile – in keeping with Iranian tradition, some painters were also great calligraphers and many were poets and writers, while indigenous artists became illuminators, or designers of objects. The supervisor of the goldsmiths under Jahangir and Shah Jahan was outstanding in several fields: he was a poet, calligrapher, engraver, lapidary and enameller as well as a goldsmith.

Artistic patronage was not confined to the emperors. Their wives, sons and daughters and the leading nobles all built mansions, mosques, tombs and other structures all over the empire, and laid out beautiful gardens. The grand residences of the greatest men (and probably some of the royal women) contained extensive libraries and they often had ateliers in their own households. However, the emperor's patronage defined the arts of the court.

Under Shah Jahan, the metropolitan style was unified as never before, and its splendour would inspire pale imitations across the empire for the next two centuries. His designers, artists and craftsmen must have worked closely together. Flowers deeply cut into the marble of the Taj Mahal recur on the emperor's jade cups, and the red carnelian and green jade flowers inlaid into white marble on his wife's cenotaph and on his father's tomb in Lahore are echoed in gold vessels enamelled in translucent red and green enamel on a pure white ground. The flowering plants painted in gold and polychrome on the borders of his manuscripts are similar to those woven on carpets or embroidered on robes. Everything is rigorously symmetrical and perfectly balanced, presenting a world of complete harmony, an earthly Paradise in which the ugly reality of poverty had no place.

13

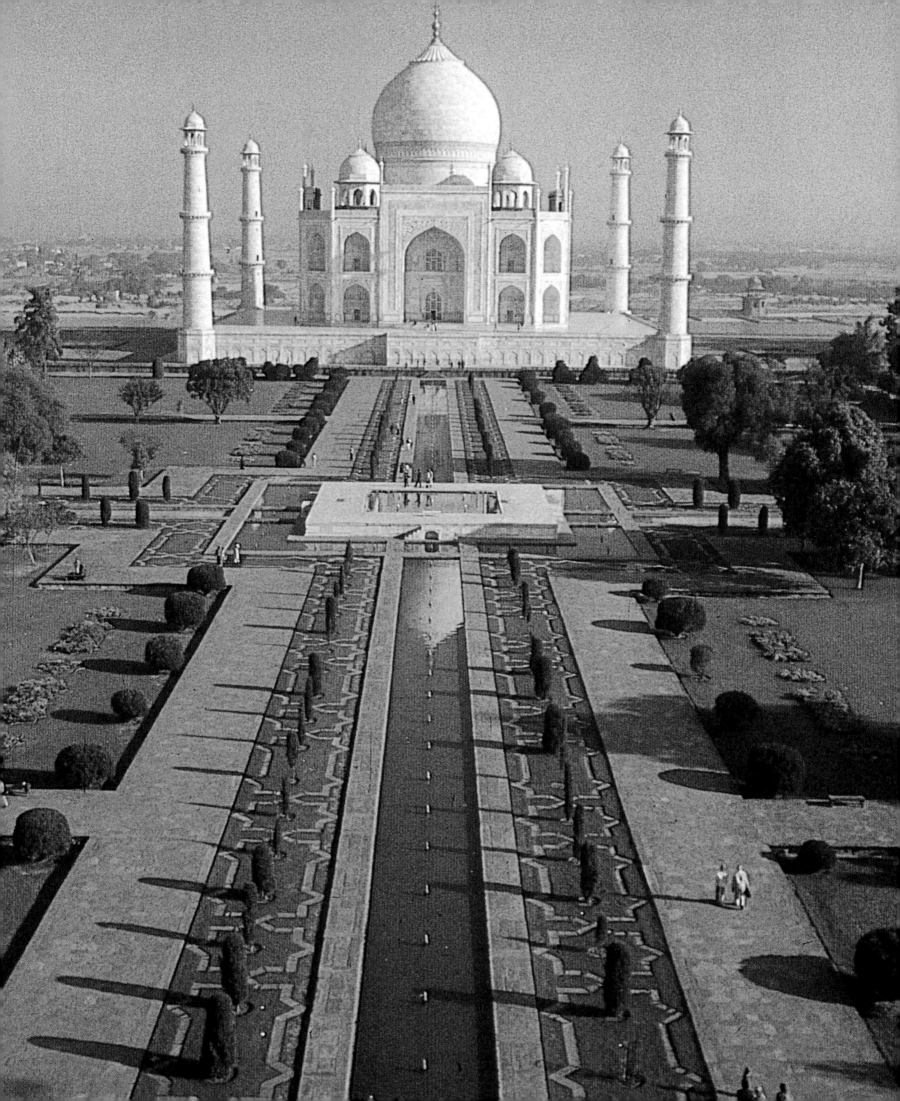

Facing page | Plate 2 | TAJ MAHAL
Agra
Plate 3 | INLAID ROUNDEL FROM THE CENOTAPH OF MUMTAZ MAHAL
Agra

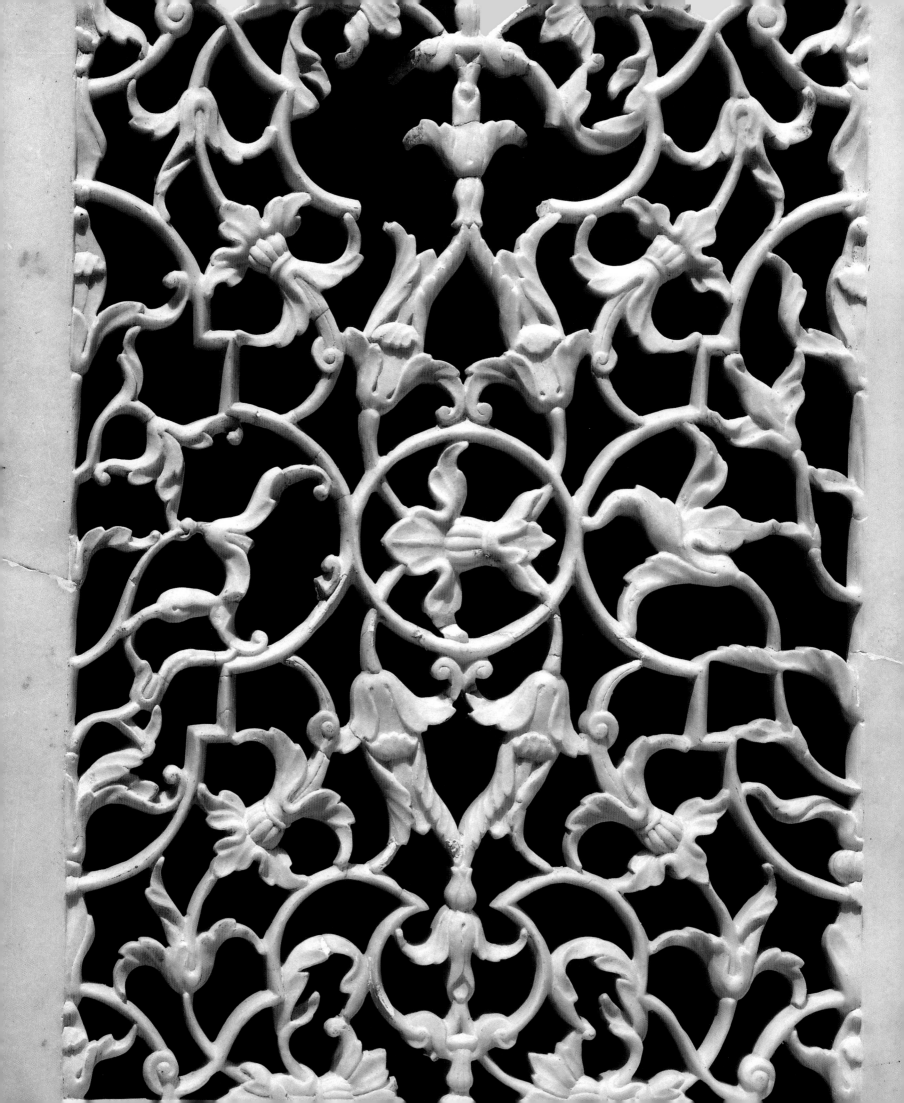

I

THE CITY AND
THE ROYAL ENCAMPMENT

DETAIL OF SCREEN (*JALI*) (see Plate 40)

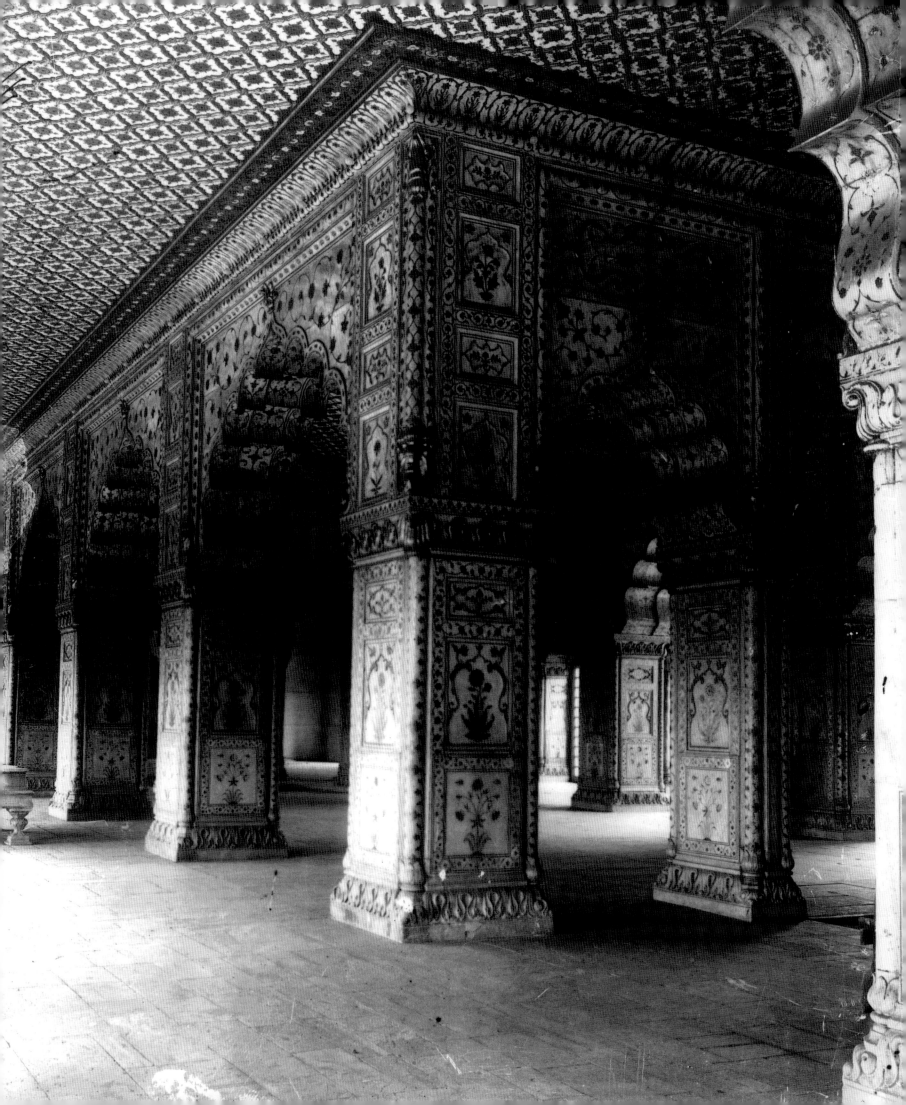

O n 6 April 1648, at the auspicious hour identified by his astrologers, Shah Jahan set
out from the imperial capital of Akbarabad at Agra to inspect his new fortified city
palace called Shahjahanabad.[1] The vast procession that accompanied him, with its
people, horses, camels and elephants, carriages and carts, took thirteen days to
travel between Agra and Delhi, the sprawling ancient capital of northern India,
where it camped outside the city walls. The emperor then completed his journey with a short boat trip
along the river Yamuna to make a ceremonial entrance into Shahjahanabad at the exact moment deemed
to be most propitious.

He made his way through the glistening new marble structures towards the Hall of Public Audience
(Plate 5) where his arrival was announced by the sound of drums. Here, he sat on the spectacular jewelled
gold throne commissioned at his accession that had until now only been seen in Agra. Celebrations
continued for the next nine days as Shah Jahan showered gold and jewels, one thousand gold- and silver-
brocade robes of honour, and generous promotions on those who had created Shahjahanabad. Poets recited
verses praising the city, and entertainments were provided by singers from Iran, Central Asia, Kashmir and
Hindustan, and by dancers and clowns.[2]

The emperor presented 400,000 rupees to his daughter Jahan Ara Begum, who had built the
main bazaar that would become known as Chandni Chowk, or Moonlight Square, as well as a famously
beautiful garden and *saray* called Sahibabad. The Crown Prince Dara Shokuh, whose residence next to the

Facing page | Plate 4 | HALL OF PRIVATE AUDIENCE, SHAHJAHANABAD, DELHI
Lala Deen Dayal, c. 1880-90.

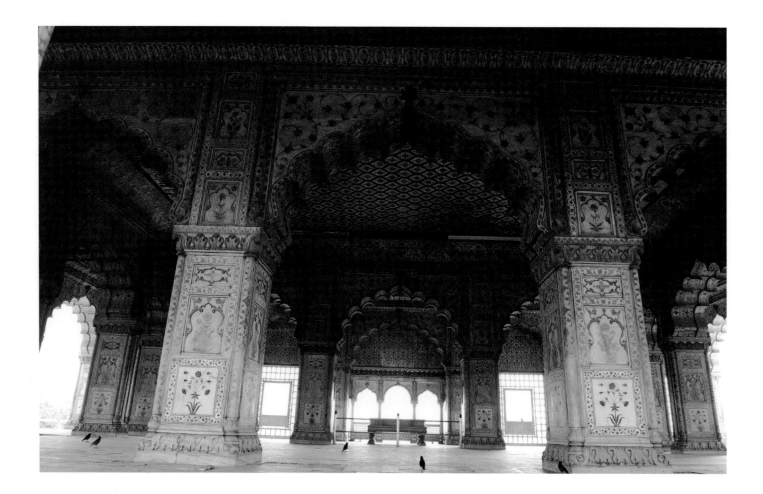

palace had cost exactly that sum and would remain the largest and finest in the city for most of the century, was given a special gold brocade robe of honour and embroidered vest, a jewelled dagger and an elephant with silver howdah.[3]

The monuments in Shahjahanabad, built by artisans summoned from all over the empire, were in the highly distinctive style of his other capital cities (Plates 5 and 6) and would influence the art and architecture of generations of future rulers, regardless of religious allegiance. None, however, would ever equal the splendour of Shah Jahan's court.

The main structures of Shahjahanabad still stand, their walls carved in low relief or inlaid with semi-precious stones in patterns of delicate flowering plants similar to those adorning the burnished gold grounds of contemporary

Plate 5 | HALL OF PUBLIC AUDIENCE,
SHAHJAHANABAD, DELHI

manuscript illumination. In some rooms, ceilings shimmer as light catches small fragments of mirror set into ornamental plasterwork, or traces of gilding. Father Botelho, a Jesuit visitor to the city in its inaugural year, saw scented roses and plants from faraway places including Portugal in the gardens divided by marble channels. The channels remain, but there are few plants, water no longer flows and the fountains are dry.

Contemporary accounts describe the opulent furnishings of the palace apartments and assembly halls, and the royal artists depicted in their paintings the carpets from Lahore and Kashmir and the velvet and gold brocade wall hangings they saw, as well as the clothing and jewels of the people who attended the court. Little is left of the vast quantities of textiles, ornaments or jewelled and enamelled vessels and weapons made for Shah Jahan and his contemporaries. Artefacts of any sort made earlier for Jahangir and Akbar, with the important exception of books or, more often, their detached pages, are extremely rare. When they do survive, they provide a fleeting glimpse of an elite world of fabulous wealth and sophisticated, technically brilliant art produced by masters from all over the subcontinent, from Iran, and even occasionally from Europe.

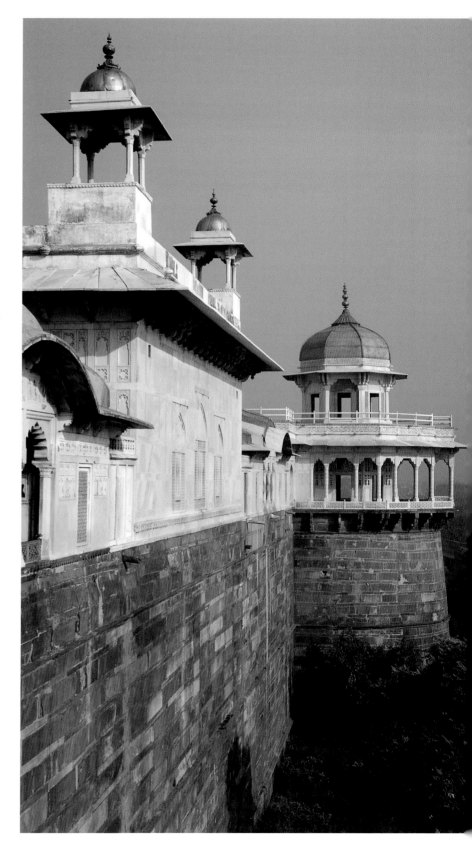

Plate 6 | PALACE WALLS AND SHAH BURJ,
AKBARABAD, AGRA

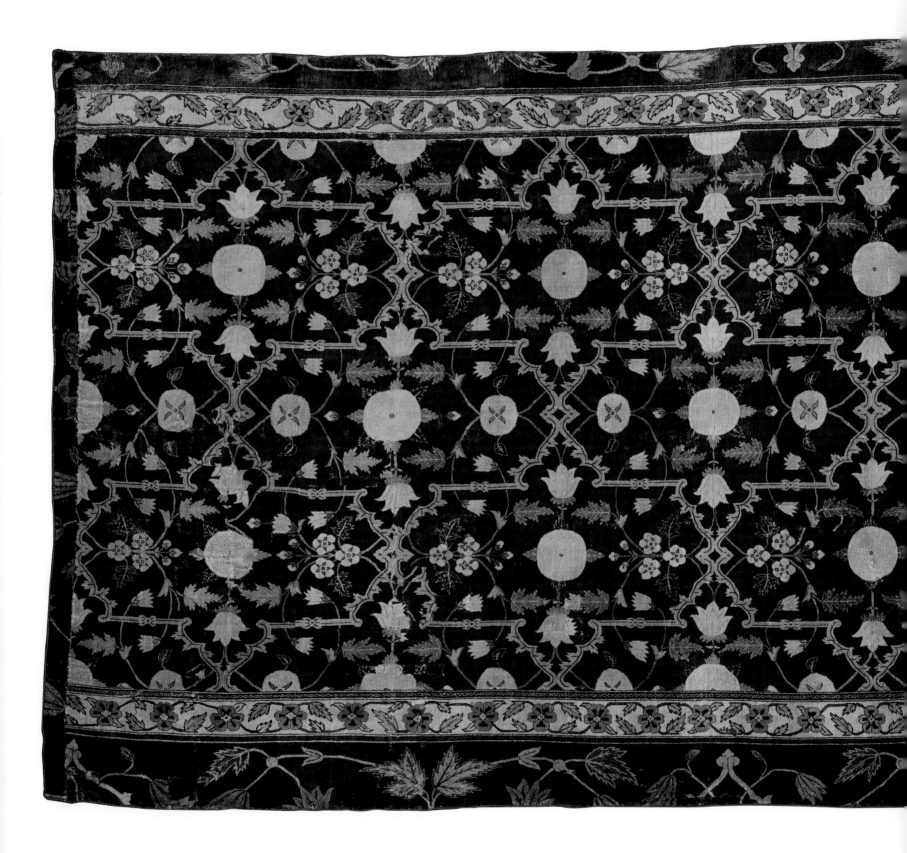

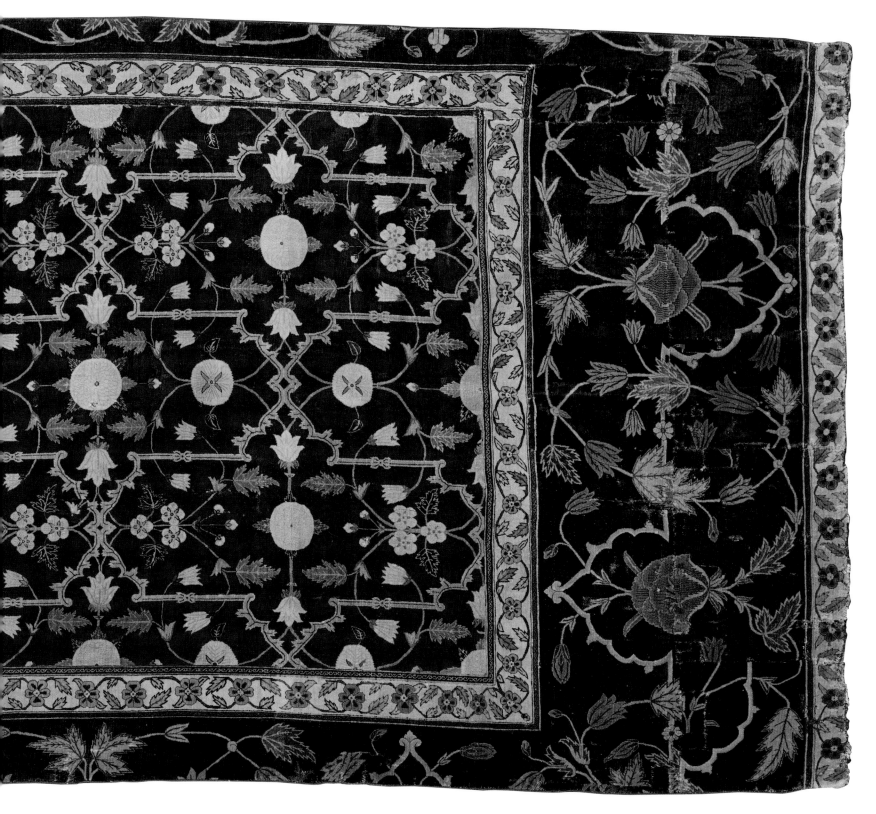

Plate 7 | CARPET FRAGMENT
Kashmir or Lahore c. 1650
Pashmina 320 cm. x 140 cm. Museu Calouste Gulbenkian,
Calouste Gulbenkian Foundation, Lisbon: T 60

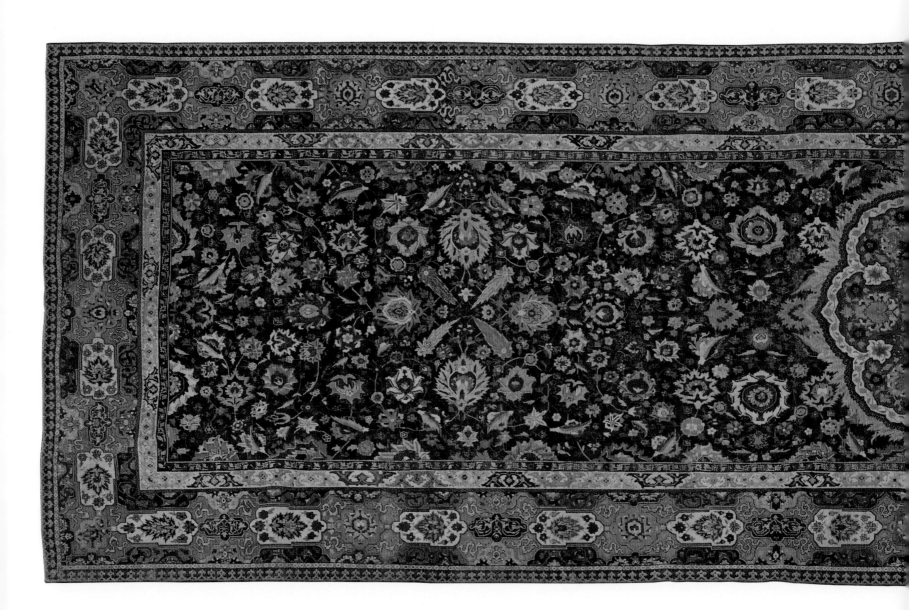

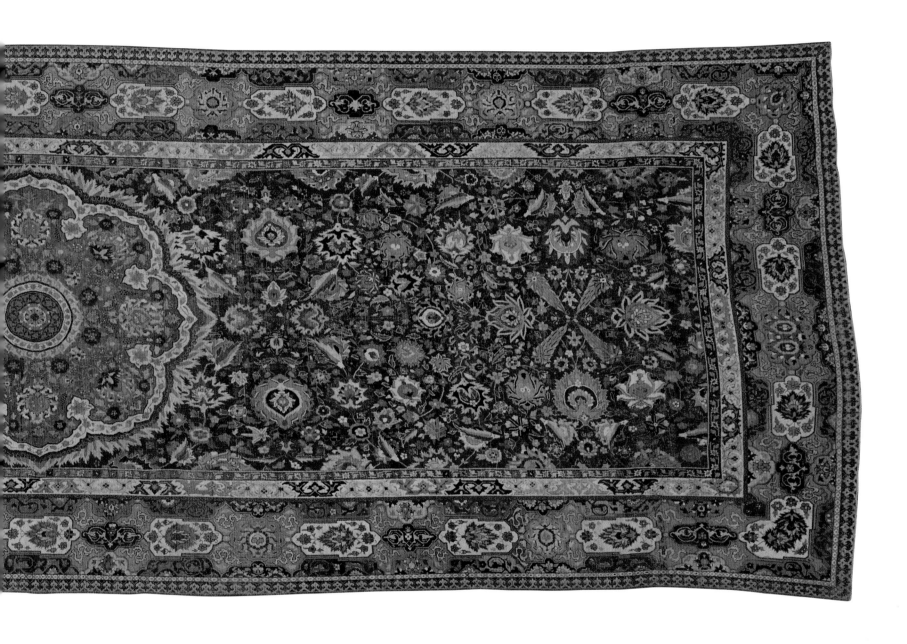

Plate 8 | CARPET
Lahore c. 1620-30
Wool 706 cm. x 255 cm. Museu Calouste Gulbenkian,
Calouste Gulbenkian Foundation, Lisbon: T 62 c

THE CONSTRUCTION OF CITY PALACES

By the end of Akbar's reign, the Mughals were a strong, wealthy power. In 1556, the boy had inherited lands that extended only along a narrow corridor of land from Kabul through Lahore to Agra and Delhi, with another sliver running from Kabul to the briefly held city of Qandahar. Territory would be lost and regained, but when Akbar died in 1605 the empire covered most of the subcontinent north of the Deccan sultanates.

Akbar built fortified palaces in Agra, Lahore, Ajmer and Allahabad to guard major strategic routes and to secure the treasuries, arsenals and the imperial household. Agra, his principal capital, would be 'stable like the foundation of the dominion of the sublime family and permanent like the pillars of its fortunes'.[4]

Following the birth of his first son, Salim, in 1569, Akbar had ordered the construction of a new city at Sikri, a village near Agra (Plates 9 and 10). Babur had been particularly fond of the locality and created one of his many gardens there, which he called the Garden of Victory to mark a nearby military triumph in the unsettled early months of his reign.[5] Akbar echoed this when he renamed the city Fatehpur, or City of Victory, in 1573 after his conquest of Gujarat.[6] Its monuments were made from the red sandstone of the region using the traditional beam and bracket method, but masons from recently conquered kingdoms introduced unusual architectural forms and carved their own distinctive decoration as effortlessly, it seems, as if they had been working in wood. Within the Great Mosque of the city, Gujarati artisans created the white marble tomb of Shaykh Salim Chishti, after whom Akbar's son was named and who had died in 1572 (Plate 12). They may also have constructed the enigmatic massive pillar inside the small building conventionally known as the *Diwan-i Khass*, or Hall of Private Audience, whose precise purpose is not known (Plate 11).[7] The sinuous brackets supporting a circular platform connected to each corner of the building by stone walkways are found in Gujarati architecture, but also occur in nearby Mandu and, significantly, in the early sixteenth-century monuments of the Lodi sultans of Delhi, whose rule Babur had ended when he defeated Ibrahim Lodi in 1526.

Some interiors retain faint traces of painted decoration that would have been designed to accompany the Persian verses that can still be made out here and there, written in an elegant *nasta'liq* script, sometimes in gold, and praising the building, its decoration or the emperor.[8] On the rooftops, fragments of turquoise glazed tiles remain. In general, the architecture draws on the established conventions of the Hindu and Muslim monuments of Hindustan and this has been interpreted as a deliberate imperial choice: it incorporated elements that were familiar to everyone, regardless of religion, in keeping with Akbar's recently proclaimed policy of universal toleration.[9]

Very different architecture simultaneously proclaimed the Islamic faith and the ancestry of the royal family. The grand domed tomb of Humayun in Delhi, completed in 1571 as Fatehpur's buildings were emerging,

Facing page | Plate 9 | THE CONSTRUCTION
OF FATEHPUR IN 1571
Composition by Tulsi, painting by Bhawani, c. 1590-5
Illustration to the *Akbar Nama*
Opaque watercolour and gold on paper 32.7 cm. x 19.5 cm.
Victoria and Albert Museum, London: IS.2-1896: 86/117

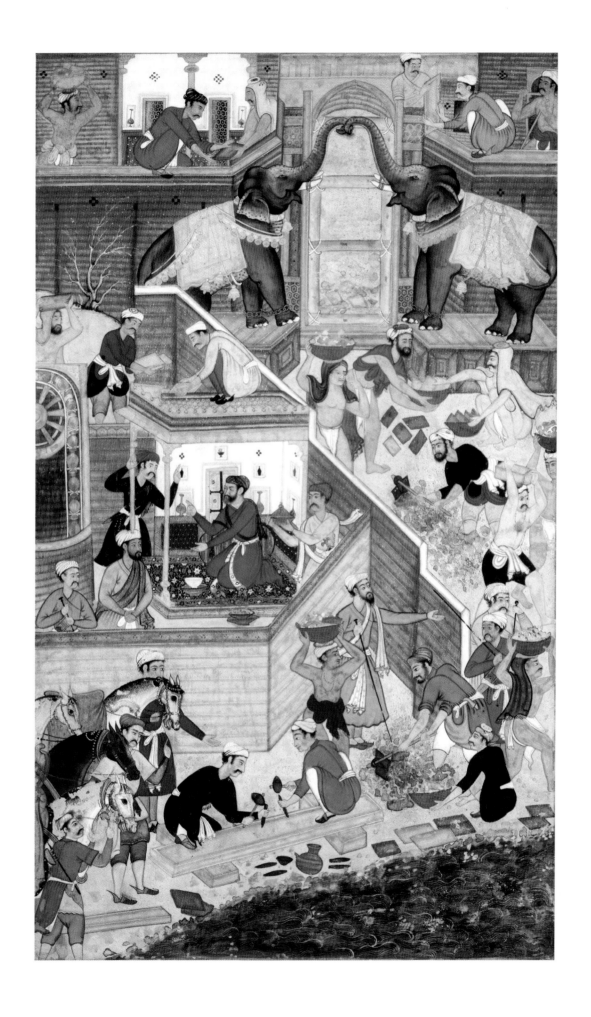

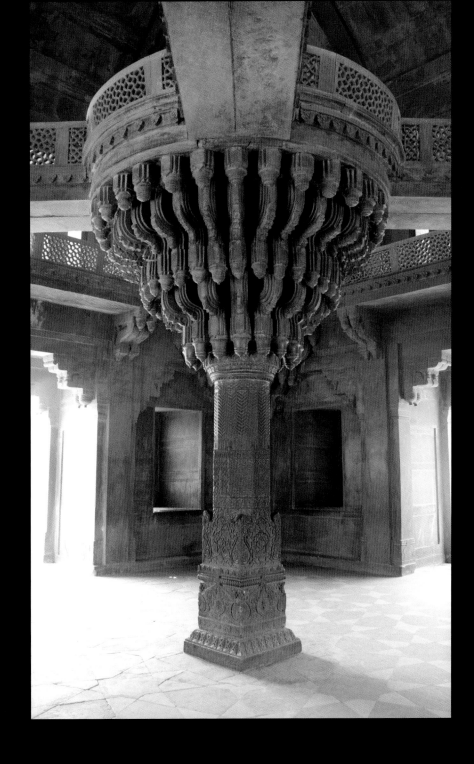

Facing page | Plate 10 | PANCH MAHAL AND ROYAL APARTMENTS
Fatehpur

Plate 11 | PILLAR IN THE DIWAN-I-KHASS
Fatehpur

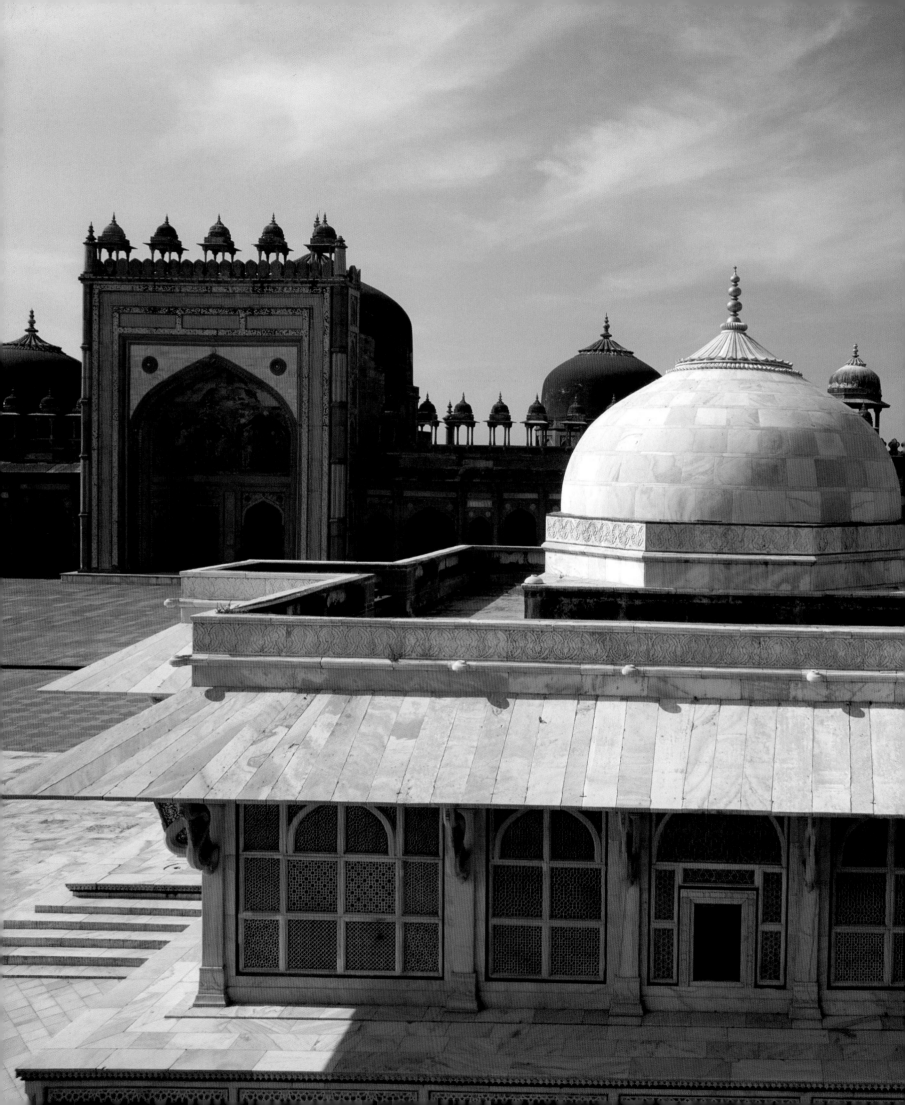

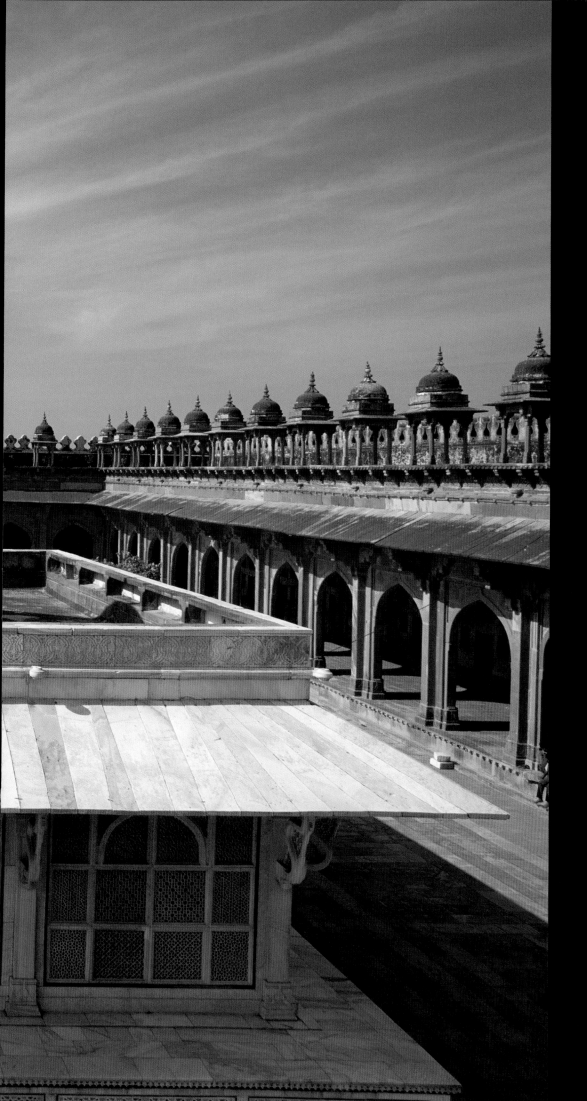

Plate 12| TOMB OF SHAYK
SALIM CHISHTI
Fatehpur

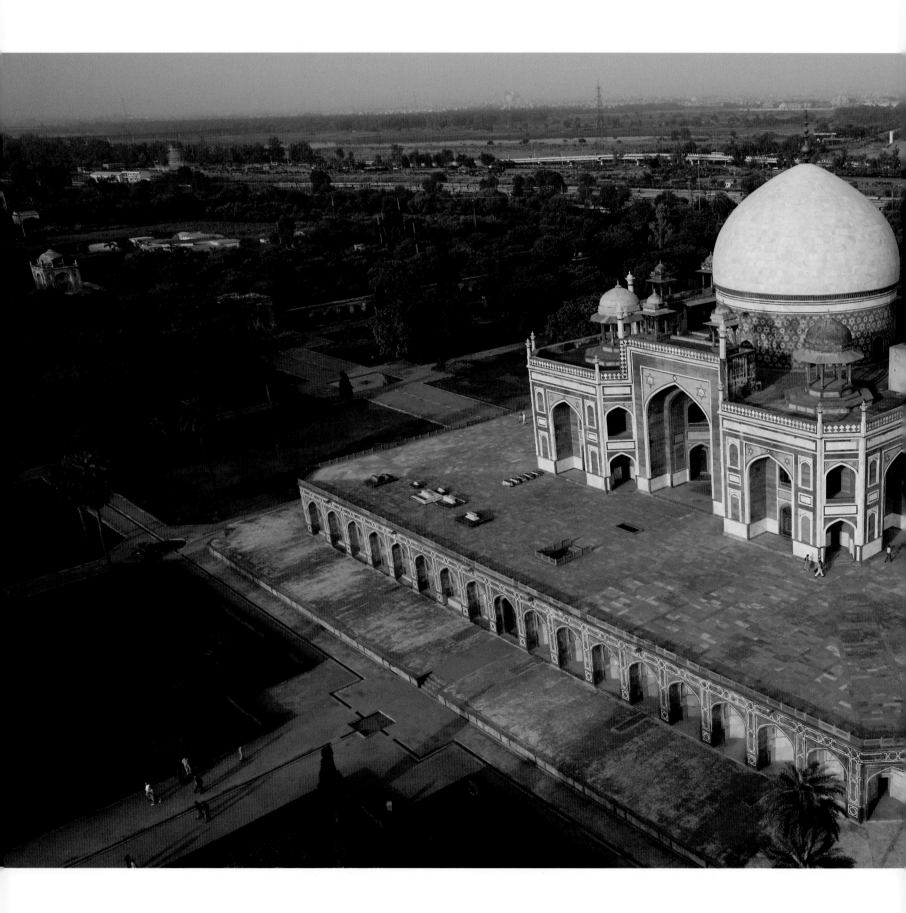

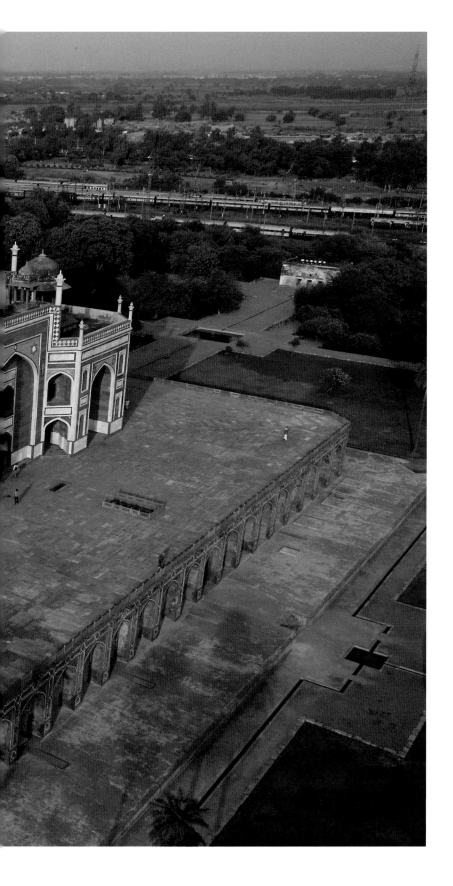

linked the Mughals to their Timurid ancestry (Plate 13). The architect, Mirak Mirza Ghiyas, was an Iranian from Herat who had been trained in the Timurid tradition that now inspired Humayun's tomb. According to some accounts, Humayun's wife was given responsibility for overseeing the project when she returned from the Hajj in 1582.[10] Its Iranian-style geometrical garden, divided into four sections by channels filled with water to symbolise the Garden of Paradise, was the design favoured by Babur that would be copied all over the subcontinent. The Mughal character of the tomb is nevertheless immediately obvious, both in the materials used – red sandstone, and white marble from the quarries of Makrana in Rajasthan – and in the superficial additions of cupolas (*chattris*) and broad, overhanging eaves known as *chhajja*. The materials and the form were the precursors of the most magnificent Mughal tomb of all, the Taj Mahal (Plate 2).

Both these broad trends in Akbar's architecture – the use of predominantly indigenous, hybrid features on the one hand and a style closer to Iranian models on the other – run through all the arts of his reign.

Much of Fatehpur still stands but little else from Akbar's reign remains within the fortifications of his other principal cities. Jahangir made modifications to the palaces that seem to have been broadly in the style of Akbar's buildings (Plate 14), and introduced innovations such as the tiled north and west walls of Lahore Fort (Plates 15 and 152). Most were swept away when Shah Jahan constructed his grand new palace buildings.

33

Plate 13 | HUMAYUN'S TOMB
Delhi

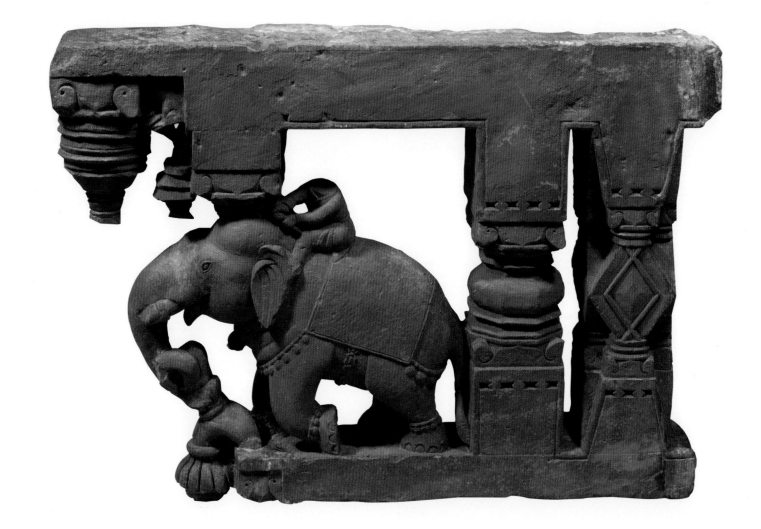

34

Plate 14 | BRACKET IN THE FORM OF AN ELEPHANT
Probably Agra, reign of Jahangir
Carved red sandstone 61 cm. x 86.4 cm. Victoria and Albert Museum, London: IS.1066-1883

Facing page | Plate 15 | TILED WALL
Lahore Fort, reign of Jahangir

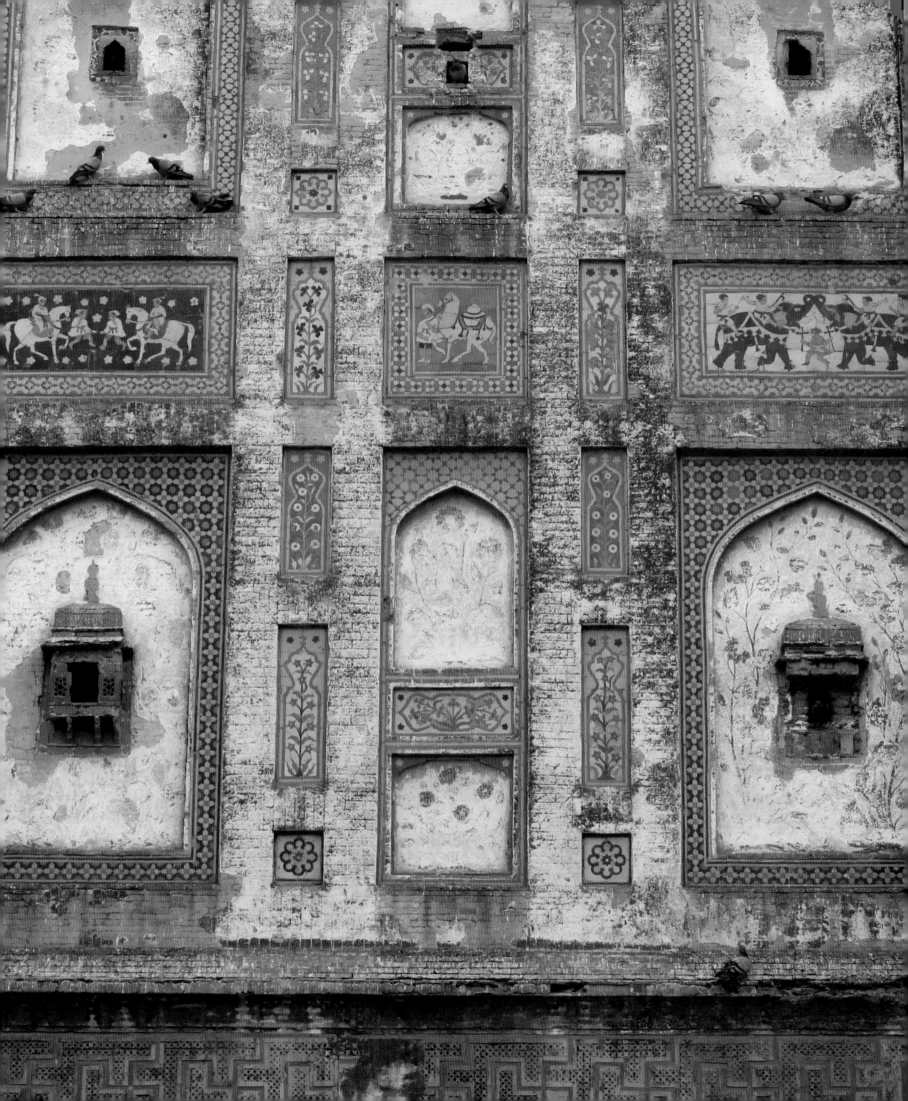

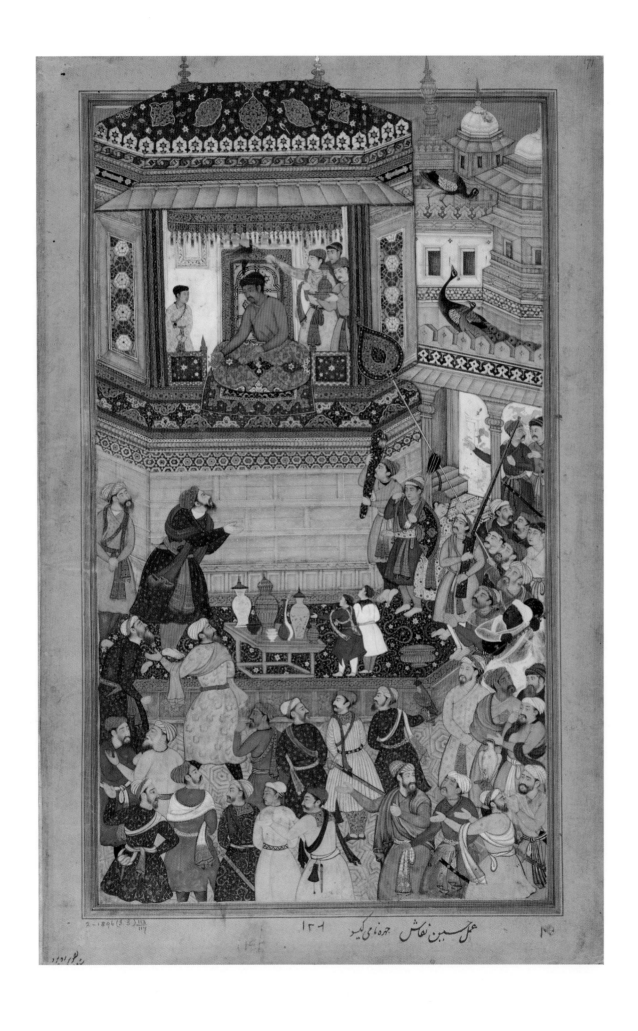

THE LIFE OF THE COURT

When the emperor was in residence, the palaces provided a grand setting for his highly structured routine and for the rituals and festivities of the Mughal year. Ambassadors came and went, and were greeted and given leave to depart with a level of pomp suited to the importance of those they represented. Individuals were moved in and out of office, and princes and leading members of the elite were despatched on important military campaigns. Births and betrothals were celebrated, and deaths mourned or commemorated. All these events had their own protocol or ceremonial and most involved the exchange of costly artefacts or precious stones. The value of everything was always carefully recorded.

Akbar's chronicler Abu'l Fazl wrote that the emperor's day began and ended with prayer. The energetic, highly disciplined ruler was said to sleep little, to eat only one main meal a day, and to listen late into the night to the discourse of 'sufis and philosophers' or to historians describing and analysing the events of the past.[11]

At some point in the day, drums would announce his arrival in the Hall of Public Audience where at first he sat alone, high up in a *jharoka*, or balcony, to perform one of his most important public offices, the dispensation of justice. From here he might also receive tribute (Plate 16). When he moved inside, the court would be arranged with great precision according to rank. Akbar was at the centre, seated on the gold throne that was the supreme emblem of royalty, with his sons and intimate confidants standing beside him. Two attendants held other royal insignia, which might include the oval shade on a long pole (*aftabgir* or *sayaban*) that protected him from the sun. In the most formal assemblies, the court stood at a distance, arranged in two lateral wings so that the emperor could be seen from the front. All these elements derived from the concepts of kingship in the Iranian cultural world to which the Mughals belonged, and continued in the reigns of Jahangir and Shah Jahan. Akbar greeted his official visitors in this public space, listened to learned men, met his skilled craftsmen, and heard the reports of the supervisors of the various departments, including the royal workshops, in order to assess their needs. Matters of governance would be discussed, and orders given. The proceedings often ended with entertainments provided by singers and musicians, or wrestlers, jugglers and acrobats. In Fatehpur, a structure added to the palace buildings accommodated a new imperial preoccupation: from 1575 the emperor engaged in a systematic study of other religions and invited the followers of different spiritual paths to join his discussions in the new *Ibadat Khana*, or House of Worship.[12] These included Jesuits, whose presence would profoundly influence the development of Mughal art.

Before Akbar retired to the harem for the night, musicians and singers performed and, as he slept, ordinary people would gather outside the walls of the palace, whether in Fatehpur, Agra, or Lahore, waiting until dawn when the emperor would rise and appear to them in a formal *darshan* or 'view' from the *jharoka*. The ceremony and these words were borrowed from the traditions of his Hindu subjects.

Facing page | Plate 16 | AKBAR IN A *JHAROKA*
Composition probably by Basawan, painting by Husayn Naqqash, faces by Kesu c. 1590-5 Illustration to the *Akbar Nama*
Opaque watercolour and gold on paper 32.8 cm. x 19.2 cm.
Victoria and Albert Museum, London: IS.2-1896: 113/117

Jahangir's official daily routine was similar to his father's, with small adjustments. On his accession, he emphasised his role as the ultimate legal authority by installing a 'chain of justice' with sixty bells, all made of pure gold, in the Shah Burj, or Royal Tower, of the palace at Agra (Plate 6). It extended to a stone post on the bank of the river so that anyone who had suffered a judicial injustice could, in theory, ring the bells and seek redress.[13] The notion was also borrowed from Iran: the Sasanian king, Khusrau Anushirvan, regarded as the embodiment of just rule, was described as having such a chain of justice in the *Shah Nama,* whose verses were read out at the Mughal court as they were all over the Persian-speaking world.

Jahangir maintained the hierarchical arrangement of people in the Hall of Public Audience, but embellished the space. In 1613, he noted that wooden railings (depicted in paintings as red, the colour of royalty), had hitherto separated the amirs, ambassadors and 'people of honour' from the lower ranks (Plate 28). He decided to emphasise the distinction of the first area which no one could enter without a specific command and ordered the railings, staircase leading to the *jharoka* and two wooden lions on the sides of the *jharoka* seat to be covered in sheet silver.[14]

Shah Jahan enhanced the formality of his court assemblies still further and changed the architecture of the main palaces where they took place. The existing halls of Public and Private Audience, his historians recorded, gave no protection against the searing heat of summer or the monsoon rains. One of his first orders on becoming emperor in February 1628 was for a covered *Chehel Sutun* (Forty-Pillared Hall) to replace them at Agra. This was completed in wood by August, and a second *Chehel Sutun* was built in Lahore in the same year in front of the *jharoka*. Both were eventually replaced by white marble, and a third was constructed in Shahjahanabad: all survive more or less intact.[15]

Despite the architectural innovations, Shah Jahan's daily routine remained close to that of Akbar, as his own historians commented.[16] Shah Jahan, too, appeared at dawn at the *jharoka*, enabling the crowds outside the palace 'to witness the simultaneous appearance of the sky-adorning sun and the world-conquering emperor, and thereby receive without obstacle or hindrance the blessing of both these luminaries'. From here, he might also review the Mughal army, or follow another tradition of Indian kingship by watching wild elephants fight.

He became, however, a more remote figure in the court assemblies than either Akbar or Jahangir had been. He oversaw public audiences from a high *jharoka*, often accompanied by his sons who stood, unless they were old enough to be granted the honour of sitting, and sometimes by his closest companions (Plate 17). This place was now demarcated by a golden railing, though silver-covered railings still separated the highest from the lower ranks.

Another architectural innovation at Shahjahanabad may still be seen. Here, the *jharoka* which was known as the 'Seat of the Shadow of God' is shaded by a white marble canopy resting on four ribbed pillars (Plate 18). Its form was inspired by the particular type of European canopy constructed for royal or holy figures known as a baldachin, influenced by models depicted in engravings brought to the court. The marble wall behind (Plate 19) is inlaid with Florentine *pietra dura* panels set between Mughal flowering plants and birds perched in blossoming trees, all inlaid with semi-precious stones in the same technique. The pillars are

Plate 17 | THE PRESENTATION OF PRINCE DARA SHOKUH'S
WEDDING GIFTS IN 1633
Signed by Balchand, c. 1635
Illustration to the *Padshah Nama* of Abdul Hamid Lahori
Opaque watercolour and gold on paper 34 cm. x 23.4 cm.
Royal Collection, Windsor Castle: RCIN. 1005025.k-1 folio 72B

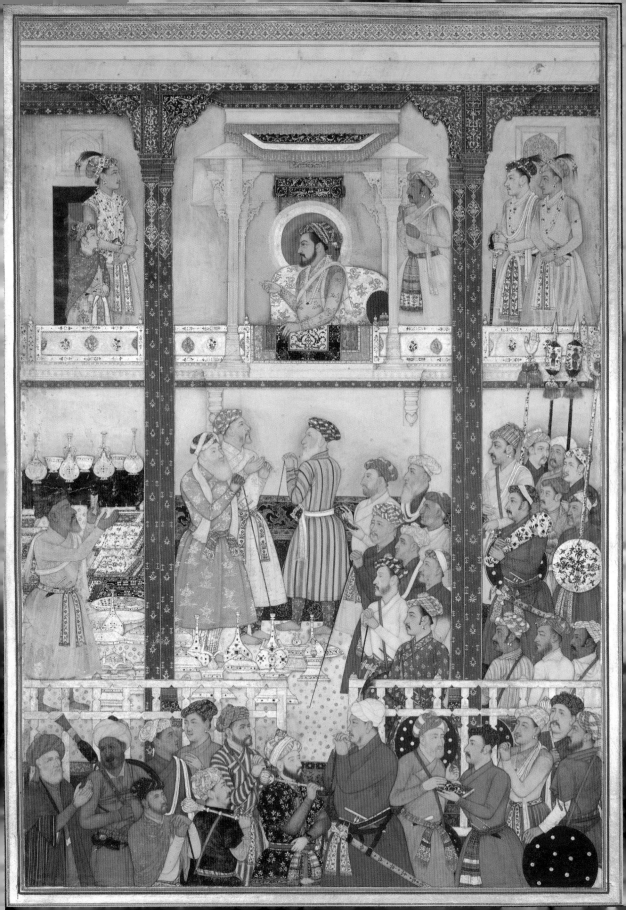

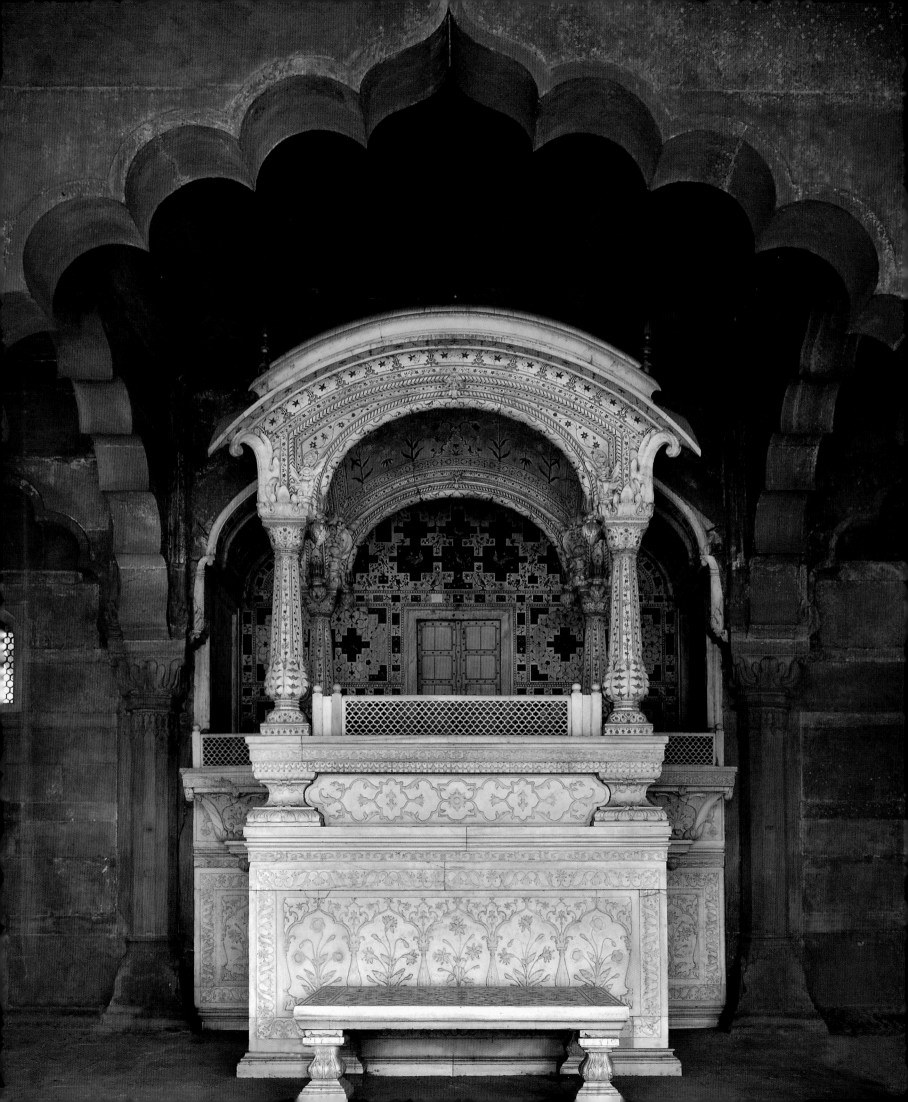

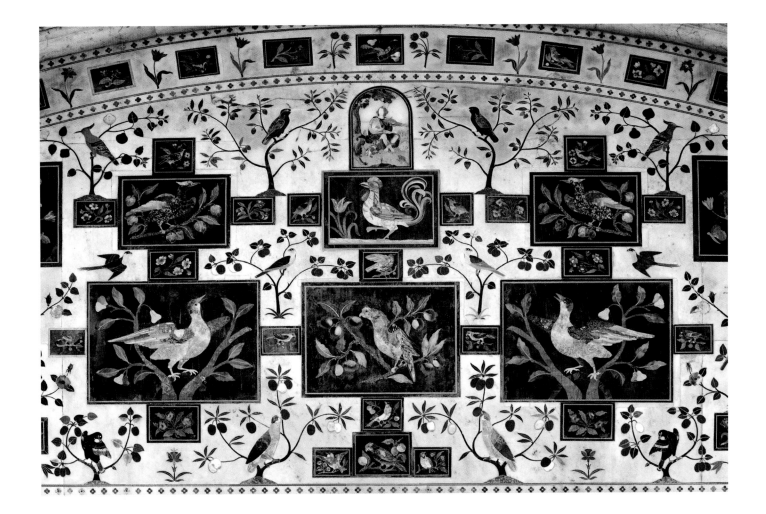

41

Facing page | Plate 18 | 'THE SEAT OF THE SHADOW OF GOD'
Shah Jahan's throne *jharoka* in the Hall of Public Audience, Shahjahanabad, Delhi

Plate 19 | DETAIL OF THE WALL BEHIND THE THRONE *JHAROKA*

decorated with Mughal *pietra dura* flowers of green jade and deep orange carnelian, while the underside of the canopy has painted floral decoration similar to designs on the borders of contemporary manuscripts. Two small hoopoes can be identified in the Mughal ornamentation of the wall (Plate 19). The bird is associated with King Solomon because it was the intermediary between him and Bilqis, the queen of Sheba, and the entire setting is laden with symbolism that presents Shah Jahan as the Solomon of his age. Shah Jahan's power, like that of the legendary king, therefore extended across the world, and the perfect justice of his rule, like that of Solomon, brought about such profound harmony that even natural enemies in the animal world coexisted in peace.[17] This theme suffused the decoration of the palace in Shahjahanabad. In the emperor's private apartments a water channel called the River of Paradise (*nahr-i behesht*) running through the emperor's private chambers passes underneath a perforated marble panel; above this is a panel carved with scales of justice enclosed by flowers, all picked out in gold and alluding to the earthly paradise created by Shah Jahan's reign (Plate 20). An inscription in the same suite of rooms records the dates construction of the city began and ended, 1639 and 1648, and the fact that it had cost six million rupees.[18]

The elevated position of the emperor meant that everyone had to gaze upwards to be able to see or speak to him, and his highest-ranking officials had to stand on a footstool to hand him papers (Plate 21). Shah Jahan's most important state business was discussed in the Hall of Private Audience, where court secretaries wrote out his orders unless the matter was extremely urgent and the emperor would write them himself. These *farmans* were then sent to the women's quarters to be stamped with the royal seal kept by Shah Jahan's wife Mumtaz Mahal until her death in 1631 and thereafter by his daughter, Jahan Ara Begum; Akbar's seal had also been kept in the women's quarters.[19] In his private audiences, Shah Jahan was more approachable: princes and amirs could talk directly to him, and he might listen to poets, philosophers and musicians, or scrutinize the work of his lapidaries, enamellers and other craftsmen, examine the calligraphy and paintings done by his scribes and artists, and meet his architects to discuss new projects.[20] He also appraised the rare birds and animals that were brought to him for the royal menagerie.

The most sensitive government matters were reserved for the beautiful interior of the Shah Burj at Agra or the Muthamman Burj (Octagonal Tower) at Shahjahanabad, where a circle of his most trusted confidants would meet in the heavily guarded chamber.

At midday Shah Jahan usually went to the harem, returning later in the day to the Hall of Private Audience to deal with affairs of state until evening, sitting in the flickering light cast by scented candles in jewelled holders. Before retiring for the night he listened to Hindustani music or to passages read by the court reader from the *Babur Nama*, the memoirs of his great-great-grandfather, or the *Zafar Nama*, the history of his distant ancestor Timur.

42

Facing page | Plate 20 | SCALES OF JUSTICE PANEL
Shahjahanabad, Delhi
Lala Deen Dayal, c. 1880-90

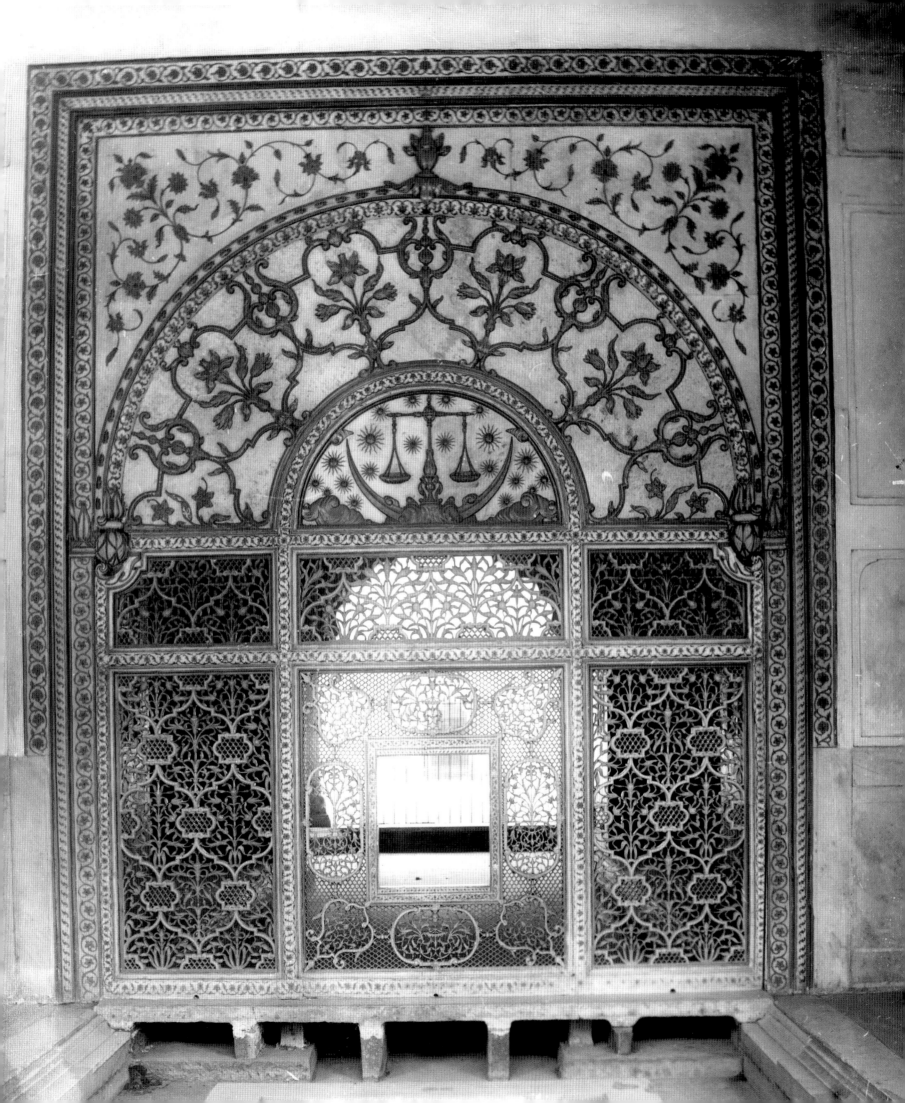

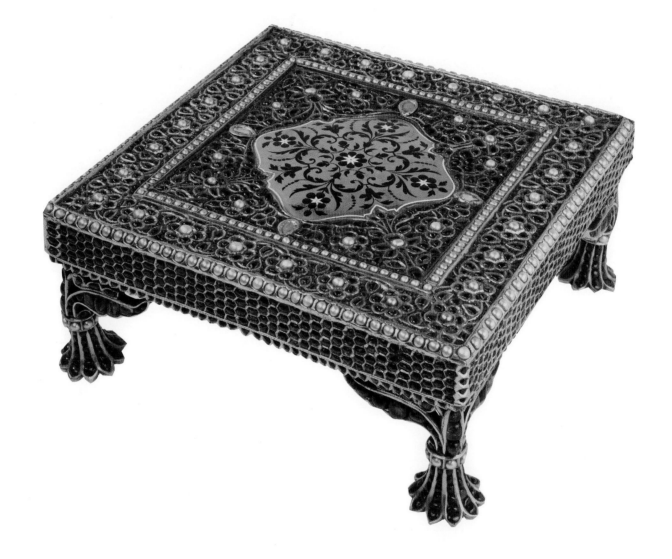

Plate 21 | FOOTSTOOL
Made by Sitaram, c. 1650
Gold, set with rubies, emeralds, pearls and diamonds with champlevé enamel
10 cm. x 23.7 cm. x 23.7 cm. The State Hermitage, St Petersburg: V3-728
Sent to Russia from Iran by Nadir Shah's embassy in 1741

NOWRUZ

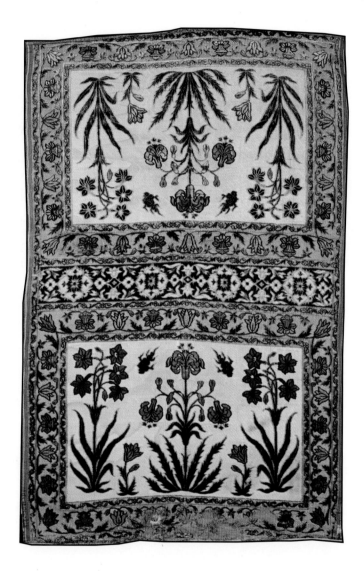

Plate 23 | *JHAROKA* HANGING
Silk velvet c. 1650
85 cm. x 56.6 cm. Chester Beatty Library, Dublin: Is TX.2

Facing page | Plate 24 | SHAH JAHAN AND HIS SON,
DARA SHOKUH
c. 1635-40
Opaque watercolour and gold on paper
Page from the 'Nasir al-Din Shah Album' 37.3 cm. x 24.9 cm.
Chester Beatty Library, Dublin: In 50.3

In all three reigns the most lavish and extensive of all the court's celebrations was the Nowruz, or New Year, the first day of the year in the 'new and divine era', introduced by Akbar on 10 March 1584. This was actually the Iranian solar calendar, which was then used simultaneously with the Islamic lunar calendar.[21] The date of Nowruz was so close to that of his accession that Akbar decided the regnal year would begin on the same day, a convention that persisted until Shah Jahan reverted to the Islamic system in his eleventh regnal year.[22]

Nowruz celebrations could last as long as nineteen days and ended on the Noble Day (*ruz-i sharif*). The court was decorated with rare and precious textiles by the grandees of the empire (Plate 23), musicians and dancers performed, poets recited their newly composed verses celebrating the arrival of spring with its blossoming flowers and gentle breezes, and artists presented paintings completed for the occasion.[23] Extraordinary artefacts made by the great masters of the royal ateliers would be revealed, and precious stones of enormous value as well as rarities acquired from all over the subcontinent, from Iran, China, Africa and Europe would pour in. The emperor visited the mansion of a great amir on each day, and might be offered anything from jewels, gem-studded vessels and weapons to elephants and horses (Plates 27, 30, 37 and 137). Usually, he chose only a few items and gave the rest back to his host.

Exceptional gifts were singled out by the court chroniclers. In 1610, Jahangir returned to Agra as Nowruz began, receiving on the way 'a small chest of European manufacture with sides of crystal and mother-of-pearl' from a senior noble.[24] Once in the city, he inspected the festive

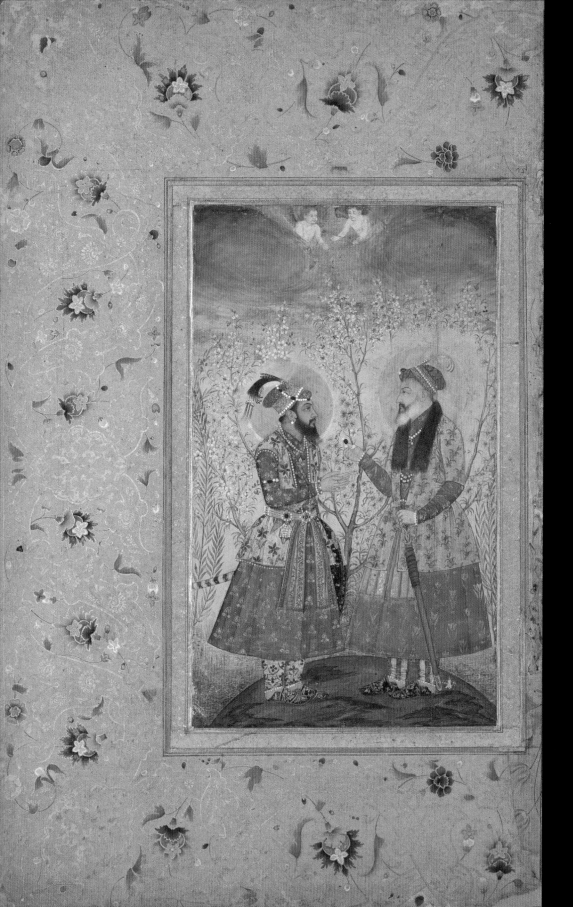

decorations of the Hall of Public Audience, and over the next days received presents from the court elite including a single pearl worth 4,000 rupees, and twenty-eight hawks and falcons. Muqarrab Khan, his childhood companion who was now governor of the western province of Gujarat with its wealthy ports of Surat and Cambay, arrived with precious stones (of which he was said to be a connoisseur),[25] jewelled utensils and European gold and silver vessels. It took two and a half months to show the rest of his offerings, which included African slaves and Arabian horses. Jahangir Quli Khan sent a silver throne, 'inlaid and painted in a novel manner' from Gujarat, and I'timad ad-Daula, the emperor's father-in-law, despatched a precious illustrated manuscript of 'Yusuf and Zuleykha' worth 1000 mohurs and copied by the famous fifteenth-century calligrapher, Mir Ali Heravi. Jahangir ended the festivities that year with a magnificent wine banquet.

As the resources of the empire increased, the Nowruz gifts became ever more extravagant and the court setting more exotic. The English ambassador Sir Thomas Roe first met Jahangir in Ajmer at the beginning of 1616. In his journal, he recorded that the emperor and his son, Khurram, had left the city on a short hunting expedition on 27 February while elaborate preparations were made for Nowruz (Plate 28). They returned on 9 March to inspect the enormous durbar space enclosed by railings that had been set up in their absence, the ground covered by huge, very fine, Iranian carpets and shaded by *shamianas*, or canopies, of 'cloth of gould, silke or velvett'.[26] Within it was a throne on a high platform, surrounded by curiosities of all kinds that included miniature houses made of silver. Khurram had installed a square pavilion whose silver-covered pillars supported a wooden canopy inlaid with mother-of-pearl and fringed with pearls, from which hung small gold pomegranates, apples and pears (the ambassador noted these were hollow). Here, Jahangir reclined against cushions embroidered with pearls and precious stones. The tents of the nobles were lined with velvet, damask or cloth of gold which formed the backdrop for their offerings to the emperor. At the end of the space, Roe saw the pictures presented by himself and his compatriots – they were portraits of his king and queen, their daughter and other ladies of the court, and the governor of the East India Company, Sir Thomas Smythe.[27]

Paintings evoke the sheer abundance described by foreign visitors such as Roe and by court historians, but cannot reflect the entire range of sensory experiences. Perfume filled the air, particularly during Akbar's reign when the palace was scented with ambergris, aloe wood and other fragrances derived from ancient recipes or invented by the emperor himself.[28] Incense was burned in perforated gold and silver

48

Plates 25 and 26 | PENDANT (FRONT AND BACK)
Probably reign of Shah Jahan
Gold, set with a carved emerald and diamonds on the front
enamelled on the back, 4.5 cm. x 4 cm.
The al-Sabah collection, Kuwait National Museum: LNS 142 J; Ja, b

Plate 27 | WINE CUP
c. 1620-50
Rock crystal set with rubies and emeralds in gold 5.3 cm. x 7 cm.
The al-Sabah collection, Kuwait National Museum: LNS 368 HS

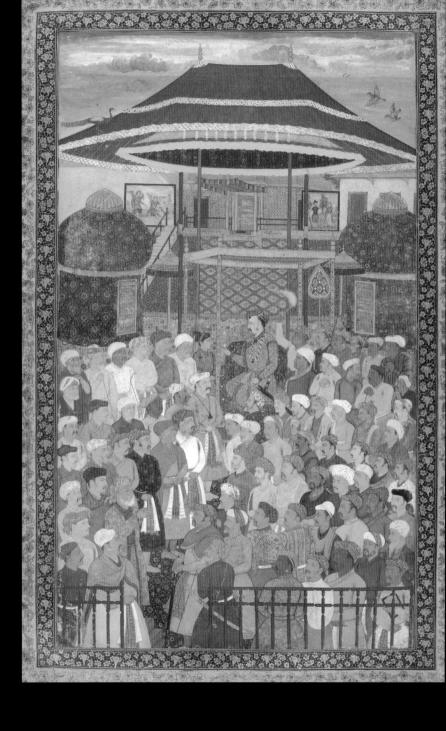

Plate 28 | JAHANGIR CELEBRATING NOWRUZ AT AJMER
c. 1615
Probably intended as an illustration to the *Jahangir Nama*
Page from the St Petersburg album Opaque watercolour and gold on paper 37.9 cm. x 22.7 cm
Petersburg Branch of the Institute of Oriental Studies, Russian Academy of Sciences; E.14 folio 2

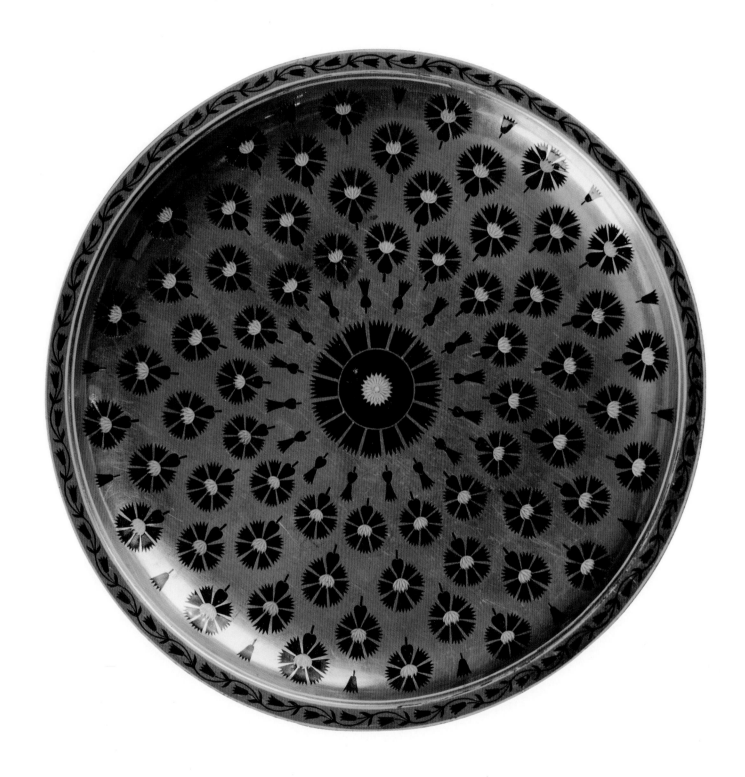

50

Plate 29 | DISH
c. 1650-1700
Gold, champlevé and basse taille enamel, Diameter 19.7 cm.
The State Hermitage, St Petersburg: V3-716
Sent to Russia from Iran by Nadir Shah's embassy in 1741

vessels, and perfumes were presented to favoured individuals. When the Safavid ambassador Muhammad 'Ali Beg came to Shah Jahan in 1631 at Nowruz, he received the customary *khil'at*, in this case a gold embroidered robe of honour and a special turban ornament. But a historian noted:

> As *pan* and *argcha,* which are composed of various fragrant essences of Hindustan, are always distributed during this festival among the nobility

and officers of state in attendance...the ambassador was presented with a jewelled casket for holding *pan* and a golden salver and a cup filled with *argcha* with saucer and cover of the same precious metal, altogether worth 20,000 rupees.[29]

A few examples of caskets for *pan* and small covered cups probably intended for *argcha* have survived from Shah Jahan's reign (Plates 33 and 181).

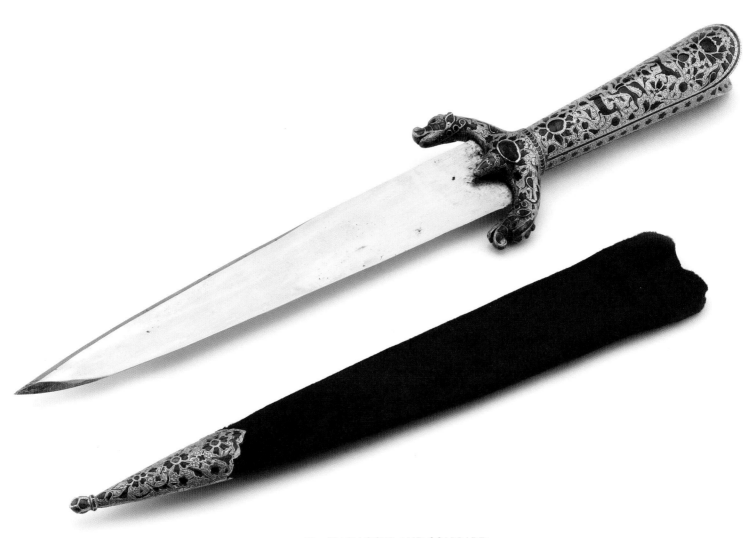

51

Plate 30 | DAGGER AND SCABBARD
c. 1620
Gold hilt and mount set with rubies and emeralds, steel blade,
scabbard wood covered with velvet
Length 35.5 cm. British Museum, London: 2001.0521.35

THE BIRTHDAY WEIGHING CEREMONY

When the emperor was weighed on his birthday in a ritual borrowed from Hindu tradition, more exceptional gifts were exchanged. Akbar was weighed on his solar calendar birthday against gold and eleven other valuable commodities, and on his lunar birthday against silver and seven other classes of goods.[30] The princes were also weighed as they came of age, though against fewer items and only on their solar birthdays.

This changed in 1607 when Jahangir was received by his oldest son Khurram in the prince's splendid house in Kabul on his sixteenth lunar birthday (Plate 31). The emperor, who loved architecture in beautiful settings, rewarded Khurram by having him weighed on this birthday as well. No specific gifts are mentioned by Jahangir when he described the event, but a painting of the 'weighing day' (*ruz-i wazn*) done a few years later as an illustration for his memoirs depicts trays full of jewelled or enamelled vessels, personal ornaments, including a dagger similar to one preserved in the al-Sabah collection (Plate 32), and precious fabrics. The Chinese statuettes and porcelain set into wall niches would probably have been found in most royal or aristocratic households within the empire. Years later, when Shah Jahan's son Aurangzeb reached the same age and was weighed against gold, his presents were itemised and included jewellery given only to princes and emperors, such as a turban ornament set with precious stones, and a necklace of pearls, spinels and emeralds, as well as royal elephants, and horses with jewelled or enamelled saddles. The total value of these presents was two lakh of rupees.[31]

Occasionally, individuals such as poets, artists or architects might be weighed against gold as a special reward.

Uniquely, Shah Jahan's daughter was weighed against gold to celebrate her recovery from a terrible accident. One evening early in April 1644 as she made her way to bed, Jahan Ara Begum had brushed against a lamp burning on the floor. The delicate fabric of her clothes impregnated with perfumed oils instantly caught fire. When her attendants rushed forward to try and save her, their own clothes were set alight and two of them died of their burns some days later. Shah Jahan himself tended to his severely burned daughter, changing the dressings applied by doctors until she slowly began to recover. On her birthday in June, Jahan Ara showed such improvement that the emperor ordered her to be weighed, though it would be eight months and eight days before she appeared at court. When she did, Shah Jahan's celebration lasted eight days and on each day he gave her extremely rare and precious jewellery whose value exceeded even the usual levels of opulence: 130 pearls of the finest quality worth five lakh of rupees; a tiara set with a single, immense diamond; a necklace of various precious stones. The revenues of Surat were assigned to her, while robes of honour, gold and silver artefacts and coins, precious stones and jewelled articles, and even flowers made of gold, were liberally distributed to her brothers, sisters and their spouses. The physicians who had tended her received other extravagant presents, from enamelled daggers to finely caparisoned horses, and Arif Chela, a servant whose dressings had been the most effective, was given his weight in silver.[32]

Facing page | Plate 31 | JAHANGIR WEIGHING
HIS SON KHURRAM
c. 1615
Illustration to the *Jahangir Nama*
Opaque watercolour and gold on paper 26.6 cm. x 20.5 cm.
British Museum, London:1948.10-9.069

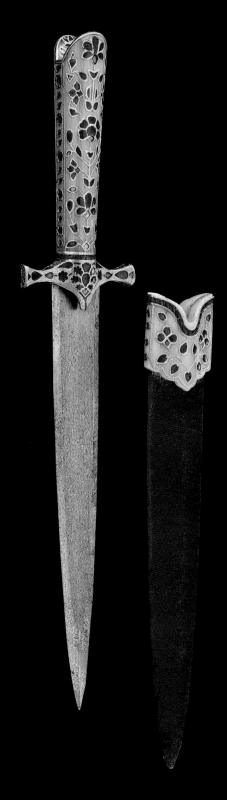

54

Plate 33 | CASKET FOR *PAN* (*PAN DAN*)
Reign of Shah Jahan
Enamelled gold 5.7 cm. x 11.5 cm.
Freer Gallery of Art, Washington, D.C.: F1986 22a-b

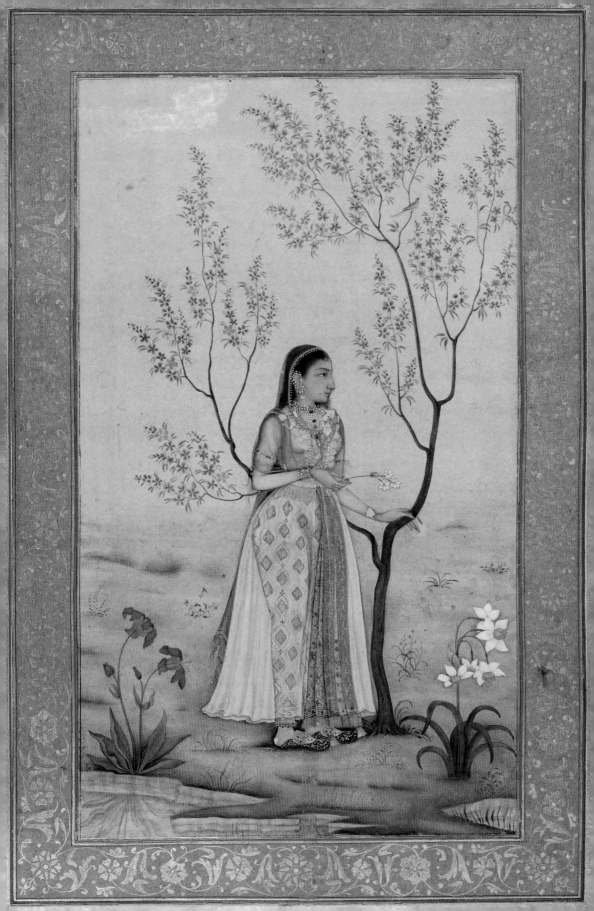

Vast expenditure was inevitably also laid out on royal weddings and a member of the family was usually given charge of the arrangements.

Jahan Ara Begum supervised the first elaborate weddings of Shah Jahan's reign when his son and designated successor Dara Shokuh married Nadira Banu Begum, the prince's cousin (Plate 34), and the emperor's second son Muhammad Shah Shuja' was betrothed to the daughter of Mirza Rustam, a member of the Safavid royal family. These marriages had been arranged by Shah Jahan's wife Mumtaz Mahal, but when she died in childbirth in 1631 they were delayed until after the first anniversary of her death.[33]

Preparations began at the end of 1632 with the despatch of jewellery, fine clothes and gold worth one lakh of rupees from Dara Shokuh's house to that of his future wife. The following February, Jahan Ara privately gave khil'ats of rich fabric and jewels to the princes, and publicly presented her uncle Asaf Khan with nine outfits and a jewelled sword and dagger of great value. Other high-ranking members of the court circle received slightly less valuable and less numerous presents, all carefully calibrated according to their rank.

The hina bandi celebration, when henna was sent to the bride on the eve of the wedding day to decorate the feet and hands of the women, then took place in the private apartments of the palace at Akbarabad. Lights sparkled from lamps and candles, and perfume wafted from the rose essence, argcha and pan carried on trays by servants. Musicians and singers performed for the first time at court since Mumtaz Mahal's death and the evening ended with fireworks along the banks of the Yamuna. The next night, the bridegroom and his procession went to the Chehel Sutun. There, Shah Jahan

57

Facing page | Plate 34 | A PRINCESS NEXT TO
A BLOSSOMING TREE
c. 1635
Page from the Dara Shokuh album given by the prince
to his wife Nadira Banu
Opaque watercolour and gold on paper 16.6 cm. x 9.9 cm.
British Library, London: Ms. Add. Or. 3129 folio 34

Plate 35 | SASH (*PATKA*)
late 17th century
Patkas with gold brocaded ends would have been included in the *khil'at*
presented by the emperor as a mark of favour

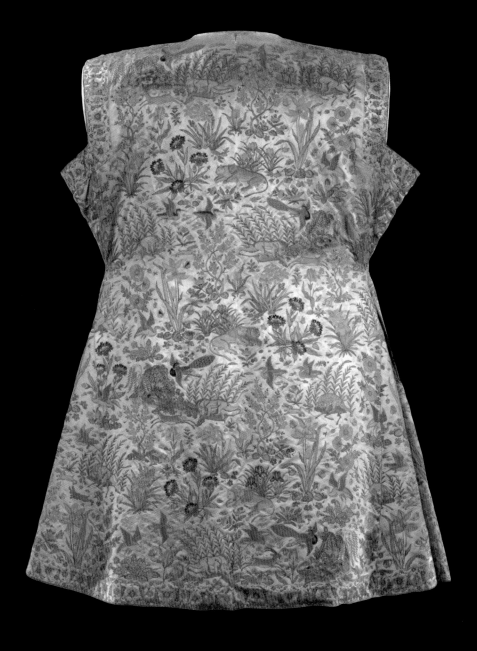

58

Plate 36| RIDING COAT
Gujarat c. 1620-30
Silk embroidered with silk thread Height 97 cm.
Victoria and Albert Museum, London: IS.18-1947
Robes of such high quality were probably originally part of a *khil'at*,

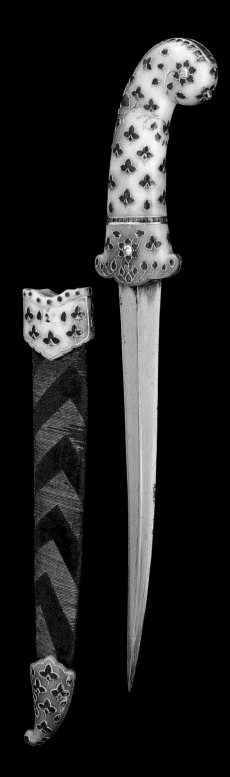

Plate 37 | DAGGER AND SCABBARD
Mughal (or Deccan sultanates), mid-17th century
Hilt of white nephrite jade set with rubies, diamonds and emeralds in gold,
the scabbard with jade mounts *en suite*, the blade steel 35.4 cm. x 8 cm.
The al-Sabah collection, Kuwait National Museum: LNS 12 HS

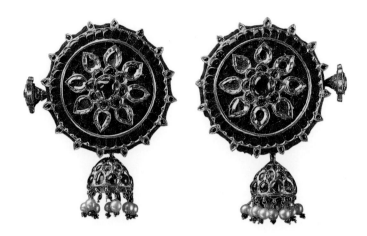

gave him jewelled weapons including a dagger with floral decoration, a necklace of large pearls and spinels, and two fine horses, one with a jewelled saddle and the other an enamelled saddle and two splendidly caparisoned elephants completed

the imperial gifts valued at four lakh of rupees. Asaf Khan received a sleeveless jacket of gold brocade of the kind known only from contemporary paintings, and the Yamuna was again lit up by fireworks, while lamps illuminated the waterfront gardens of the great mansions. The marriage ceremony was performed here, and then the leading court poet recited his celebratory verse containing a chronogram, or date given by the numerical value of the letters in certain words.

Even then, the celebrations were not over. A week later, Dara Shokuh covered the ground between the palace and his house with plain and embroidered velvet, and cloth of gold and silver for the emperor to walk across in the *pa andaz* ceremony and Shah Jahan performed *nisar* (bounty spreading) by scattering gold and silver coins and precious stones as he went. Shah Shuja's marriage a few days later was very similar, as was that of their brother Aurangzeb five years later (Plate 39). The presents they received were also almost identical to those given to Dara Shokuh for his wedding.

Plate 38 | PAIR OF EAR ORNAMENTS
Late 17th century
Gold set with rubies, diamonds and emeralds
8.2 cm. x diameter 4.3 cm.
The al-Sabah collection, Kuwait National Museum: LNS 1809 Ja, b

Facing page | Plate 39 | SHAH JAHAN RECEIVING PRINCE
AURANGZEB AT HIS WEDDING IN 1637
c. 1640
Illustration to the *Padshah Nama* of Abdul Hamid Lahori
Opaque watercolour and gold on paper 33.8 cm. x 23.5 cm.
Royal Collection, Windsor Castle: RCIN. 1005025.k-1 folio 218B

62

Plate 40 | SCREEN (*JALI*)
Delhi or Agra, reign of Shah Jahan
White marble, carved and pierced 58.5 cm. x 76.5 cm.
Victoria and Albert Museum, London: 07071 (IS)
Acquired by the Indian Museum before 1879

THE CONCEALED WORLD OF THE ZANANA

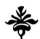

The women of the royal family were often extremely influential figures and from the time of Babur played crucial roles in peacemaking. When Salim rebelled against Akbar in 1601, for instance, Hamida Banu tried to negotiate a rapprochement between the prince and his father, and Akbar occasionally left his mother in charge of government, while Jahangir's wife Nur Jahan became one of the most powerful figures in the empire as his health deteriorated.[34] Occasionally, the royal ladies were present at public assemblies, watching out of sight from upper balconies or from behind the screens of buildings (Plate 40) or tents. In 1616, when Sir Thomas Roe was allowed to approach Jahangir at his *jharoka* at Ajmer, he glimpsed two of the emperor's wives at a nearby window. Curiosity had made them pull apart the reeds of the curtain screening them, and Roe recorded: 'I saw first their fingers, and after laying their faces close, now one eye, now another; sometyme I could discerne the full proportion ... if I had had no other light, their diamonds and pearles had sufficed to show them.'[35]

This discretion makes paintings depicting royal births in the harem all the more remarkable.

Shortly before Jahangir's birth, his mother Maryam az-Zamani had travelled to Sikri to be near Shaykh Salim Chishti, who had predicted that Akbar would soon have his long-awaited son. The birth of the 'world-illumining pearl of the mansion of dominion and fortune, the night-gleaming jewel of the casket of greatness and glory' was joyously celebrated. The event would be included as an illustration to Akbar's official history, and to Jahangir's memoirs (Plate 41). Here, the viewer is allowed to peer over the walls to see inside the harem whose entrance is guarded by women, as decreed by Akbar in his regulations for the institution within the royal household.[36] Outside, one of the royal ladies consults the male astrologers casting the infant's horoscope next to the royal red *qanats*, or tent panels, that mark the entrance. Inside, musicians provide an accompaniment to the scene dominated by the chamber in which Maryam az-Zamani reclines on her bed while her servant cradles the newborn baby next to his jewelled cradle. The senior ladies of the court are singled out by their tall hats set with aigrettes; others wear men's turbans. The most important woman in the gathering, presumably Hamida Banu, sits on a golden chair.[37]

A painting of Jahangir celebrating the Hindu Spring festival of Holi provides a rare view of the women of the court at play in the private quarters of the palace, intoxicated with wine and spraying each other with red powder in a garden pavilion covered with carpets (Plate 41). Their ornaments and clothes may be seen in equally rare depictions of royal women painted in the reign of Shah Jahan and preserved in the borders of one of his albums (Plate 111).

63

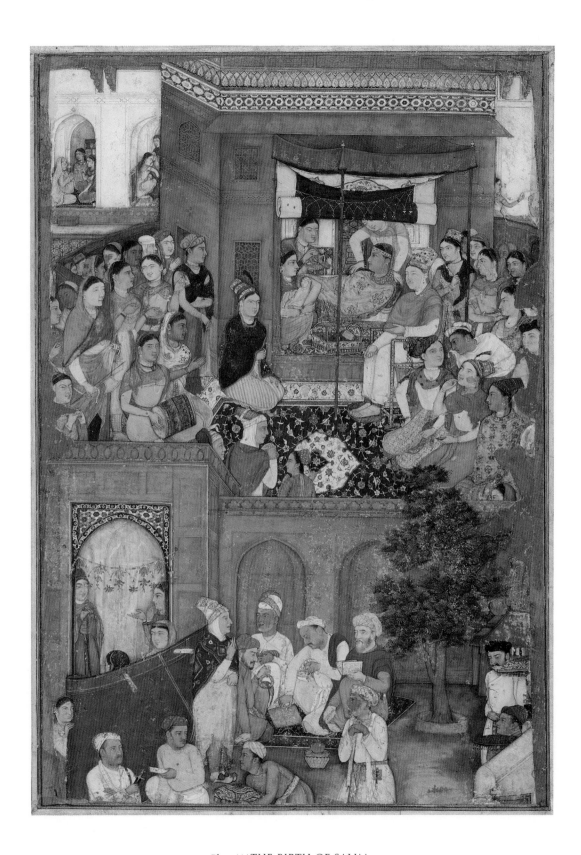

Plate 41 | THE BIRTH OF SALIM
c. 1618, Illustration to the *Jahangir Nama*
Opaque watercolour and gold on paper 26.4 cm. x 16.4 cm.
Boston, Museum of Fine Art: Inv. 14.657 Francis Bartlett Donation of 1912 and Picture Fund

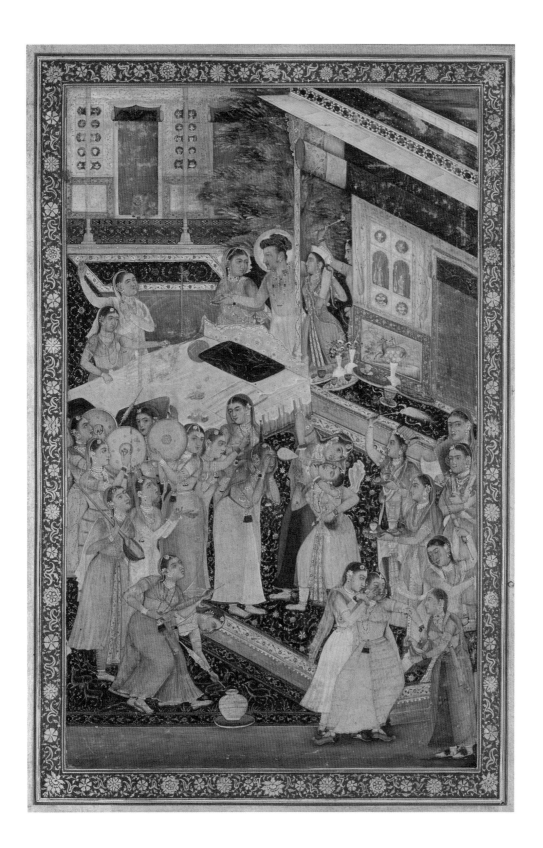

Plate 42 | JAHANGIR AND LADIES OF THE COURT CELEBRATING HOLI
c. 1635-45
Opaque watercolour and gold on paper
Folio 38.9 cm. x 27.2 cm. Painting 24 cm. x 15 cm. Chester Beatty Library, Dublin: In 07A.4

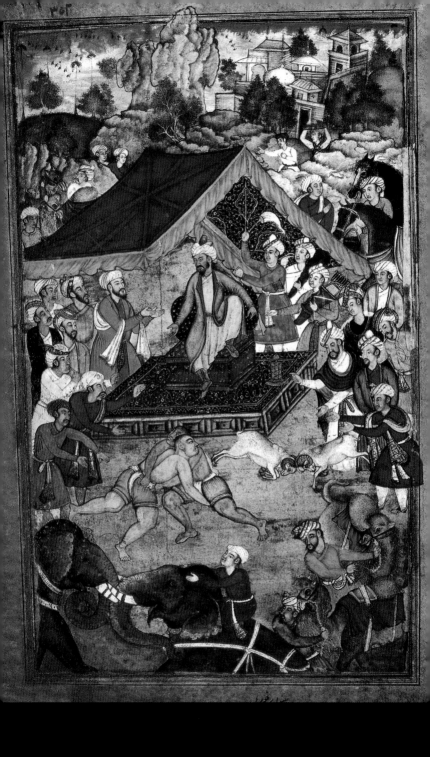

Plate 43 | BABUR WATCHING ELEPHANT, RAM AND
CAMEL FIGHTS, AND WRESTLERS
By Banwari Khurd, c. 1590
Illustration to the *Babur Nama*, National Museum, New Delhi: 50.326

COURT PASTIMES

Various amusements of the court are listed by Abu'l Fazl in the *A'in-i Akbari*.[38] Akbar played chess and cards, but he may have preferred *pachisi* (or *chaupar*), the traditional Indian board game long associated with the aristocracy. At one point it became a court obsession, as Abu'l Fazl recorded: 'Formerly many grandees took part in this game; there were often as many as two hundred players, and no one was allowed to go home before he had finished sixteen games, which in some cases lasted three months. If any of them lost his patience and got restless, he had to drink a cup of wine'.[39] No *pachisi* boards or counters associated with any Mughal emperor are known, though a popular myth claims that beautiful women were used as pieces on the large-scale *pachisi* board set into the flagstones of a courtyard at Fatehpur for Akbar's amusement.[40]

In his youth, Akbar was especially fond of pigeon-flying, and the descriptions of the birds in the palace collection made by his chronicler Abu'l Fazl are the equal in their closeness of observation to anything written by Jahangir, the famous royal naturalist. Beautiful and well-trained pigeons made suitable gifts, and were exchanged between royal families in different countries, as were other special birds and animals. Some were kept simply for their plumage, which might be of the colour of steel, dark grey like the powder of antimony, pale as peaches, or with the yellow hue of Indian-made paper; others were trained to do particular tricks, like imitate the call to prayer, strut, or pretend to be dying.[41]

More vigorous leisure sports included polo (*chowgan*), which Akbar even played at night, using balls of slow-burning wood that were kindled and smouldered for the duration of the game. Even here, the appearance of the court was considered: 'For the sake of adding splendour to the games, which is necessary in worldly matters, His Majesty has knobs of gold and silver fixed to the tops of the *chowgan* sticks. If one of them breaks, any player that gets hold of the pieces may keep them.'[42]

Fights were often staged between elephants, buffaloes, stags, cocks and other birds and animals for the amusement of the court and the common people (Plate 43). Father Monserrate, the Jesuit who came from Goa to Fatehpur in 1580, reported that Akbar sometimes spent entire days occupied by 'deer, pigeons, cocks, birds, cages, fights of wild elephants, wild buffaloes, fights among men, mock quarrels… and other pastimes'.[43] It was left to Akbar's own historian to record the emperor's enjoyment of idiosyncratic pastimes such as training frogs to catch sparrows, and arranging fights between spiders.[44]

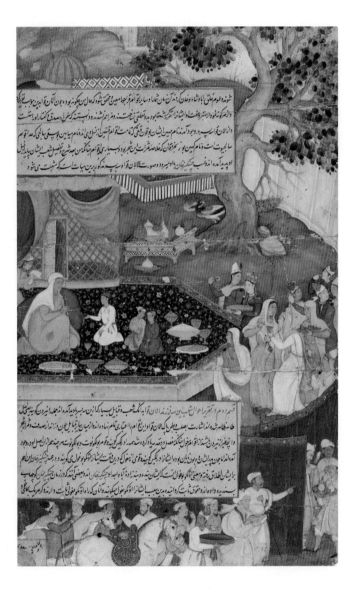

Plate 44 | ALANQUVA AND HER THREE SONS
Page from a *Chinghiz Nama* dated 1596
Opaque watercolour and gold on paper 34 cm. x 21 cm.
Los Angeles County Museum of Art: 78.9.9 From the Nasli and Alice
Heeramaneck Collection, Museum Associates Purchase

The most elaborate celebrations could only be held when the court resided in and around the capitals; those held when the court was away from the main treasuries, workshops and storehouses were necessarily less ambitious.

The emperors and their family moved round their domains frequently, travelling in vast encampments between the capitals or making less ponderous progress on shorter journeys or when hunting purely for pleasure (Plate 44). Whenever the emperor appeared in public in a formal procession he was surrounded by emblems of royalty including the *aftabgir* and the *chatr,* or parasol, to which at least five standards (*'alams*), flags, and a collection of arms wrapped in red cloth known as the *qur* were added.[45] In Shah Jahan's reign, these are often shown in paintings of palace assemblies where they had become, like everything else, more ornate than ever before. The royal wives often travelled on elephants, concealed within decorated howdahs, with their female servants following on camels under white sunshades.[46]

The large processions demonstrated to the populace the magnificence of the ruling power. The royal family, including the harem, the men of rank and their households, the court offices, cooks (Plate 47), workshops and bazaars, elements of the army, and their servants, musicians (Plate 46) and other followers all set out, with animals to transport goods and people. Hundreds of men were required to set up the encampment, effectively a small town and always laid out in exactly the same way according to principles established by Akbar, with an east-west axis oriented towards Mecca.[47] Two sets of tents, all carpeted and lined with special

68

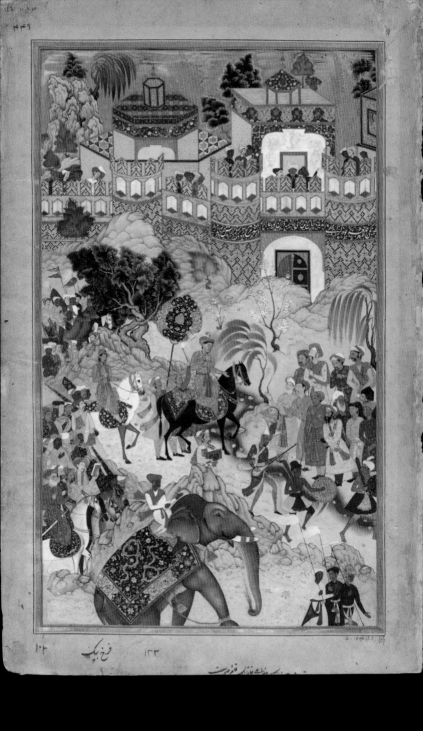

Plate 45 | AKBAR'S TRIUMPHAL ENTRY INTO SURAT IN 1572
By Farrokh Beg c. 1590-5
Illustration to the *Akbar Nama* Opaque watercolour and gold on paper 31.8 cm. x 19.1 cm.
Victoria and Albert Museum, London: IS.2-1896: 117/117

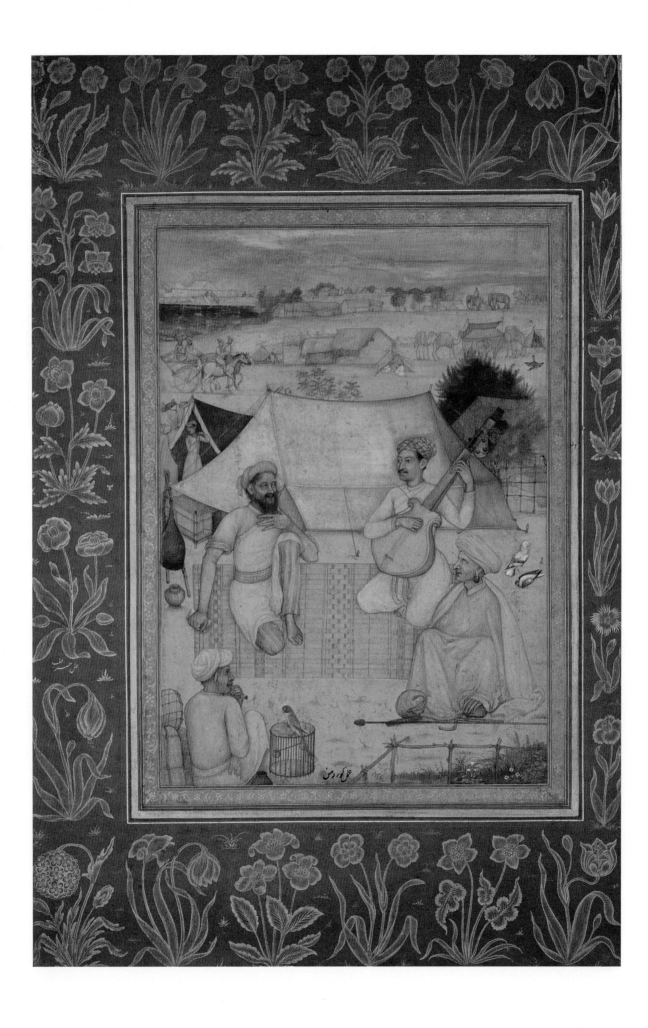

70

hangings, allowed one to travel ahead to be ready for the next halt. Each set required at least 100 elephants, 500 camels and 400 carts to move it.[48]

The camp's equipment was supplied by the *Farrash Khana*, regarded by Akbar as one of the most important departments of the imperial establishment.[49] The private apartments and the harem were placed at the heart of the encampment, within a heavily fortified enclosure with a gateway that could be securely locked, a necessary precaution given the occasional attempts on Akbar's life.

Sir Thomas Roe entered this enclosure in Jahangir's camp which extended over half a mile and was marked by red *qanats*. At the centre was the emperor's mother-of-pearl throne, and all around, neatly arranged, were the green or white tents of the nobles. Their magnificence, he wrote, left him ashamed of his own inferior accommodation.[50]

The tent used for public assemblies was the *bargah*, a canopy without side panels, which Abu'l Fazl reported could be so large that it took 1000 men a week to set up and could accommodate 10,000 people. The logistical complications this implies suggest that the standard version must have been smaller. Wood was used to assemble eighteen small houses in this part of the camp were designed to be easily dismantled. According to a history of 1579, they were lined with European brocade and velvet.[51] Akbar slept and prayed in a wooden two-storey structure, making his *darshan* from the upper *jharoka* opening. State business was carried out in the same area, and small tents with latticed openings allowed the ladies of the harem to be present without being seen. At the end of the day Akbar relaxed with select companions in a moonlight (*mahtabi*) courtyard, seated on a platform beneath a canopy.[52]

Akbar's travelling tents, like those of Jahangir and Shah Jahan, were red on the outside, the colour marking a royal prerogative that was extended by each emperor to his sons as they came of age. In Jahangir's second regnal year,

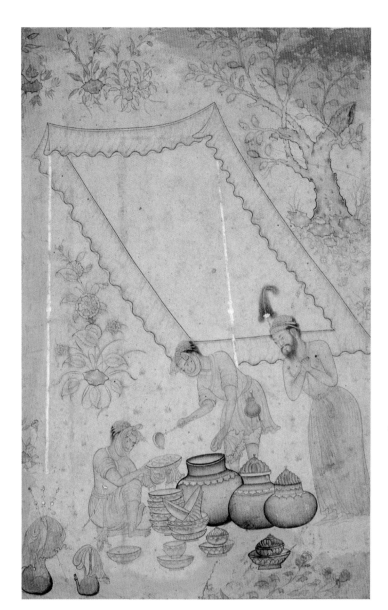

Facing page | Plate 46 | MUSIC IN CAMP
By Govardhan
Drawing, watercolour wash and opaque watercolour on paper, the borders indigo with gold floral decoration (by Harif, c. 1640)
Folio 39.1 cm. x 27.3 cm. Painting 23 cm. x 16.6 cm.
Chester Beatty Library, Dublin: In 07A. 11

Plate 47 | COOKS IN AN ENCAMPMENT
c. 1600
Drawing on paper 21 cm. x 13.6 cm.
Museum für Asiatische Kunst: MIK I 5690

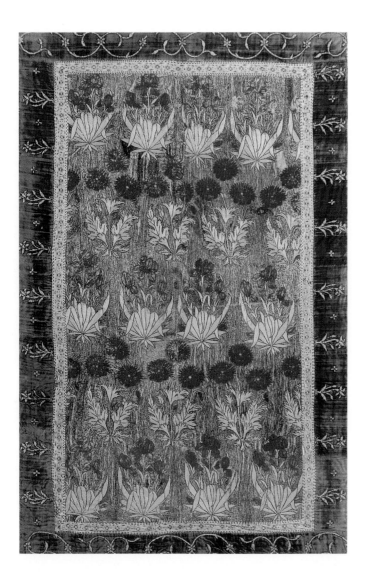

for example, when the fourteen-year-old Khurram was betrothed to Arjumand Banu Begum (later given the title Mumtaz Mahal), he received a promotion to the rank of 8000 in the Mughal system, as well as the royal insignia of a flag, drum and standard, and *aftabgir*, and was granted the use of a red tent.[53]

The meanderings of the court might last for weeks or months, during which time the individuals closest to the emperor were given formal charge of the principal cities with their treasuries. As the procession lumbered onwards, women gave birth, people died and many of the regular activities of the court carried on regardless. Pauses between major stations were brief. When Jahangir and the royal family left Gujarat in 1618 to return to Akbarabad after an absence of more than three years, Arjumand Banu gave birth to her first son, Aurangzeb, on the journey. They halted for just three days, and the celebrations waited until they reached nearby Ujjain, one of the *jagirs* of Khurram who by now had been given the title Shah Jahan, which he would retain as emperor. Here, the prince presented his father with trays of precious stones and jewelled items, as well as 50 elephants.[54]

72

Plate 48 | WALL OR TENT HANGING
Gujarat second half of 17th century
Cotton, quilted and embroidered with silk and silver-gilt thread
188.1 cm. x 120.7 cm.
Calico Museum of Textiles, Ahmadabad: 289

Facing page | Plate 49 | PRIMER
c. 1650
Carved ivory with traces of polychrome decoration, set with garnets and rubies and with steel mounts 19.6 cm. x 7.6 cm. x 3.1 cm.
Virginia Museum of Fine Arts, Richmond: 68.8.142
The Nasli and Alice Heeramaneck Collection, Gift of Paul Mellon

THE ROYAL HUNT

At all times, hunting was a frequent pursuit and the theme of the royal hunt decorated the artefacts of the court (Plate 49 and 52). Whenever the emperors embarked on hunting expeditions with a huge entourage, there was usually an ulterior motive. In regions where rebellion was thought to be fomenting, the arrival of what was a barely disguised army would usually be a silently effective warning.[55] At the same time, these larger hunts allowed the emperor to test the bravery, self-control and other skills of his highest-ranking nobles that would be equally applicable to warfare.

The most complicated Mughal hunt enjoyed by the emperors, the *qamargah,* was inherited from the distant Mongol tradition of their Central Asian ancestors (Plates 50 and 51). In these, beaters radiated out over an area of several miles and then turned back to the centre, drawing closer together to trap their prey for the emperor and his nobles to kill. At other times, wild elephants were hunted and carefully captured to be tamed. The value of a fine elephant was said to be equal to 500 horses and some would be chosen for the emperor's personal use, and given names; they might subsequently be presented, bedecked with rich accoutrements, to foreign rulers or to the highest-ranking members of the court. Cheetahs were also trapped so that they could be trained to hunt, and detailed regulations concerning the care of both within the royal household were laid down.[56] The princely pursuit of hunting with falcons

73

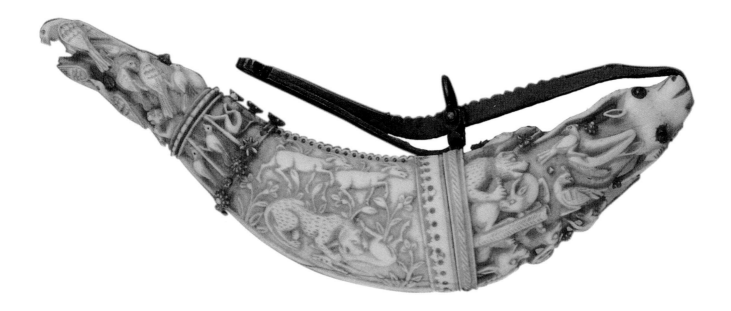

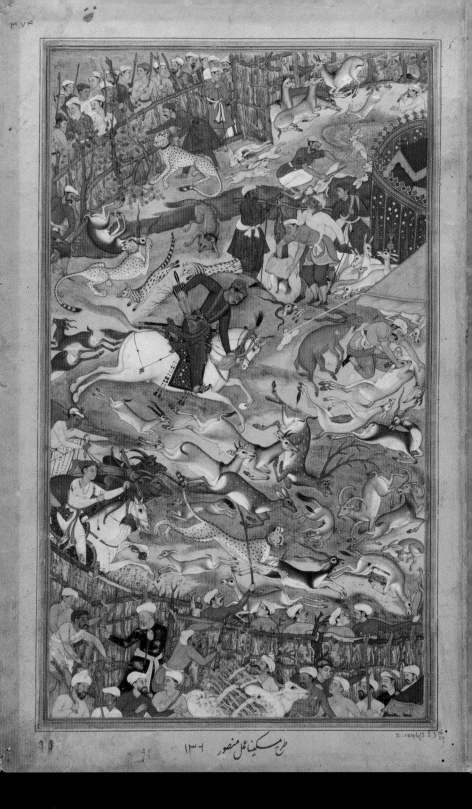

۱۳۷ طرح مسکینا عمل منصور

Plates 50 and 51 (facing page) | A ROYAL *QAMARGAH*
Double page composition by Miskina, with colouring by Mansur (left) and Sarwan (right)
c. 1590-5 Double page illustration to the *Akbar Nama*
Each folio 32 cm. x 19 cm. Victoria and Albert Museum, London: IS.2-1896, 55/117 and 56/117

(Plate 53) was one of Akbar's especial passions, and he trained these birds himself, paying great attention to their diet. Rare specimens were always extremely valuable, and their keepers were highly paid.[57]

The emperors often preferred very simple hunting expeditions, but even here there might be another purpose. Akbar sometimes travelled unencumbered with only a handful of servants, moving swiftly across large areas to arrive unannounced so that he could assess at first hand the condition of his subjects and punish anyone oppressing the populace.[58]

Jahangir's hunting expeditions occupied weeks, and even months, of his time during a reign filled more than any other with travels across the empire. Nevertheless, his royal duties could not be ignored: the court was always deemed to be wherever the emperor was. In his second regnal year, he set out for Kabul from Lahore with Nur Jahan and the ladies of the royal household, on what he described in his memoirs as simply a hunting tour, in which the women took part. In

fact, he also intended to suppress a rebellion involving his brother Khusrow.[59] The journey allowed him to inspect one of his many small architectural commissions, a tower built in 1606 in one of his favourite hunting grounds near the grave of a much loved antelope, and that had been inscribed with a prose eulogy by Muhammad Husayn Kashmiri.[60] As Jahangir moved northwards to Kabul, hunting and enjoying the scenery, pausing from time to time at particularly appealing places to hold wine banquets, his official business followed. He had handed over fiscal and administrative duties to I'timad ad-Daula for the duration of this expedition, but suffered from one of his many illnesses caused by excessive consumption of alcohol and opium. I'timad ad-Daula's son, Asaf Khan, therefore had to catch up with the royal camp to be assigned the emblem of office, a jewelled inkwell and pen-case (Plate 54). The emperor's role as supreme arbiter of justice also continued. Near Kabul, the son of Raja Bikramajit arrived from Gujarat, where he had been arrested on a charge of murder. Jahangir established the facts of the matter and

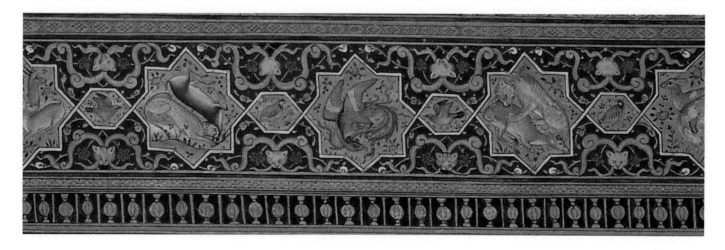

Plate 52 | DETAIL FROM A THRONE
OF JAHANGIR (see Plate 162)

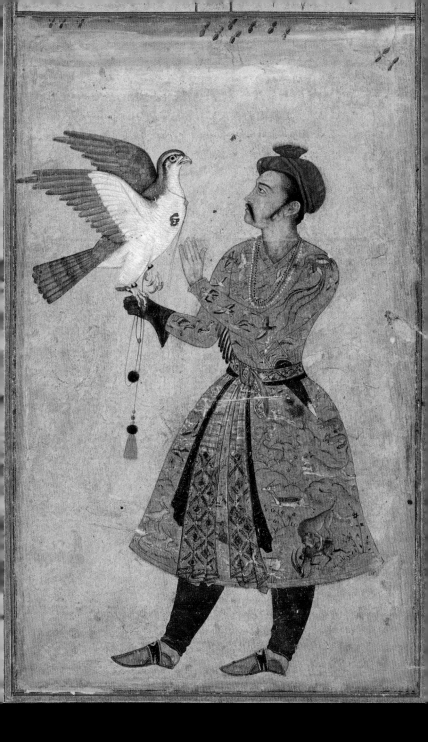

Plate 53 | A FALCONER
c. 1600
Opaque watercolour and gold on paper,
14.2 cm. x 8.5 cm. Los Angeles County Museum of Art
The Nasli and Alice Heeramaneck Collection, Museum Associates Purchase: M.83.1.4

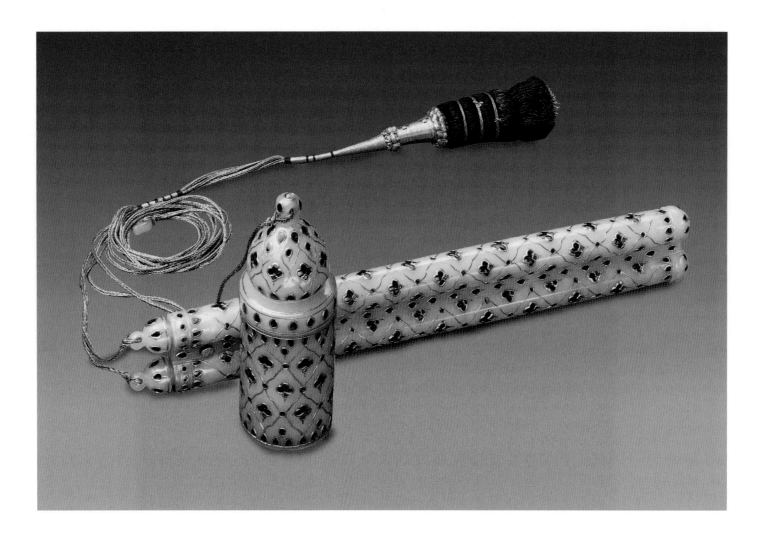

issued summary justice: the man's tongue was cut out and an order given that he was to be imprisoned ever after.[61]

Throughout his travels, Jahangir visited places of outstanding natural beauty and made architectural embellishments. He occasionally made improvements to the houses and gardens of others, as in 1618 when he visited

Plate 54 | INKWELL AND PEN-CASE
Mid-17th century
Nephrite jade set with diamonds and rubies in gold, the inkwell lined with silver 11 cm. x 4.1 cm. x 27.5 cm.
The al-Sabah collection, Kuwait National Museum: LNS 84 HS

another house built for Shah Jahan in Ahmadabad, the capital of the province of Gujarat where the prince was governor. Jahangir wrote: 'In a little garden in Khurram's palace are a platform and a pool... I ordered a slab of marble carved to fit the hollow space so that one could sit and lean against it'. He composed the verse himself: 'Seat of the king of the seven climes, Jahangir son of the King of Kings, Akbar' (Plate 55). [62]

All the emperors loved Kashmir, with its appealing climate and ravishing flowers. The different routes to this mountainous region were so tortuous that the royal camp had to be divided into smaller components that travelled consecutively. Transportation difficulties, however, did

not prevent Jahangir from commissioning in Kashmir an immense tent of a kind called *aspak*, probably for the palace at Lahore.[63] When he fell seriously ill there in 1627, he tried to return to Lahore, but died before he could reach the city, on 29 October.

At the time, Shah Jahan was at the opposite end of the empire, directing the campaign against the sultans of the Deccan, giving Nur Jahan an opportunity to try and declare her own son, Shahriyar, emperor instead. This was ruthlessly prevented by her brother, Asaf Khan, who then moved Shah Jahan's sons from Lahore to the safety of Agra. Here, they were reunited with their father, who had rushed there for a swiftly arranged coronation (Plate 56).

It seems that Asaf Khan transported Jahangir's superb new canopy which formed a centrepiece of Shah Jahan's accession celebrations, hovering over all the lower, smaller canopies and sheltering the place where the new emperor took his seat.[64] The canopy over the ruler, whether fabric or architectural, represented the sky and, by extension, the universe. To emphasise its celestial symbolism, a sun rosette was often added at the centre directly over the head of the emperor, as may be seen in paintings of canopies at the courts of Jahangir and Shah Jahan, and in existing palace architecture (Plates 1, 56, 112 and 118). When he sat beneath the canopy, the emperor appeared before the court as the King of the World, the phrase used repeatedly to hail Akbar, the literal translation of Shah Jahan's title, and synonymous with 'Jahangir', the 'World Seizer'. The concept was regularly alluded to in all the arts of the Mughal court.

80

Facing page | Plate 56 | SHAH JAHAN RECEIVES ASAF KHAN
AND HIS THREE ELDEST SONS AT AGRA IN 1628
Signed by Bichitr
c. 1630 Illustration to the *Padshah Nama* of Abdul Hamid Lahori
Opaque watercolour and gold on paper 30.8 cm. x 21.1 cm.
Royal Collection, Windsor Castle: RCIN. 1005025.k-1 folio 50 b

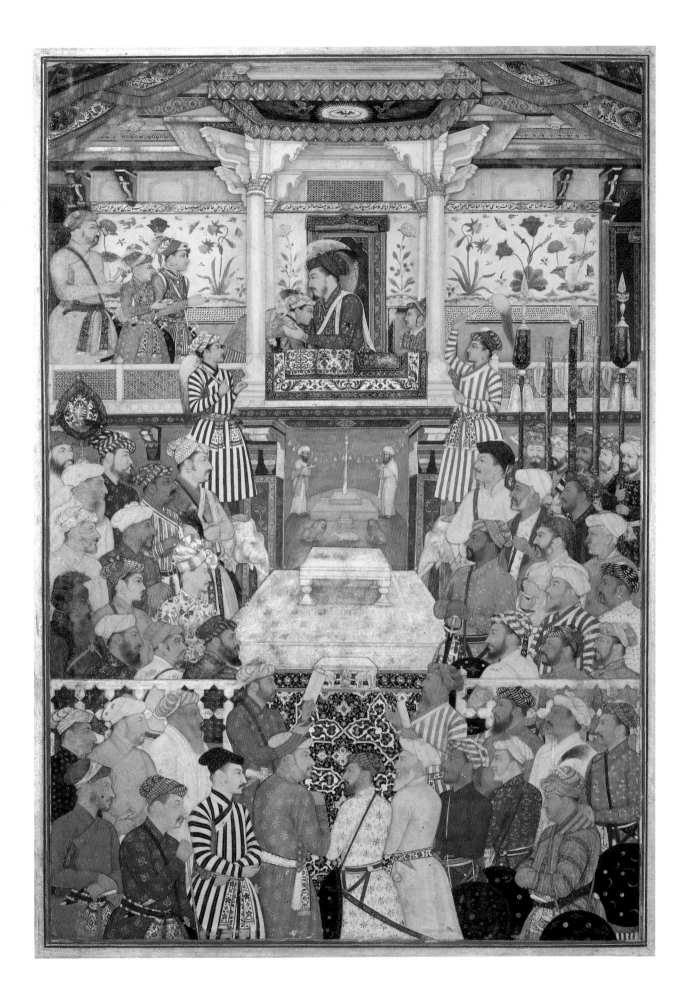

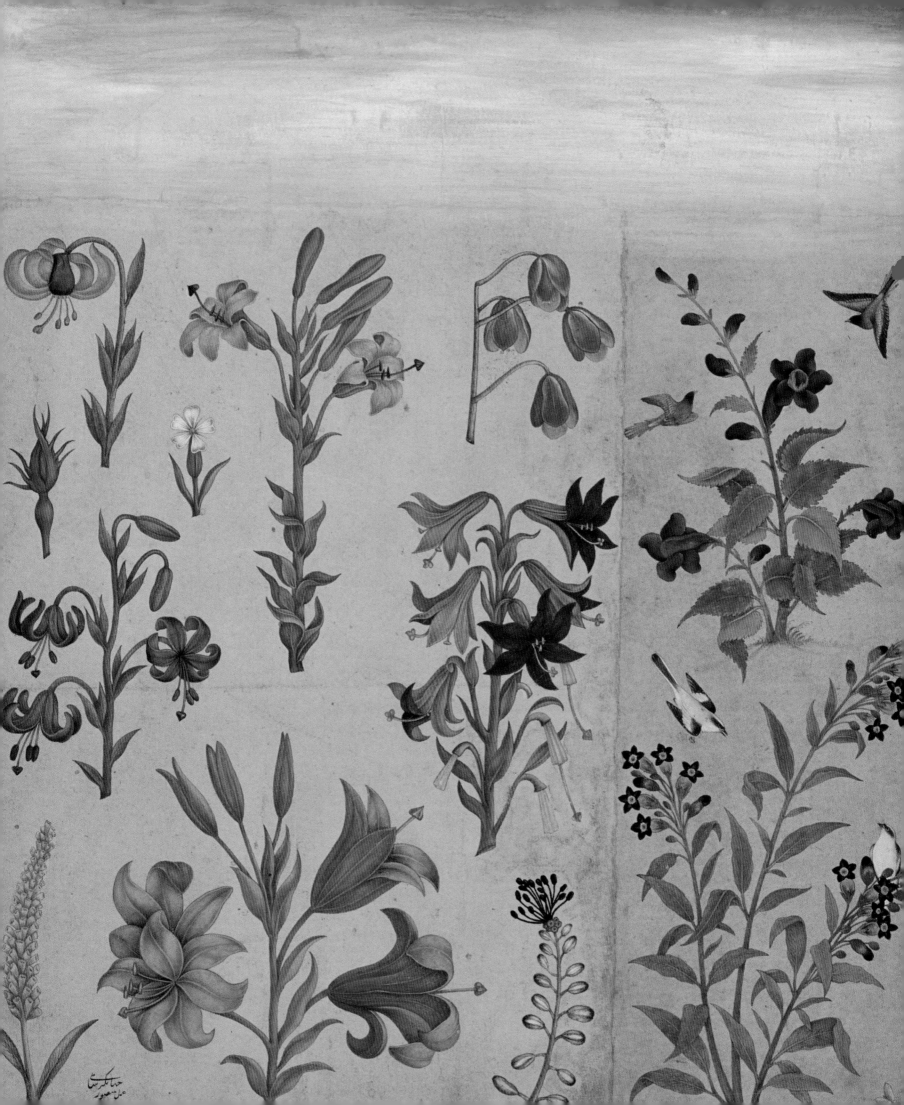

II

THE MUGHAL
'HOUSE OF BOOKS'

DETAIL FROM FLOWER STUDIES (see Plate 100)

B y the time the future emperor Akbar reached the age of four years, four months and four days in November 1547, his father Humayun had made solemn arrangements for the boy's education. The royal astrologers identified a time so auspicious that it might happen only 'once during cycles and lifetimes' for instruction to begin, but when the moment arrived, as Akbar's chronicler Abu'l Fazl reported long afterwards, the small boy had disappeared.[1] An energetic search of the palace failed to find him, and the historian wrote that despite all the subsequent efforts of his teachers, Akbar's 'inspired mind' never became 'the reception chamber of inky impressions'. In other words, the emperor never learnt to read and write, as Jahangir confirmed in his memoirs.

Yet, his patronage attracted scholars and writers from Iran and Central Asia, and produced what one commentator described as 'the most brilliant period of Persian literature' in Hindustan, as well as some of the finest manuscripts of the Mughal dynasty.[2] These were inherited by his successors, and artists who had grown up in his service became the great masters of Jahangir's reign, passing on their skills to a new generation at the court of Shah Jahan.

It seems possible that Akbar was simply dyslexic.[3] However, his inability to read was not a barrier to acquiring knowledge. When he resided in the palaces, daily readings from the books in his extensive

Facing page | Plate 57 | ILLUMINATED PAGE FROM THE GULSHAN ALBUM
Period of Shah Jahan Opaque watercolour and gold on paper 40 cm. x 24.5 cm.
Golestan Palace Library, Tehran: Manuscript No. 1663

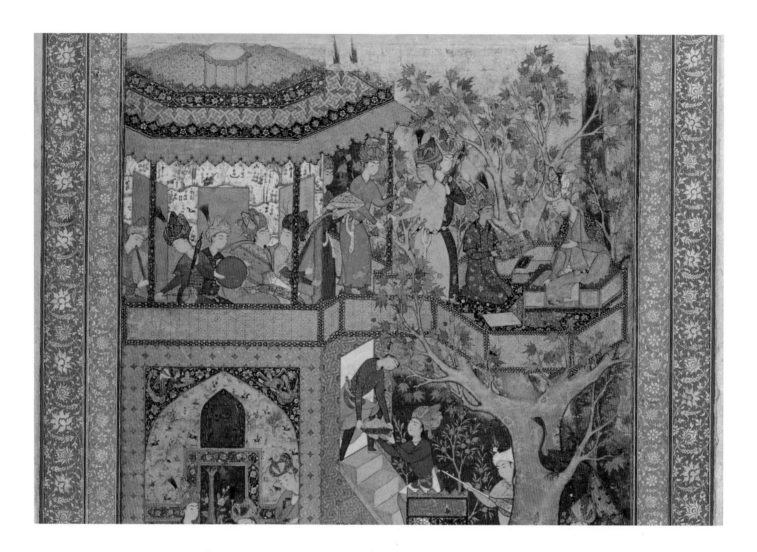

86

library took place in public assemblies, and when he travelled, men such as the Iranian Mir Sharif, who had a particularly beautiful voice, might read mystical Persian poetry to him in his private quarters.[4] The emperor constantly listened to recitations of Ferdowsi's *Shah Nama*, or 'Book of Kings', to the poems of Jami, Sa'di, Hafez and Khaqani, and to ethical treatises. History had a special fascination for him. As Abu'l Fazl put it, there were 'no historical facts of the past ages,

or curiosities of science, or interesting points of philosophy' with which Akbar was unacquainted; his memory was said to be prodigious and he not only recited Persian verses but also composed poems in Hindi and Persian.[5] Father Monserrate, who heard the emperor's conversations with historians and philosophers at Fatehpur in 1580, commented on Akbar's acute intelligence and eloquence.[6]

Plate 58 | AKBAR PRESENTING A PAINTING TO HIS FATHER
(detail of Plate 63)

THE CULTURED COURT

The royal milieu was at all times highly cultivated and many at court – including the women and the greatest artists and craftsmen – were poets and writers. Poetry recitals and competitions were standard entertainments, and verses were composed for major events and celebrations. Calligraphy was regarded as a far greater art than painting, however much this might be admired, and the work of famous calligraphers was avidly collected (Plates 60 to 62, 80 and 101). Even Akbar, despite his shortcomings, was said to have paid great attention to the work of his calligraphers and particularly encouraged Muhammad Husayn of Kashmir who was called *Zarrin Qalam*, or 'Golden Pen' (Plate 78).[7] Beautiful manuscripts were precious possessions to be collected and commissioned, and given as marks of honour, affection or respect. Notations on their flyleaves and in the margins show that they were regularly examined in the royal library, the women's quarters where many books were also kept, and in the libraries of the highest-ranking noblemen.[8]

Few illustrated manuscripts of Babur and Humayun have survived, but their literary interests are not in doubt. Babur wrote his autobiography in Turki, his first language, but knew Persian equally well and loved poetry. He was himself a poet of merit, writing verses in both languages.[9] He was familiar with the work of the greatest calligraphers of the Persian-speaking world and with its artists, not least Kamal al-Din Behzad whose paintings would be acquired and treasured by his successors, and who set the standard against which Mughal artists would always be measured. One of Babur's own manuscripts was an outstanding fifteenth-

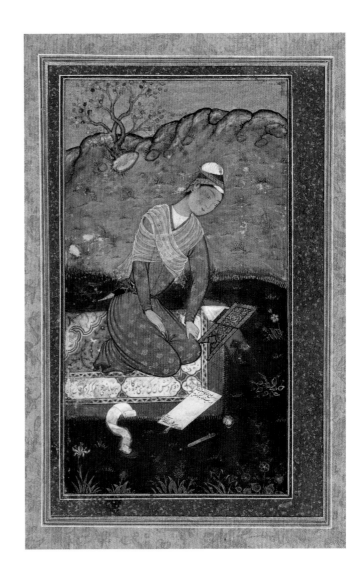

87

Plate 59 | SELF PORTRAIT OF MIR SAYYID ʿALI
Probably painted in Lahore c.1555,
Opaque watercolour and gold on paper
Page 31.5 cm. x 20 cm. Painting 19 cm. x 10.5 cm.
Los Angeles County Museum of Art: M 90.141.1
Bequest of Edwin Binney III

88

Plate 60 | PERSIAN QUATRAIN
Calligraphy by Mir 'Ali Iran, second half of 16th century
Borders Mughal, c. 1615
Ink, opaque watercolour and two colours of gold on paper
Page 38.9 cm. x 27.2 cm. Panel 20.6 cm. x 12.3 cm.
Chester Beatty Library, Dublin: In. 07A.15

Plate 61 | VERSES IN PERSIAN AND TURKI
Calligraphed by Mir 'Ali in Bukhara, possibly in the 1520s
Illumination signed by Dawlat, c. 1615 Borders reign of Shah Jahan
Ink, opaque watercolour and gold on paper
Page 38.8 cm. x 26.6 cm. Panel of calligraphy 21.7 cm. x 12.8 cm.
Victoria and Albert Museum, London: IM 12a-1925

Plate 62 | PERSIAN QUATRAIN
Calligraphy signed 'Faqir 'Ali' Iran second half of 16th century
The borders reign of Jahangir, c. 1610-18
From the Gulshan album
Ink, opaque watercolour and gold on paper 42 cm. x 26.5 cm.
Staatsbibliothek zu Berlin: 'Berlin Album' folio 13b

Facing page | Plate 63 | THE YOUNG AKBAR PRESENTS A
PAINTING TO HIS FATHER
Signed by 'Abd us-Samad, Kabul c. 1550-5
Page from the Gulshan album
Opaque watercolour and gold on paper
Golestan Palace Library, Tehran: Manuscript No. 1663, folio 70

century copy of the *Shah Nama* produced in Herat, the Timurid capital and great centre of book production, which he first visited in 1506. The volume stayed with him throughout his life and passed directly down the line of his successors to 'Alamgir, as shown by the seal impressions and inscriptions on its flyleaf, including one written by Shah Jahan.[10]

Humayun loved books so much that Abu'l Fazl described them as his 'real companions'. He even took them on military campaigns, when the risk must have been deemed less than leaving them behind with a librarian during his unsettled life. In 1536, during a failed campaign in Gujarat, Humayun's encampment was plundered and a box of his most cherished volumes seized. It included a history of Timur, calligraphed by Mir 'Ali Heravi and illustrated by Behzad.[11] The volume was restored to the Mughal library some time before 1572, when Mirza Jamal ad-Din Husayn Inju of Shiraz entered Akbar's service and presented it to him.[12]

Humayun's legacy to Mughal painting was of profound importance. By 1540, he had lost most of the land he inherited from Babur to the Afghan nobleman, Sher Khan, who made Delhi his capital and adopted the title Sher Shah. Humayun was also in conflict with his brothers Kamran and Askari, who seized control of Kabul and Panjab, leaving him no choice but to go to Iran with his very young wife, Hamida Banu, and take refuge at Shah Tahmasp's court. After Humayun recaptured Kabul in 1545, war with Kamran continued for another eight years. Finally, Humayun became the undisputed ruler of Kabul, eliminating any further opposition by having his brother blinded.[13]

The new stability finally allowed him to indulge in his passion for art. He invited the master artists Mir Sayyid 'Ali (Plate 59) and Khwaja 'Abd us-Samad, whom he had met in Tabriz, to join him in Kabul.[14] Years later, in AH 999 / 1590-1 AD, 'Abd us-Samad would show the historian Bayazid Bayat a letter preserved in the royal library at Lahore written by Humayun. The emperor noted that the artists had arrived in

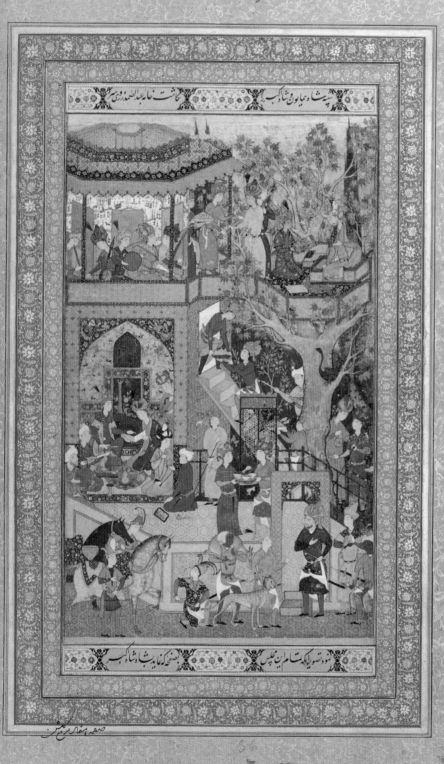

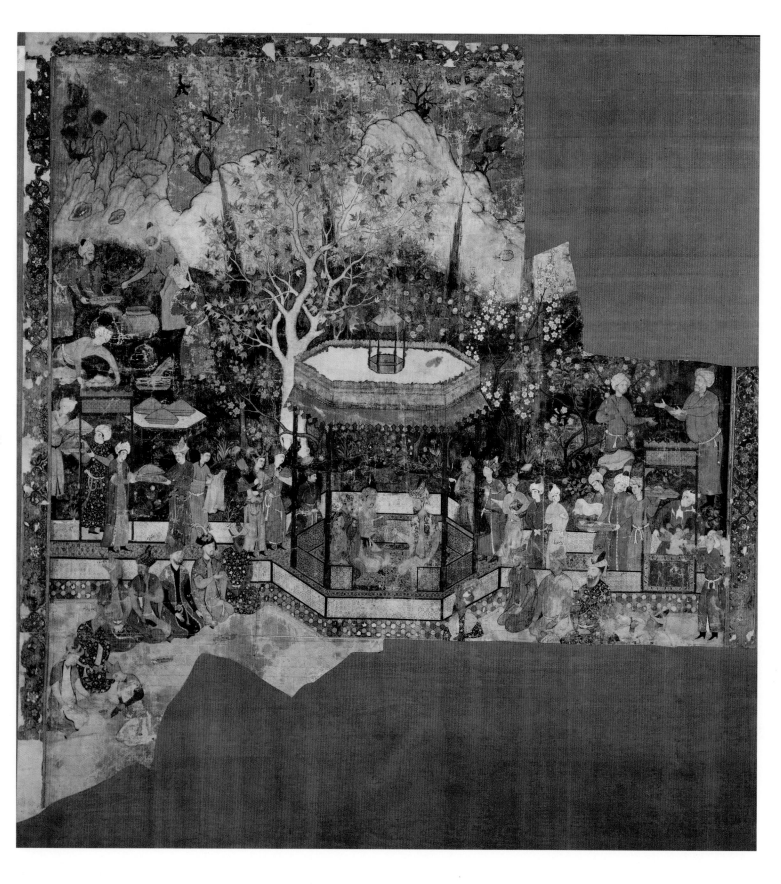

92

Kabul at the end of 1552, and described a remarkable feat accomplished by Mir Sayyid 'Ali, whom he called 'The Rarity of our Time' (*Nader al-'asri*) – the artist had painted a polo scene on a single grain of rice, and written a verse between the polo posts at each end.[15]

In Kabul they taught Akbar painting and their close relationship with the royal family is suggested by 'Abd us-Samad's picture of a court entertainment (Plate 63). Musicians play in a two-storey pavilion whose upper level has a walkway leading to a hexagonal platform resting on the branches of a tree. Here, Akbar holds out a painting to Humayun, who wears the distinctive turban he had himself devised, and used to bestow on favoured individuals (Plate 58). 'Abd us-Samad's signature is on the cover of a book placed on the green tiles of the courtyard, and verses above and below the picture identify the ruler and his young son, their names placed exactly over their heads.[16] The verses also point out that the painting Akbar so anxiously offers his father is this very one.

Before Mir Sayyid 'Ali and 'Abd us-Samad left Kabul they may have collaborated on the large painting on cotton, portraying Humayun holding a wine banquet in a garden (Plate 64). Many of the figures in the scene, now conventionally called 'The Princes of the House of Timur', were altered by Jahangir's artists to change it into a dynastic portrait, and it was further modified after Shah Jahan's accession when the faces of the new emperor and his son were added.[17]

In 1555, Humayun finally regained Hindustan after an interval of nearly fifteen years and the court left Kabul for Delhi. He died six months later, and in January 1556 the fourteen-year-old Akbar became emperor.

93

Facing page | Plate 64 | PRINCES OF THE HOUSE OF TIMUR
Painted by Iranian artists for Humayun, c. 1550-60,
with later additions by Nanha, Bichitr, Govardhan, Dawlat, Balchand,
Inayat, Hiranand and Mohan, Gouache on cotton, 108.3 cm. x 106.9 cm.
British Museum, London: 1013.2-8.1, Bought from Ganeshi Lall of Agra
with funds provided by the Art Fund and W. Graham Robertson

AKBAR'S ATELIER

Akbar's early years were filled with battles as rebellions broke out on all sides and he rapidly expanded his territory under the direction of Humayun's general and friend, Bayram Khan. However, by the end of 1560 the rapidly maturing young man and his mentor had clashed so seriously that Bayram Khan was forced to depart for Mecca. On the way to the pilgrim port of Surat he was assassinated by Afghans, leaving a wife and four-year-old son, 'Abd'ur Rahim, who grew up under Akbar's protection and became one of the great political and literary figures of his time.[18]

In the years that followed, the Mughal armies won spectacular victories, many led with panache by Akbar himself. Some of the rulers of Rajasthan became close to Akbar, particularly Raja Bihari Mal whose daughter married the emperor in 1562. Others surrendered, especially after the fall of the supposedly impregnable fort of Chittor to the Mughals in 1568. When it was captured, Akbar ordered its occupants to be massacred in a brutal act that would not be repeated by the otherwise tolerant ruler, but the cataclysmic defeat led to other swift capitulations. By the time the foundations of Fatehpur were being laid, artists from the newly annexed or defeated regions must have started to arrive at court, just as stonemasons came to take part in the construction of the new city. Inscriptions on manuscripts of the 1580s and 1590s point to the connection of some artists to Gujarat, Gwalior, Lahore, and Kashmir.[19]

Abu'l Fazl briefly describes the *Taswir Khana*, or atelier where figural painting was undertaken, in his account of the imperial household entitled the *A'in-i Akbari* ('Institutes of Akbar') compiled in the 1590s.[20] His list of seventeen outstanding artists of the reign is headed by Mir Sayyed 'Ali and Khwaja 'Abd us-Samad, and includes the name of another artist, Farrukh, who had arrived at court in 1585 and was usually known as Farrukh Beg. The rest were almost certainly indigenous, and their names show that most were Hindus. They worked within the larger *Kitab Khana*, or 'House of Books', with the calligraphers, painters, gilders and bookbinders who together produced or maintained the manuscripts in the royal library.[21] The layout of each new volume was determined by the regular arrangement of its calligraphy that provided unity and harmony, with spaces provided at carefully chosen intervals for the artists to supply paintings.[22]

Few illustrated manuscripts produced at Fatehpur survive.[23] The major undertaking of the *Kitab Khana* at this time, however, was the creation of the multiple volumes of the *Qesseh-yi Amir Hamza*, or 'The Story of Amir Hamza', often known simply as the *Hamza Nama* ('The Book of Hamza') (Plates 65 and 66).[24]

The stories, thought to have originated in Iran in the eleventh century, are very loosely based on the life of the Prophet Muhammad's uncle, but their central theme is the eternal battle between the forces of good and evil. Hamza and his heroic companions travel across huge distances, battling against unbelievers and encountering giants, dragons, witches, sorcerers and mysterious magical forces.[25] The tales were widely performed by professional storytellers and an incident that took place in 1564 shows that they also entertained the Mughal court. Akbar was once hunting wild elephants and camped overnight in the forest. The next morning, before setting off again, he 'listened for some time to Darbar Khan's recital of the story of Amir Hamza'. The

Plate 65 | LANDHAUR IS ABDUCTED IN HIS SLEEP
c. 1562-77, Illustration to the *Hamza Nama*
Gouache and gold on cotton 59.3 cm. x 45.2 cm.
MAK-Austrian Museum of Applied Arts/Contemporary Arts, Vienna: BI 8770/19

storyteller (*qesseh khwan*) came from a distinguished line – his father had performed the same service at the court of Shah Isma'il in Iran.[26]

By then, Akbar had probably already ordered a version of the stories to be written down, though it is not known precisely when this took place. Mullah 'Abdul Qadir Badauni mentions in his clandestine history of Akbar's reign that the monumental project of producing the text and its illustrations took fifteen years to complete, but does not say when it began or ended. Other sources suggest it was between about 1562 and 1577.[27] The text, written by Khwaja Ata'ullah Munshi of Qazvin, was copied by 'calligraphers with a golden pen', and a hundred 'peerless figural painters, illuminators, designers and bookbinders' completed the volumes.[28] At first, Mir Sayyid 'Ali directed the work, and each volume took two years to complete. After seven years he left for Mecca, and under 'Abd us-Samad's supervision everything proceeded at a faster pace. In later years, Abu'l Fazl wrote that twelve volumes had been produced, with fourteen hundred pictures done by 'magic-making masters', though other writers provide slightly different statistics.[29]

No source has yet been found to shed light on the most intriguing aspect of all: how artists from different parts of the subcontinent came to be employed, and the manner in which they learnt new conventions and concepts from their Iranian teachers. It is not even known whether they shared a common language. The artists certainly learnt from direct tuition, especially from 'Abd us-Samad. Abu'l Fazl, who records that many of his pupils in turn became masters, briefly provides details about one of them. Akbar had noticed

a young Hindu called Daswanth, who was drawing pictures on a wall. Recognizing his artistic promise, the emperor entrusted this son of a palanquin bearer to 'Abd us-Samad. Daswanth's talent was so great that his name follows his teacher's in Abu'l Fazl's list and his work is preserved in Akbar's most important manuscripts (Plate 67). However the historian adds: 'the darkness of insanity enshrouded the brilliance of his mind and he died, a suicide'.[30] The historian describes Daswanth's work as 'masterpieces' and elsewhere in the conventional accolade, compares his works with those of Behzad. He states that Daswanth died in 1584.[31]

Only a very small proportion of the *Hamza Nama* illustrations remain. All are detached from their original volumes, the bindings of which are lost. Nevertheless, they show the early stages of the new style of painting produced when the radically different traditions of Iran and Hindustan came together, matching the process that simultaneously produced new architectural forms.[32] In the *Kitab Khana*, however, the Iranian influence was more pronounced.

Akbar's transplanted Safavid masters introduced landscapes filled with cloud-like rocks where people and animals at the edges of the picture are cut in half by the edges of the frame (Plate 66). Figures are depicted from hitherto unseen angles, and their faces are expressionless, emotion being signified by means of the codified gestures of Iranian book painting. Its stock characters include beautiful winged *peris* (angels) and startling *divs* (demons) with flame-edged goggling eyes, vividly-coloured spotted bodies and other peculiar physical features. The *divs* in particular were enthusiastically adopted by Akbar's painters.

Obvious signs of the hand of Mir Sayyid 'Ali or 'Abd us-Samad are lacking, though they may have provided the refined detail highlighted with gold on textiles, armour and architecture that contrasts strikingly with plain areas of deep monochrome and the crude painting on some of the folios. Overall, the defining characteristic of the *Hamza Nama*

96

Facing page | Plate 66 | ARGHAN DEV BRINGS
THE CHEST OF ARMOUR FOR HAMZA
Illustration to the *Hamza Nama*, c. 1562-77
Gouache and gold on cotton
Page 79.1 cm. x 63.3 cm. Painting 67.5 cm. x 52.5 cm
Brooklyn Museum of Art, New York, Museum Collection Fund: 24.47

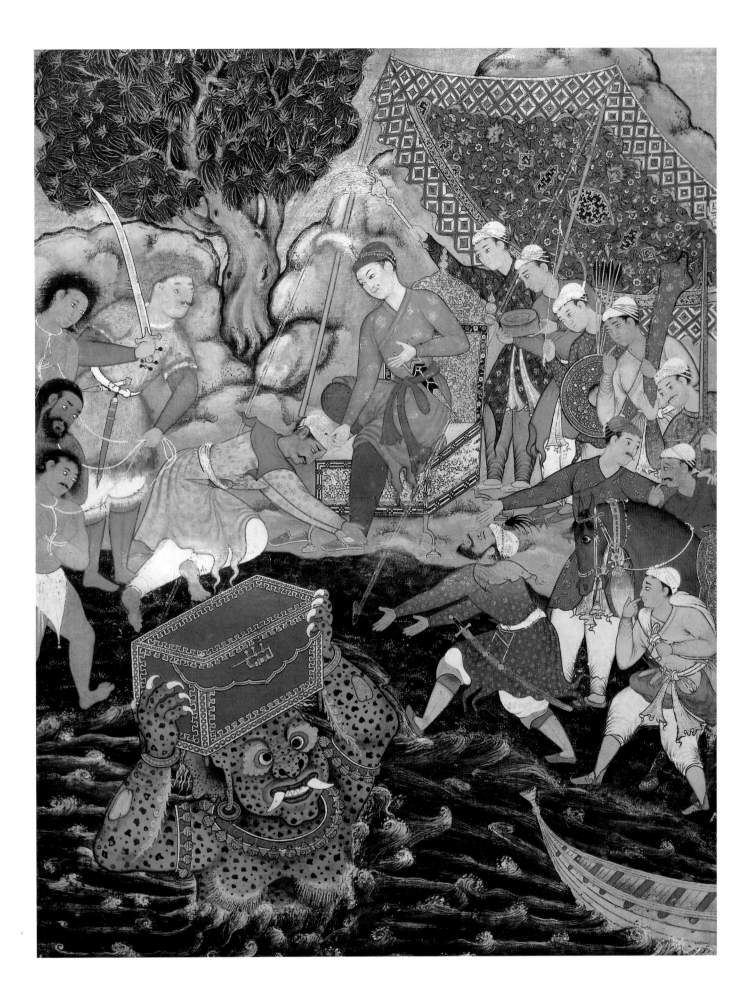

illustrations is an immense vitality, especially in the highly naturalistic and occasionally humorous depictions of animals, drawn from long-established Indian traditions of sculpture and painting.

The relationship between the architecture depicted in these paintings and actual buildings in Fatehpur suggests that the volumes were completed in the city. A few other manuscripts were also done there. An illustrated *Shah Nama* commissioned in 1582 must have been a significant undertaking in the Fatehpur *Kitab Khana*, but has disappeared. A very fine *Gulestan* of Sa'idi, calligraphed in the city by Akbar's admired master Muhammad Husayn *Zarrin Qalam* in AH 990/1582-3 AD, has survived intact.[33]

In about 1574, Akbar had begun to commission translations of Sanskrit works into Persian.[34] He then established a formal 'House of Studies', or *Maktab Khana,* at Fatehpur for the translation of the *Mahabharata.* A group of pandits was appointed to provide learned explanations of the text that were then written down in limpid Persian, the simple style reflecting Akbar's desire for the finished volume to be easily understandable. Through this, he hoped to promote tolerance by dispelling ignorance.[35] The emperor was closely involved in the discussions and Badauni was appointed to help with the translation of what he described in his unofficial history as 'puerile absurdities', instantly confounding the emperor's expectations. Some of the scholar's views occasionally seeped out, making the emperor lose his temper and call him

a 'turnip eater'.[36] Others completed the text entitled the *Razm Nama*, or 'Book of War', and by the time Abu'l Fazl's brother, the renowned scholar and poet Fayzi, rewrote part of it in ornate prose, the court had moved to Lahore. Abu'l Fazl probably wrote the preface, dated AH 995/12 December 1586-1 December 1587 AD. A magnificently illustrated copy in several volumes was presented to Akbar four years later and remains intact in the collection of the Jaipur royal family, hidden from public view.[37]

Other translations were made and illustrated. The reluctant Badauni completed the *Ramayana* in AH 992/1584-5 AD and the imperial copy that appeared in 1588 included paintings by five artists with Gujarati connections.[38] In AH 1003/1594-5 AD, he completed the translation of the Sanskrit *Katha Sarit Sagara*, or 'Ocean of Stories' (Plate 68).[39]

These texts were quickly copied in the libraries of others within the royal circle. 'Abdu'r Rahim, who by now had attained the highest offices in the empire, was a renowned scholar who knew Persian, Arabic, Turki and Hindi, and had some knowledge of Sanskrit and even Portuguese. He was an acclaimed poet in Persian and Hindi, and the staff of his famous library which was said to welcome a hundred visitors every day included the son of the great calligrapher Mir 'Ali of Herat. Among the manuscripts produced in it was an illustrated copy of Akbar's new translation of the *Ramayana* (Plate 69).[40]

Facing page | Plate 67 | TIMUR AS A CHILD
PLAYING AS KING
By Daswanth and Jagjivan Kalan, c. 1590 Illustration to the *Timur Nama* Opaque watercolour and gold on paper
Khuda Bakhsh Library, Patna: Catalogue No. 551 H.L No. 107 f. 2b

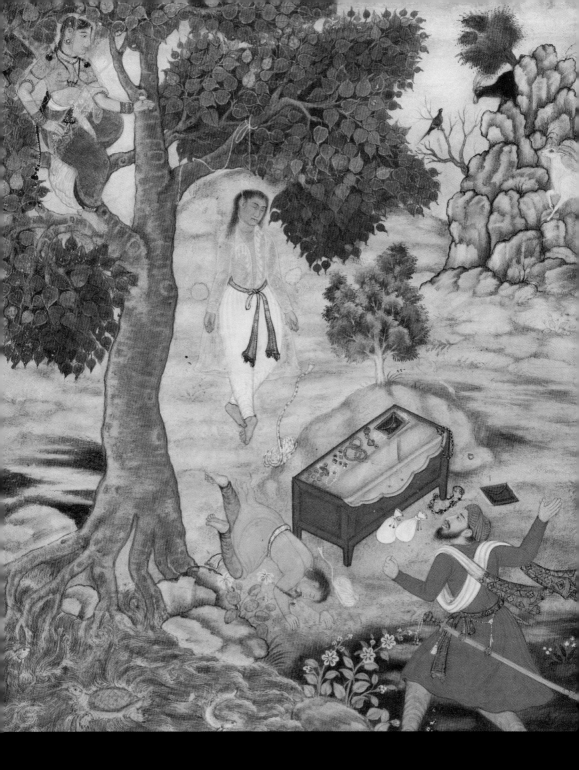

Plate 68| THE TALE OF THE CUNNING SIDDHIKARI
c. 1590 Illustration to the Persian translation of the
Katha Sarit Sagara or 'Ocean of Stories'
Opaque watercolour and gold on paper 16.5 cm. x 13.4 cm.
Los Angeles County Museum of Art: M.78.9.12
From the Nasli and Alice Heeramaneck Collection Museum Associates Purchase

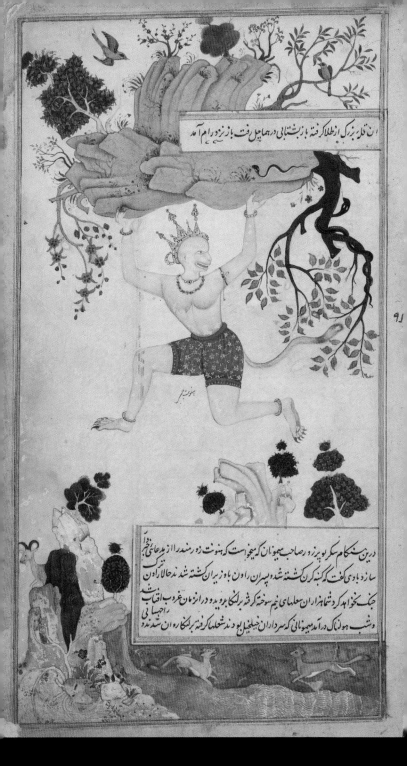

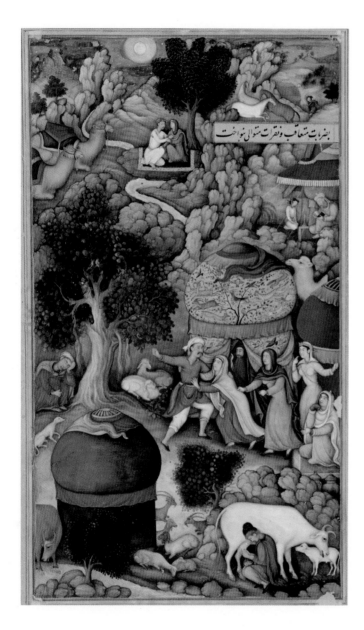

Plate 70 | AN UNFAITHFUL WIFE AND HER LOVER
By Miskin Page from the *Baharistan* of Jami, c. 1595
Opaque watercolour and gold on paper
Page 30 cm. x 19.5 cm. Painting 24 cm. x 13.5 cm.
Bodleian Library, Oxford: Ms. Elliott 254 folio 42a.

When Akbar lived in Lahore, he was in his forties, ruling a secure, wealthy empire. He commissioned small, beautifully illustrated volumes of poetry (Plate 70), but the majority of the manuscripts produced in the Lahore *Kitab Khana* suggest that the emperor's main concern was with retelling the past.[41] The end of the Muslim millennium was imminent, and in AH 990/1581-2 AD, Akbar commissioned its history: the illustrated copy of the *Tarikh-i 'Alfi* was completed in AH 997/1588-9 AD.[42] The origins of his family were examined in the *Timur Nama* (Plates 67 and 71) and in the *Chinghiz Nama* (Plate 44). 'Abd'ur Rahim was requested to translate into Persian Babur's memoirs that had been written in Turki, which only a few at court now understood. He completed his work entitled the *Babur Nama* towards the end of November 1589.[43] Several illustrated copies were made between about 1590 and 1606, all of which place scenes from Babur's eventful life within the anachronistic architecture of contemporary Hindustan (Plate 72). They also included many appealing studies of the birds, animals and flowers described by its observant royal author (Plate 73).[44]

At the same time, new memoirs were commissioned. Babur's daughter Gulbadan Begum, who had been close to Akbar's mother and had joined his own household in 1557, returned to court from Mecca in 1582, and the emperor asked her to write recollections of her life.[45] The memoirs of Humayun's ewer bearer, Jowhar, rewritten by the prolific Fayzi in ornate prose, were completed in September 1589. Bayazid Bayat, who had entered Humayun's service in 1544, wrote a 'Memoir of Humayun and Akbar' (*Tazkira-yi Humayun wa*

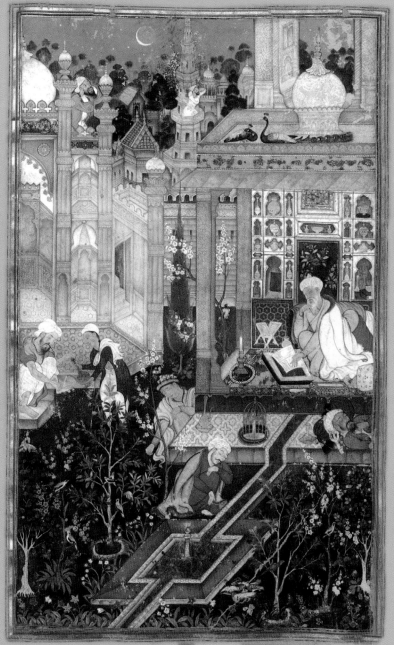

3

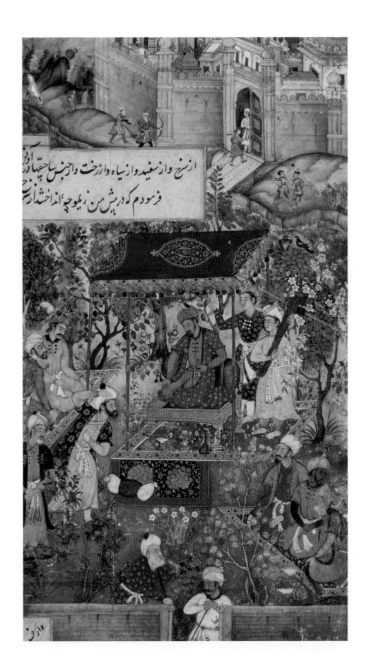

Plate 72 | BABUR RECEIVING UZBEK ENVOYS
IN A GARDEN
By Ram Das, c. 1590 Illustration to the *Babur Nama*
Page 26.4 cm x 16.7 cm. Painting 24.3 cm. x 13.5 cm.
Victoria and Albert Museum, London: IM.275-1913

Akbar).[46] Thus by 1589, when Abu'l Fazl began the definitive history of the reign, Akbar had ensured that there were several eyewitness accounts of the early years of the Mughals. The other major resource was the Record Office, established in 1574 to collect reports despatched from all the provinces of the empire, records of the daily proceedings of the court, and obituaries of prominent people.

By his own account, Abu'l Fazl wrote more than five drafts of his text which was partly recast by Fayzi. When Fayzi died in October 1594, Abu'l Fazl's grief brought a temporary halt to the work, but he finally presented the *Akbar Nama* to the emperor in April 1596. A further volume appeared two years later (Plate 75).

The illustrations made for the first royal copy of the manuscript seem to have been painted as Abu'l Fazl wrote and rewrote his text, meaning their position had to be adjusted several times, as demonstrated by their corrected page numbers and other details (Plates 16, 50 and 51).[47] The historian notes that Akbar himself selected the passages to be illustrated, as he did for other manuscripts. The artists who painted them include fourteen of the masters listed by Abu'l Fazl in the *Akbar Nama* itself.[48] The only missing names are those of Mir Sayyid 'Ali, who had left the court long before and had died in Mecca; Daswanth who was also dead; and 'Abd us-Samad who no longer seems to have been involved in workshop production. He was still very much part of the court, however, as shown by his encounter with Bayazid Bayat in the library at Lahore. During his long career in Akbar's service, he had been entrusted with highly important administrative posts, including that of master of the royal mint at Fatehpur. In 1583 he became deputy to Akbar's son, Murad, when the prince was given charge of the royal household, a position Abu'l Fazl describes as being 'equal to the administration of a great kingdom', and in 1586 or 1587, held high office in the province of Multan.[49] Throughout his life, 'Abd us-Samad must have continued to paint, as suggested by a very fine

Plate 73 | BIRD-CATCHING NEAR KABUL
By Bhag, c.1598 Illustration to the *Babur Nama*
Opaque watercolour and gold on paper
National Museum, New Delhi: 50.336/132

signed work dated AH 996, regnal year 32, corresponding to 1588 AD (Plate 74).[50]

The pictures in the royal *Akbar Nama* are much more than simple illustrations. As might be expected, major events are included, such as Akbar's visit to the shrine of Mu'in ad-Din Chishti at Ajmer to give thanks for the birth of his first son Salim (Plate 79), but other scenes relate to events that seem unexceptional unless considered in close relation to the text which emphasizes the spiritual life of the emperor and his role as the shadow of God on earth. Abu'l Fazl frequently presents historical events as examples of a series of profound hidden meanings underpinning Akbar's life, in a history that was explicitly intended to be a moral treatise and a handbook of political science 'for the instruction of mankind'.[51]

The *Akbar Nama* and all the other histories would have been read by the elite of the court, but the elevation of Persian as the primary language of the empire's administration meant they eventually had a very wide readership. This was the result of an order issued by the Hindu Raja Todar Mal who had been in Akbar's service since the early 1560s and became finance minister in 1582.[52] He made major reforms to the revenue system and two years later decreed that all government accounts, in all the provinces of the empire, should be written in Persian.[53] Knowledge of literary Persian then became an essential requirement for any ambitious young Hindu wishing to succeed as an accountant or secretary in the Mughal administration as shown in a letter written by Chandra Bhan Brahman, a famous poet of Shah Jahan's reign, to his son. He advised the boy to persevere with his Persian studies and, especially, to read histories such as the *Akbar Nama*, ethical treatises, notably Nasir ad-Din Tusi's *Akhlaq-i Nasiri*, and poetry including Sa'di's *Golestan* and *Bustan*.[54] Many of these classic works were illustrated at different times within the imperial *Kitab Khana*.[55]

Plate 74 | JAMSHID WRITING ON A ROCK
By 'Abd us-Samad
Dated AH 996, regnal year 32 [1588 AD] the borders c.1600-18
Page from the Gulshan album Opaque watercolour and gold on paper 42 cm. x 26.5 cm.
Freer Gallery of Art, Smithsonian Institution, Washington, D.C.: F.1963.4

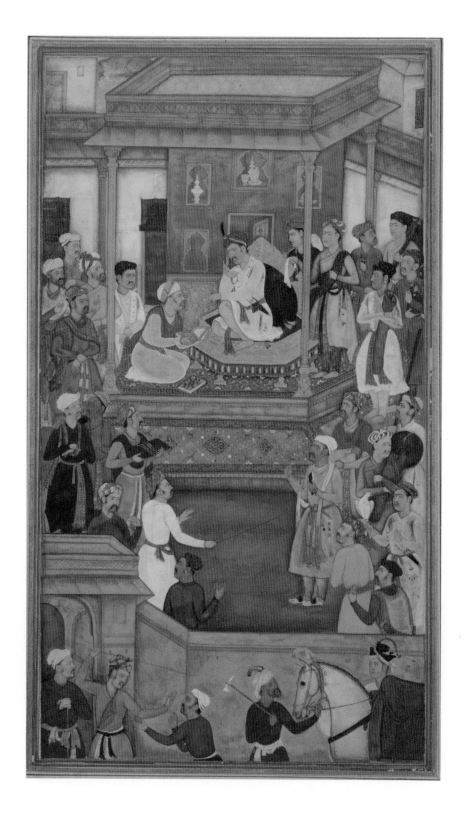

Plate 75 | ABU'L FAZL PRESENTS AKBAR WITH THE *AKBAR NAMA*
By Govardhan, c.1603-4 Illustration to the *Akbar Nama*
Opaque watercolour and gold on paper 24 cm. x 13.5 cm.
Chester Beatty Library, Dublin: MS 3 f. 177 r.

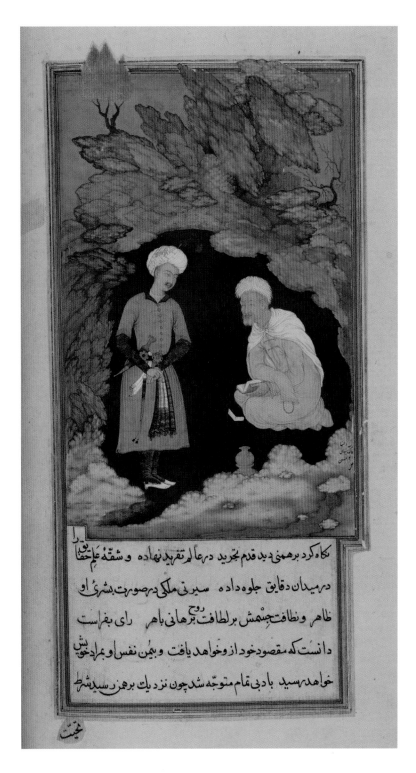

Plate 76 | KING DABSHALIM AND THE SAGE BIDPAI
By Abu'l Hasan
Illustration to the *Anwar-i Suhayli* ('Lights of Canopus') by Husayn Va'iz Kashifi
Dated AH 1019/1610-11 AD
Opaque watercolour and gold on paper 15 cm. x 9.4 cm.
British Library, London: Ms.Add. 18579, folio 206A

THE VERSATILE ARTISTS

Some of Akbar's leading artists had other highly developed talents. The Iranians were often poets or calligraphers. Mir Sayyid 'Ali was a renowned poet writing under the name Joda'i, conveying the Sufi concept of man's 'separation' from God, while 'Abd us-Samad was a superb calligrapher known as *Shirin Qalam*, or 'Sweet Pen'.[56] 'Abd'ur Rahim employed a painter called Maulana Ibrahim *naqqash* of whom it was said: 'He was unrivalled in calligraphy, gilding, bookbinding, and was skilled as an engraver on precious stones.'[57]

Others had several skills within a narrower range. Specialist illuminators worked principally on the embellishment of manuscripts or panels of calligraphy, but probably also added details of carpets, clothing or architecture to book illustration. Mansur, for instance, was also an illuminator (Plate 78) as well as an illustrator (Plate 50), and may have supplied ornamental designs to the royal workshops (Plate 167). Many artists probably painted pictures on the walls of imperial buildings. The mansions of the grandees of the empire were also painted, as one source makes clear. 'Abd us-Samad's son Sharif Khan grew up in service to Prince Salim, and was appointed to high office when the prince became emperor with the title Jahangir. When Sharif Khan attended a distinguished gathering of Jahangir's nobles at the house of Mirza Aziz Khan Koka in Agra, his host told him that 'Abd us-Samad had done all the paintings on the walls of the private apartments in which they stood.[58] Some buildings in Fatehpur, Lahore and Agra still retain faint traces of scenes that relate closely to paintings in books produced in Akbar's reign, which themselves depict intricately decorated architecture.

111

Facing page | Plate 77 | DETAIL OF ILLUMINATED PAGE
FROM THE GULSHAN ALBUM (see Plate 57)

Plate 78 | OPENING FOLIO OF THE *AKBAR NAMA*
Calligraphed by Muhammad Husayn al-Kashmiri *Zarrin Qalam*
Illuminated heading (*sarlawh*) signed 'Mansur *naqqash*', c.1604
Ink, opaque watercolour and gold on paper 40.5 cm. x 27.5 cm.
British Library, London: Or. 12988

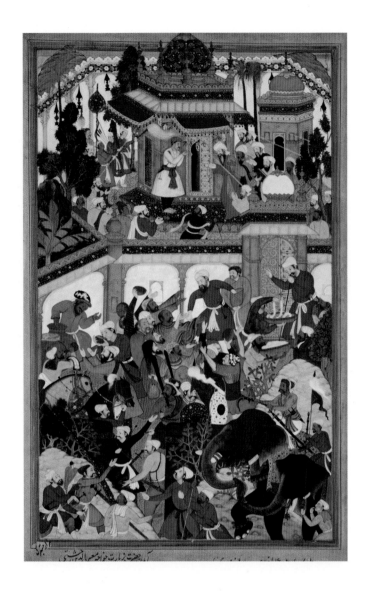

Ghostly shadows of paintings remain in the interiors of palace buildings at Lahore are all that remain. The sole evidence that portraits of Akbar, Salim and the prince's brothers were once on the inside walls of the *jharoka*, and angels and *divs* on the ceiling, is provided by the account of William Finch, an English merchant who saw them when he explored the city in 1611.[59]

Other kinds of work are similarly known only from written sources. When Abu'l Fazl mentions the various pastimes of the court in the *A'in-i Akbari,* he describes the changes that Akbar had made to the playing cards of a traditional game called *ganjifa*.[60] In it, each suit represented a department of the royal household, and each card depicted a member of its staff. In the suit of the financial department, a king of assignments and his vizir were shown inspecting *farmans*, or royal orders, and the volumes of revenue accounts. The people involved in the production of these books were shown on the other cards: they included the paper maker and the person who stained paper; the *musawwir* (painter) and the *naqqash* who ornamented books and documents; the *jadwal kash*, who drew the fine blue and gold lines that frame or separate text; the bookbinder; the *mistar* maker, who impressed the lines on the pages to help the copyists maintain straight lines when writing; and the calligrapher who copied the *farmans*.[61] None of these cards have survived. They would probably have been painted by the *Kitab Khana* artists, who had only to portray their own companions, as they did in the margins of contemporary manuscripts (Plates 62 and 80).

112

Plate 79 | AKBAR VISITING THE TOMB OF
MU'IN AD-DIN CHISHTI AT AJMER
Composition by Basawan, painting by Ikhlas, faces by Nanha
c. 1590-5 Illustration to the *Akbar Nama*
Opaque watercolour and gold on paper 32.8 cm. x 20.1 cm.
Victoria and Albert Museum, London: IS.2-1896: 23/117

Facing page | Plate 80 | PERSIAN TEXT, PERHAPS THE
BEGINNING OF A LETTER
Iran, late 16th century The borders reign of Jahangir, c. 1610-18
From the Gulshan album
Ink, opaque watercolour and gold on paper c. 42 cm. x 26.5 cm.
Staatsbibliothek zu Berlin: 'Berlin Album': Ms A 117 folio 18a

THE MUGHALS AND EUROPE

It is clear from the names of artists recorded by librarians on paintings in royal manuscripts of the late 1580s and early 1590s that the *Kitab Khana* had expanded considerably. Methods of working may have changed in order to streamline the production of the heavily illustrated volumes of these years. Most of the paintings were done by two artists — the senior artist designing the composition (*tarh*) and his junior doing the 'work' (*'amal*), painting in the details. However, a third specialist role appears in the notations made by librarians: the painting of faces, 'nami chehreh' or 'chehreh nami'.

The new emphasis on portraiture can be connected with the arrival at court of Europeans bringing Western art. When Abu'l Fazl writes that 'portraits [*surat*] have been painted of all His Majesty's servants, and a huge book [*kitab*] has been made', he measures the artists' work against two standards: the work of Behzad, as usual, but also 'the magic-making of the Europeans [*farangi*, or "Franks"]'.[62]

Akbar's first recorded meeting with Europeans came in 1573 after he captured Surat (Plate 45). His letter to the Portuguese living in Diu, written in December 1572, prompted a delegation to travel to Surat to meet Akbar, bringing 'many of the curiosities and rarities' of their homeland.[63] The emperor then despatched an embassy to the main Portuguese settlement of Goa in 1575 to learn more about these foreign arts. The envoys carried his letter to the king of Portugal requesting a copy of the Gospels. The embassy returned three years later, Gospel-less, but decked out in European clothes and bringing exotic presents including a pipe organ painted with images of Jesus and the saints, and a musician to play it.[64]

Akbar now wrote to Goa to invite suitable people to take part in his religious debates. When the first Jesuit mission to the Mughal court entered Fatehpur in 1580, the inhabitants of the city stopped and stared, 'wondering who these unarmed men might be, with their long black robes, their curious caps, their shaven faces, and their tonsured heads'.[65] The Jesuits' conviction that Akbar was about to convert to Christianity was unfounded, but none of them could have anticipated the effect of their gifts on court art. They brought a copy in oils of the famous 'St Luke Madonna' in Rome, as well as printed books, some of which were illustrated, and very fine engravings including Albrecht Dürer's *Small Passion* and *Virgin and Child*. They also gave Akbar seven volumes of Christophe Plantin's 1572 Polyglot Bible, with its engraved frontispieces.[66] Akbar allowed the Fathers to use a building at Fatehpur as a chapel, and here they dramatically unveiled two paintings of the Madonna and Child to the amazed people of Fatehpur. The emperor brought his mother Hamida Banu and other members of his family to see them, and sent along 'his chief painter and other painters'. At Nowruz in 1582, Christian paintings even decorated the court: one of Akbar's relatives had secretly borrowed a painting of the Virgin from the emperor's collection to display in the *jharoka*, draped with cloth of gold, because he thought it would please the emperor — as it did.[67]

When the Jesuits were asked to explain Christian doctrine to Akbar's young sons and a three-year-old daughter, they showed the children pictures in books. Akbar ordered the court artists to be present, and to paint everything Father Monserrate suggested to them.[68] In this way, copies of European models began to appear in Mughal paintings (Plate 81).

The first Jesuit mission stayed for three years before returning to Goa. A second came and went in 1591, leaving little impression, but the arrival of a third mission in 1595 had a very significant influence on Mughal painting, possibly because a Portuguese painter accompanied it. The engravings

given to Akbar were copied by his artists, who used tracings to enable them to transfer complete images onto a single page, or to insert small details into a different composition.[69] Soon, they were able to produce their own pastiches of this exotic art (Plate 84) but perhpas the most profound Western influence was on portraiture.

In manuscripts of the 1590s, Akbar is identifiable by his attributes of royalty, or by his prominent position in the composition, rather than exclusively by his features, which are not particularly distinctive (Plate 79). By contrast, the small portraits of leading court figures that he commissioned around the same time have a sense of individuality. These followed conventions that would continue virtually unchanged long

Plate 81 | THE MADONNA PRAYING BEFORE THE CRUCIFIX AND THE 'ST LUKE MADONNA'
Ascribed to 'the master Manohar' (*amal-i Ustad Manohar*), c. 1600
Detail of a page from the St Petersburg album
Opaque watercolour and gold on paper
Madonna 7.2 cm. x 6 cm. 'St Luke Madonna' 5.8 cm. x 2.8 cm.
St Petersburg Branch of the Institute of Oriental Studies
Russian Academy of Sciences: E.14, folio 53 recto

after Akbar's death: the figures stand against a plain, pale green background, their faces usually in profile, shoulders turned towards the viewer and feet to the side, in the manner of figures in earlier Hindu and Jain book painting (Plate 83).[70]

Akbar's son Salim, the future emperor Jahangir, competed fiercely with his father to acquire new European works, sometimes even purloining consignments sent from Goa before they reached Akbar. On seeing a painting of the Virgin in 1595, Salim immediately asked the Portuguese painter to make him a copy. The following year the Jesuits complained that their man had no time to do anything except copy 'Christ, Our Lord and Our Lady' for Salim from images in Akbar's library.[71] In 1597, the prince was seen supervising his own artists as they copied small paintings of religious subjects including the Descent from the Cross. Five years later, when Father Jerome Xavier completed his Persian text entitled the *Mir'at al-Quds* or 'Mirror of Sacredness' and gave it to Akbar, Salim ordered his artists to make a better version with twice as many pictures in it.[72] His interest in these Christian subjects continued in the early years of his reign.

Plate 82 | OPENING FOLIO OF THE *AKBAR NAMA*
Calligraphed by Muhammad Husayn al-Kashmiri *Zarrin Qalam*
Illumination signed 'Mansur *Naqqash*', c.1605
Opaque watercolour and gold on paper, British Library, London: Or. 12988
The first folio has two holograph library accession notices by Jahangir
AH 1028/19 December 1618-7 December 1619 AD and
Shah Jahan AH 1037/12 September 1627-30 August 1628 AD

Plate 83 | FOUR MUGHAL PORTRAITS
c. 1600-18 Opaque watercolour and gold on paper c. 42 cm. x 26.5 cm.
Staatsbibliothek zu Berlin: Page from the Gulshan album: Ms A 117 folio 4b
The portraits depict Khezr Khan Khandeshi (top left), possibly painted in Akbar's reign;
'Abdullah Khan (top right); Bakhtar Khan who was a famous musician (*kalavant*) at the court
of Bijapur and entered Mughal royal service (dated AH 1024/1615-6 AD) (lower left);
and 'Abdul Wahhab, the son of the physician and mathematician Hakim 'Ali,
in the service of both Akbar and Jahangir.

PRINCE SALIM'S ATELIER

Akbar had moved to Agra from Lahore in 1598 to launch a military campaign in the Deccan. The emperor returned to the city in May 1601 to find that Salim had rebelled, set up a rival court at Allahabad, and assumed the imperial title *padshah*.[73] The rebellion became infinitely more serious the following year when Salim hired assassins to kill Abu'l Fazl, one of Akbar's oldest and closest friends. The scholar's head was sent to Allahabad.

Allahabad Fort had been built by Akbar on a prominence overlooking the confluence of the rivers sacred to Hindus – Ganga, Yamuna and Saraswati. There, holy men lived and pilgrims thronged to immerse themselves in the waters. The spiritual character of the city was entirely at odds with Salim's erratic and occasionally barbaric behaviour caused by extravagant consumption of opium and alcohol, but is nevertheless reflected in the themes of some of the manuscripts produced by his artists in Allahabad. An illustrated *Yoga Vashisht* of 1602 was probably completed there, and a *Raj Kunwar* certainly was, as its colophon dated AH 1012/1603 AD states.[74] An illustrated volume of the poems of Amir Hasan Dihlavi was copied by the calligrapher Mir 'Abdullah *Mushkin Qalam* ('Musky Pen') in July 1602 and contained fourteen pictures (Plate 85), including a portrait of the calligrapher.[75]

The most significant artist of the small group at Allahabad was the Iranian Aqa Reza who had come to Hindustan and entered Salim's service some time before 1586 or 1587.[76] His presence at the rebel's court is shown by his signature in the golden sky of a painting in purely Safavid style in which he describes himself as 'the aspiring disciple [*murid*] of King Salim' (*murid-i padshah-i Salim*) (Plate 86).

The most intriguing, yet elusive of all the artists connected to Salim were women. Their rare surviving works include copies of European prints, one of which is signed by Nadira Banu who identifies herself as the pupil of Aqa Reza and daughter of one Mir Taqi. In another painting, she adds that she is a 'servant of King Salim' (*bandeh-ye padshah-i Salim*), implying that she too was at Allahabad.[77] Her title 'Banu' indicates she was of high birth, and painting seems to have been regarded as a suitable occupation for royal or aristocratic ladies (Plate 87). She may have been associated with two other women bearing the same title, each known from a single work. Ruqiya Banu signed her name on a drawing of a corpulent youth in Safavid dress and a portrait of Shah Tahmasp is attributed to Sahifa Banu (Plate 88).[78] Given the Safavid connections and their closeness to Aqa Reza, it is very likely that all were Iranian. Paintings by Aqa Reza, Nadira Banu, and Ruqiya Banu are all preserved in an album that would become one of the masterpieces of Jahangir's reign.

Plate 84 | THE LAST JUDGEMENT AND THE RESURRECTION OF THE DEAD
Page from a *Khamsa* of Mir Ali Shir Nava'i, calligraphed by
Sultan 'Ali of Mashhad, AH 897/1491-2 AD
Illustrations added for Jahangir and annotated by him in AH 1014/1605 AD
Ink, opaque watercolour and gold on paper
Royal Collection, Windsor Castle: MS. A 8, folio 5b

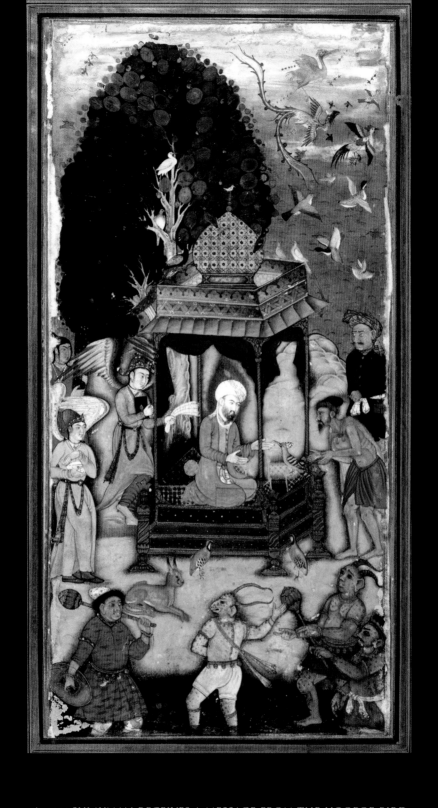

Plate 85 | SULAYMAN RECEIVES A MESSAGE FROM THE HOOPOE BIRD
Allahabad 1602, By Mirza Ghulam Page from a *Divan* of Amir Husayn Dehlavi copied by Mir 'Abdullah
Opaque watercolour and gold on paper 20.2 cm. x 10 cm.
Walters Art Museum, Baltimore: W.650, folio 157A

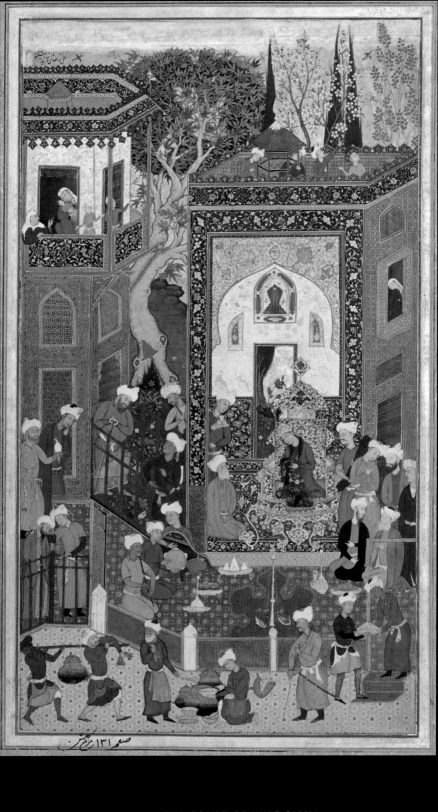

Plate 86 | THE COURT OF KING SALIM
Signed by Aqa Reza, c. 1601-4 Page from the Gulshan album
Opaque watercolour and gold on paper
c. 42 cm. x 26.5 cm. Golestan Palace Library, Tehran: No. 1663, folio 70

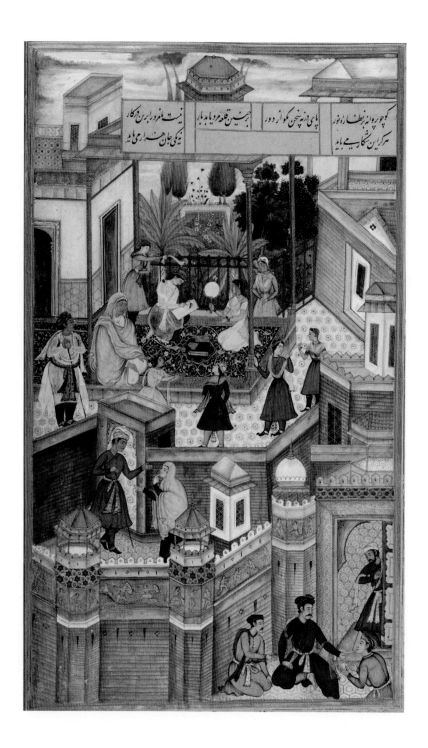

122

Plate 87 | THE PRINCESS PAINTS A SELF-PORTRAIT
By Jaganath, Completed by Akbar's 40th regnal year, c. 1595
From the *Haft Paykar* ('Seven Beauties') of the *Khamsa*, or 'Quintet'
of Nezami calligraphed by 'Abd'ur Rahim *Anbarin Qalam*
Opaque watercolour and gold on paper Page 30.2 cm. x 19.8 cm.
British Library, London: Or.12208, folio 206a, Bequest of C.W. Dyson Perrins

Plate 88 | SHAH TAHMASP OF IRAN
By Sahifa Banu, c. 1600
Opaque watercolour and gold on paper
Page 38.7 cm. x 25.3 cm. Painting 15.1 cm. x 9.2 cm.
Victoria and Albert Museum, London: IM.117-1921
Bequeathed by Lady Wantage

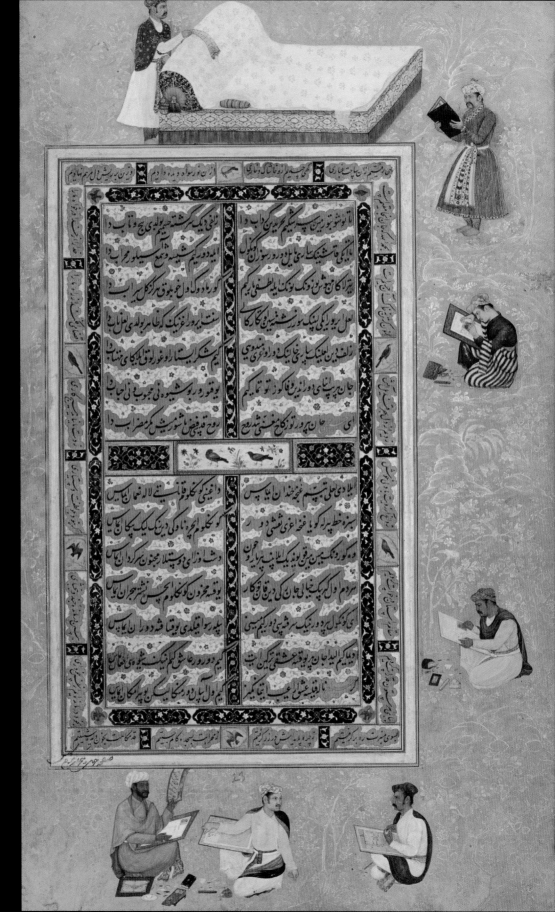

PAINTING FOR JAHANGIR

Some of the folios of the Gulshan, or 'Rose Garden' album (*muraqqa'-i Gulshan*) had already been created in 1600 at Agra, as demonstrated by a dated inscription on one of them, but the final volume contains work done as late as 1618.[79]

The word *muraqqa'* literally means 'patchwork'. In this context, it alludes to the patching together of carefully selected written and painted components on pages that are framed by decorative borders. The opening folios of the Gulshan album are heavily illuminated, and the fine lines scrolling across the ornamentation are burnished so that the gold would sparkle when the page was turned and caught the light. As in most royal Mughal albums, two pages with pictures of closely related scale, shape and subject alternate with two pages of illuminated calligraphy placed equally harmoniously. Their borders are unique.

Some panels of calligraphy by sixteenth-century Iranian and Indian masters are enclosed by golden landscapes of Timurid and Safavid inspiration in which gazelles, lions and other animals confront dragons, *kilins* and *simorghs* between rocky outcrops, trees and flowers. Occasionally, small vignettes of contemporary Mughal court life are inserted into this fantasy world: Jahangir, his wife and sons appear, courtly couples listen to poetry or music, scholars read, servants prepare food over small fires, and artists and craftsmen carry out their daily tasks (Plates 62 and 184).

Some of the figures are fully coloured but most are painted in gold, subtly emphasised by a thin wash of red or green watercolour and sometimes by fine black outlines or details painted in dull ochre tones. In other pages, Biblical and allegorical characters copied from Western engravings, or portraits copied from English miniatures brought by merchants, are even more bizarrely included.[80] All this was clearly not chosen at random: individuals often stare fixedly at particular lines of calligraphy or at each other in a manner that implies purpose. Everything must originally have been related to themes governing the selection of word and image in the album, but these are no longer understood, in part because the pages are now unbound and dispersed.

The borders enclosing the paintings are equally varied but completely different in style (Plates 83 and 100). The paper may be stained red, blue or turquoise, to allow the complex gold designs to be seen more clearly.[81] Dense patterns meander across the confined space, their flowing rhythm occasionally interrupted by symmetrically arranged cartouches. Pairs of small birds of seemingly infinite variety inhabit the blossoms of the borders, and animal masks are half-concealed within palmettes. The paintings in the Gulshan album are by great Iranian artists of the past including Behzad, Mir Sayyid 'Ali and 'Abd us-Samad, and by the more recent arrivals Aqa Reza and Farrukh Beg. The leading Hindustani artists of the reigns of Akbar and Jahangir are also included, and there are many European engravings. On the other hand, the pre-Mughal traditions of the subcontinent are completely ignored.

125

Facing page | Plate 89 | TURKI ODES BY HUSAYN BAYQARA
Calligraphy probably Iran or Hindustan, second half of 16th century
Borders Mughal with portraits of artists signed by Dawlat, c. 1610
Page from the Gulshan album
Opaque watercolour and gold on paper c. 42 cm. x 26.5 cm.
Golestan Palace Library, Tehran: No. 1663

The album seems to have been finished when it was inherited by Shah Jahan on his accession to the throne. Illuminated opening pages were added, and the final completion of the album in 1636 was celebrated in a poem by the court poet, Abu Talib Kalim Kashani.[82]

One page provides an extraordinary glimpse of Jahangir's artists (Plate 89). In the border, above a panel of calligraphy, an empty bed awaits a royal character, as indicated by the expectant servant holding over it a sash, which was an emblem of royalty. Nearby, a standing figure studies a portfolio. The gold pen-case tucked into his own sash suggests that he holds an official post, perhaps a superintendent of artists, because all the other figures are engaged in painting portraits. The left-handed youth in a black and white *jama* concentrates intensely on his work, his equipment on the ground next to him: a red box with painted gold designs contains his pigments, and shells contain the colours that he has mixed with water (Plate 91). A minute inscription on the paper resting on his board states that he is Abu'l Hasan, known from other sources to be Aqa Reza's son, born in 1588 or 1589.[83] Similar inscriptions identify the older artist beneath him as Manohar, and the figure in the lower right corner as Bishandas, 'the nephew of Nanha', who seems to be

in conversation with Govardhan, the man in front of him. All the portraits are signed as the work of Dawlat.

The remaining artist who appears to be instructing Govardhan, holds up a sheet of paper on which is written that the portraits were done by order of Jahangir, and that this is Dawlat himself (Plate 90). Almost nothing is known about these artists except that they had all been in Akbar's service and now clearly worked very closely with Jahangir.

By the time these portraits were painted, the pace of manuscript production in Akbar's *Kitab Khana* seems to have slowed down. Some of Akbar's artists may have moved into new employment while others remained in Jahangir's service, even into their old age. Farrukh Beg, for instance, continued to paint up to at least his 'seventieth year', as Jahangir recorded on several of his works. One, in Deccani style, was completed

Plates 90 and 91 | DETAILS OF GULSHAN ALBUM (see Plate 89)

Facing page | Plate 92 | RUSTAM SLAYS THE WHITE DIV
Page from a *Shah Nama*, or Book of Kings c. 1608 Mughal court circle
Opaque watercolour and gold on paper
Page 23.5 cm. x 14.61 cm. Painting 17.15 cm. x 12.07 cm.
Los Angeles County Museum, Los Angeles: M.71.49.3
Gift of the Michael J. Connell Foundation

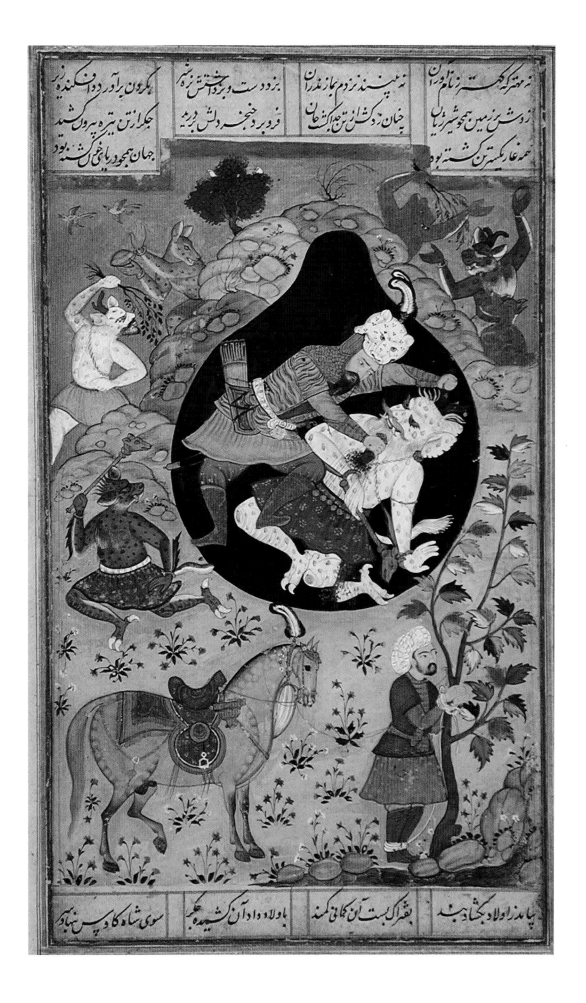

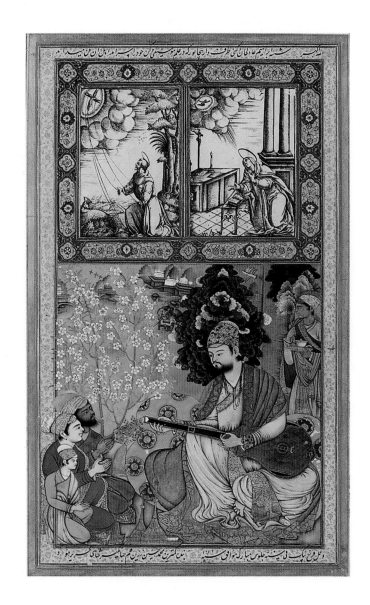

128

Plate 93 | IBRAHIM ʿADIL SHAH II OF BIJAPUR
By Farrukh Beg, according to the inscription by
Muhammad Husayn al-Kashmiri
Painted in Ajmer c. 1615
Opaque watercolour and gold on paper
with two European engravings above
Page 62.5 cm. x 42 cm. Naprstek Museum, Prague: A12181

at Ajmer, according to its inscriptions (Plate 93). Its date, 1615, shows that he must already have been about forty when he came to Hindustan in 1585.[84] Other artists must have been very young when they entered royal service, or like Abu'l Hasan, were born into it if their artist father already worked for Akbar. On the evidence of the names mentioned in contemporary inscriptions on paintings, the total number of royal artists seems to have been reduced considerably, perhaps because the emperor travelled so frequently and so far from the royal *Kitab Khanas*.

New manuscripts certainly continued to be produced and old ones given new paintings (Plates 92 and 84). But Jahangir's artists now left the royal cities to accompany him on his expeditions across the empire. In general, the artists seem to have painted whatever took Jahangir's fancy, recording the distinctive flora and fauna of the regions they crossed, depicting important or interesting individuals, and adding paintings to the walls of monuments.[85] The style of Mughal painting changed significantly in his reign. Compositions, usually now done by a single artist, became sparser and the people within them larger. Considerable attention was paid to details of clothing, jewellery and architectural decoration. Some of the portraits done for Akbar were added to the Gulshan album, arranged in groups of four with the joins occasionally disguised by the addition of buildings or a landscape (Plates 83 and 94). Portraits in exactly the same style done for Jahangir of his own leading court members – and of the emperor himself – must have been kept in the *Kitab Khana* as prototypes. Whenever an artist needed to include a particular individual in a crowded scene of a durbar, he would trace their outline and add it to his composition, a method producing marked discrepancies in scale between the figures (Plate 95) which was nevertheless retained in Shah Jahan's reign for depictions of court assemblies.[86]

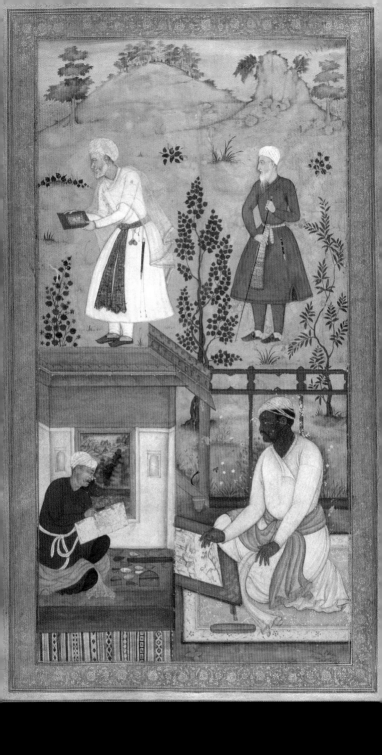

Plate 94 | FOUR MUGHAL PORTRAITS, INCLUDING TWO ARTISTS
c. 1600-18 From the Gulshan album
Opaque watercolour and gold on paper c. 42 cm. x 26.5 cm.
Staatsbibliothek zu Berlin: 'Berlin Album': Ms A 117 folio 21a

THE JAHANGIR NAMA

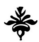

Jahangir followed his great-grandfather's example in recording the events of his reign in a diary, and was also profoundly curious about the natural world. Unlike Babur, he commissioned illustrations for his memoirs, regularly ordering artists to paint on the spot the scene, person, animal or flower he described. After twelve years he ordered the supervisors of the royal library to make a fair copy of the memoirs up to that point, and to make multiple copies of it.[87] The first was given to Shah Jahan, and subsequent volumes to Jahangir's father-in-law, I'timad ad-Daula, and brother-in-law Asaf Khan; others were to be sent abroad 'to be used by the rulers as a manual for ruling'.

The book's frontispiece painting was finished even before the definitive copy of the text. Jahangir was in Ahmadabad in July 1618 when Abu'l Hasan, by now entitled *Nadir az-Zaman*, or 'Wonder of the Epoch', presented it (Plate 95). The emperor wrote admiringly: 'Without exaggeration, his work is perfect, and his depiction is a masterpiece of the age. In this era, he has no equal or peer'.[88]

Only a few illustrations from the *Jahangir Nama* manuscript survive, including the scene of Shah Jahan's birthday weighing that retains its text (Plate 31), and the capitulation of the fiercely independent Rana of Mewar to Shah Jahan in 1616 where the artist, Nanha, has discreetly included himself, painting the Rana's portrait (Plates 96 and 97).

Although Jahangir stated Abu'l Hasan was without equal, he added that another artist, Mansur, had been graced with the honorific title *Nadir al-'Asr*, or 'Rarity of the Age'. His talent for depicting animals had been evident during Akbar's reign (Plate 50) but he now became renowned for his studies of individual animals and birds, and for his paintings of flowers. When the emperor was given a bizarre animal that he described as a wild ass striped like a tiger for Nowruz in 1621, Mansur was ordered to paint the curious animal before it was despatched as a gift for Shah 'Abbas of Iran. His name is not mentioned in the *Jahangir Nama*, but the emperor recorded it in his annotation to the finished work (Plate 98).

Mansur must usually have accompanied the peripatetic emperor. When Jahangir moved to Delhi in 1619 after a long absence, a beautiful falcon sent by Shah 'Abbas arrived at the royal encampment and Mansur was ordered to paint it. When they visited the ravishing springtime countryside of Kashmir in 1620, and the emperor wrote ecstatically about the wild red roses, violets and narcissi in the fields, and the tulips planted on the roofs of wooden houses, he also noted that Mansur painted more than a hundred studies of flowers. Curiously, Mansur's rare surviving study of a tulip, possibly the *Tulipa Lanata* which grows in Kashmir, follows the conventions of European botanical illustrations rather than looking like a flower growing in the wild (Plate 99).[89] Another rare signed study of flowers is preserved in the upper left part of a panel in the Gulshan album (Plate 100).

130

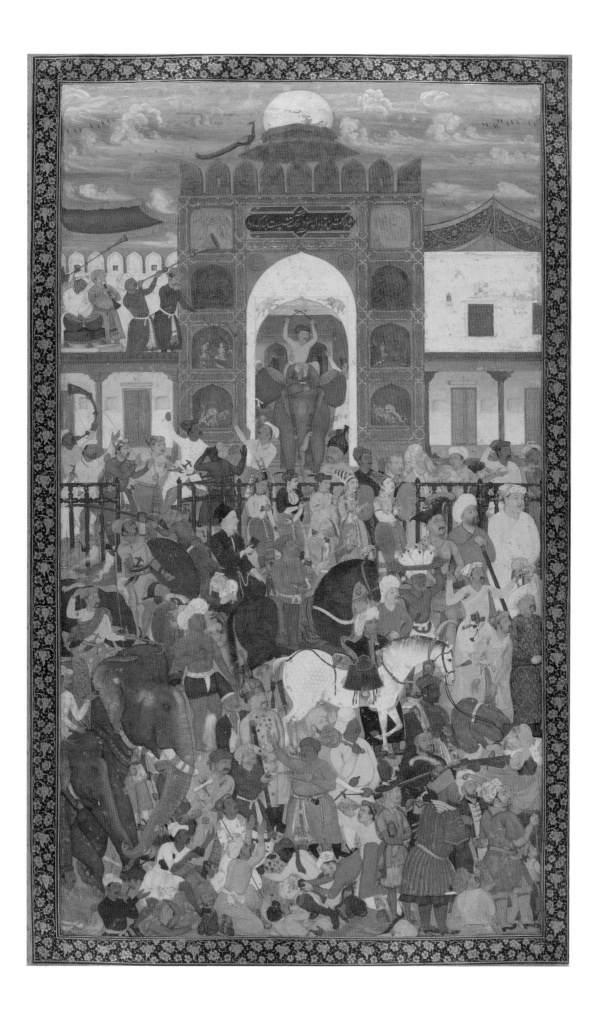

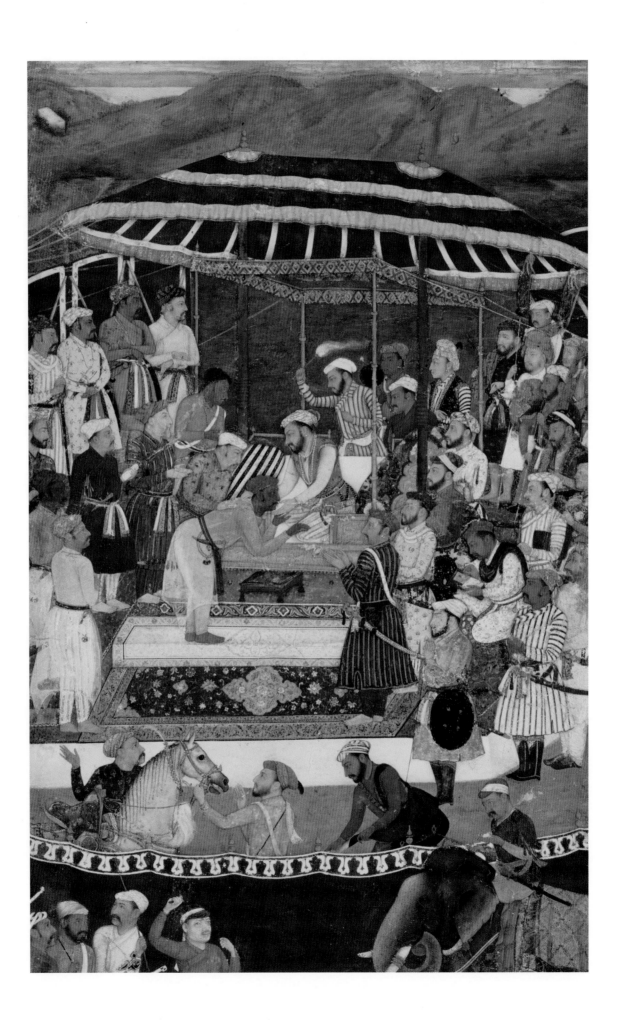

Here, Mansur copied identifiable engravings in the European volumes known as herbals, or florilegia, that circulated widely in Europe in the late sixteenth and early seventeenth century. However, the specific book from which they came has not so far been identified, because the same engravings were used by several different authors. [90]

Dawlat, like Mansur, was an illuminator, and he too copied flowers from European engravings, scattering his blossoms between the calligraphy in Jahangir's albums and introducing a naturalism that owes nothing to first-hand observation of the real world (Plate 101). [91] These flowers, like the scrolling designs in the emperor's manuscripts', recur in the carved decoration of his monuments, again implying a close relationship between the artist-designers of the court and the royal architects.

Facing page | Plate 96 | SHAH JAHAN RECEIVING THE
SUBMISSION OF RANA AMAR SINGH OF MEWAR IN 1614
Signed by Nanha, c. 1615-18 Illustration to the *Jahangir Nama*
Opaque watercolour and gold on paper 31.3 cm. x 20.1 cm.
Victoria and Albert Museum, London: IS.185-1984

Plate 97 | THE ARTIST NANHA (Detail of Plate 96)

Plate 99 | RED TULIPS
Signed by Mansur, c. 1620
Opaque watercolour and gold on paper
Maulana Azad Library, Aligarh: 60-1-B 3

135

Plate 100| FLOWER STUDIES
The panel at upper left copied from a European herbal
signed by Mansur '*Jahangir shahi*', c. 1615
Page from the Gulshan album
Opaque watercolour and gold on paper
Golestan Palace Library, Tehran: No. 1663 p. 103

Plate 101| PAGE OF CALLIGRAPHY
Calligraphy by Mir Ali, Iran or Bukhara c. 1505-45
Illuminated decoration signed by Dawlat, c. 1610-20 Borders c. 1650
Ink, opaque watercolour and gold on paper Page 39.1 cm. x 27.3 cm.
Calligraphic panel 23.5 cm. x 12.1 cm. Chester Beatty Library, Dublin: 07A.11

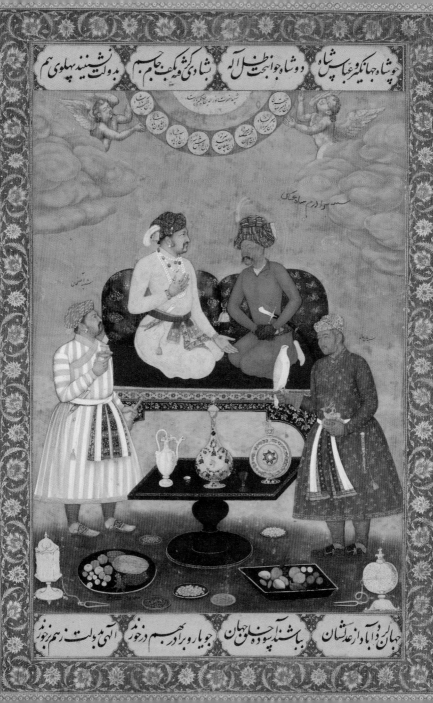

THE 'ALLEGORICAL' OR 'DREAM' PAINTINGS

In 1613, the court moved to Ajmer and stayed there for nearly three years. A series of some of the strangest paintings of his reign was probably begun in this city dominated by the shrine of the Sufi mystic Mu'in ad-Din Chishti. In these, complicated visual allusions to Jahangir's Timurid ancestry, to the dreams that he had in or near Ajmer, or to his personal preoccupations, are combined with minutely written commentaries and verses emphasising the emperor's role as the dispenser of justice and, again, his lineage that is inscribed on golden roundels encircling the name and titles of the emperor.[92] Jahangir appears in all the paintings, sometimes accompanied by individuals he knew well, or by people he had never met, like his regular correspondent Shah 'Abbas of Iran (Plate 102). He is surrounded by symbols and motifs conveying concepts of Iranian kingship, and by elements drawn from Hindu or Christian iconography. In the most striking of these paintings, Jahangir is illuminated by a vast golden halo probably alluding to his title *Nur al-Din*, 'Light of the Faith' (Plate 103). The halo consistently indicated royalty in paintings from the beginning of Jahangir's reign until the nineteenth century. Its form was copied from the Christian art brought by the Jesuits, but it expressed the ancient Iranian concept of kingship that spread eastwards

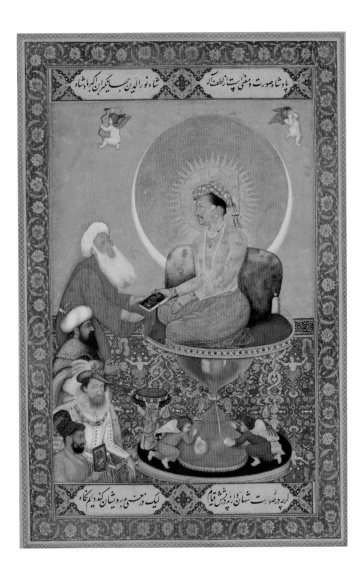

139

Facing page | Plate 102 | JAHANGIR ENTERTAINS
SHAH 'ABBAS OF IRAN
c.1615-20 Opaque watercolour and gold on paper 25 cm. x 18.3 cm.
Freer Gallery of Art, Smithsonian Institution,
Washington, D.C.: F.1942.16a

Plate 103 | JAHANGIR PREFERRING
A SUFI SHAYKH TO KINGS
Signed by Bichitr, c.1615-20
Opaque watercolour and gold on paper 25 cm. x 18.3 cm.
Freer Gallery of Art, Smithsonian Institution,
Washington, D.C.: F.1942.15

of Kiyanid kings of the Iranian stylized history of the world, the *Shah Nama*]. It is communicated by God to kings without the intermediate assistance of anyone, and men in the presence of it bend the forehead of praise towards the ground of submission.[93]

In the painting, Jahangir sits on a giant hourglass, receiving a book from a white-bearded figure who may be Shaykh Husayn, the pre-eminent figure of the Ajmer shrine. Two cherubs with earnest expressions write on the glass: 'God is Great. O Shah, may the span of your life be a thousand years', proclaiming the eternity of his reign while the sand flowing swiftly downwards alludes to the passing of time.[94]

Jahangir gazes without expression into the distance, appearing not to notice his surroundings. The verses above and beneath him provide the explanation:

He is the King in the image [*surat*] and in spirit by God's kindness
Shah Nur ad-Din Jahangir, son of Akbar the emperor
Although in the image kings stand in his presence
Yet in spiritual reality he perpetually gazes at darvishes[95]

and westwards, and whose significance was explained by Abu'l Fazl:

Royalty is a light emanating from God, and a ray from the sun, the illuminator of the universe, the argument of the book of perfection, the receptacle of all virtues. Modern language calls this light *farr-i izadi* [the divine light] and the tongue of antiquity called it *kiyan khura* [the Kiyan halo: ie that of the ancient line

Plate 104 | PORTRAIT OF A EUROPEAN GENTLEMAN
c. 1615-20 Opaque watercolour and gold on paper
Detail of a page from the St Petersburg Album 6.7 cm. x 4.9 cm.
St Petersburg Branch of the Institute of Oriental Studies
Russian Academy of Sciences: E.14 folio 58 recto

The kings on the left are an Ottoman sultan, identifiable by the shape of his turban and by his jewels, and a figure wearing a bejewelled and plumed hat who is unmistakably James I of England. The third person is the artist Bichitr, whose humble signature is on the top of the footstool supported by golden caryatids.

The inclusion of James I marks a new phase of European influence in Mughal court art. By the time his ambassador, Sir Thomas Roe, presented Jahangir with the paintings that were displayed at Ajmer during Nowruz in 1616, Jesuit influence at court was negligible. The dominant member of the third Jesuit delegation from Goa, Father Jerome Xavier, had left in 1614, the year Jahangir temporarily suspended the mission because of hostile Portuguese action at

140

sea. For the next twelve years, no European work of art seems to have arrived at court via the Jesuits.[96]

Instead, Jahangir's appetite for exotic novelties was satisfied by the paintings and artefacts brought by his own agents and by foreign merchants. These men had already reached Akbar's court at the end of his reign, but the constant presence of the Jesuits combined with his lively interest ensured that religious art would be more influential. Western miniature paintings, particularly those by English artists with their luminous colours and jewelled settings, must have greatly appealed to the Mughal court and were copied with minute attention to detail. Bichitr had clearly seen more than one image of King James, because he combined details of two separate famous English royal jewels to create an ornament in the manner of a Mughal turban aigrette.

As before, European paintings brought by Roe and others who arrived slightly before him were either reproduced exactly by the court artists, or provided a general source of inspiration (Plate 104). Miniature-size likenesses of court characters began to appear in a Western oval or rectangular portrait format in which, for the first time in Mughal art, only the upper part of the subject was depicted (Plate 105). The convention would persist in Shah Jahan's reign (Plates 106 and 108). Portraits of the

emperor in the new style were bestowed on favoured individuals, and were sometimes worn in the turban, set in gold or jewelled frames, perhaps themselves influenced by English hat jewels.[97] The gold 'portrait coins' were worn in the same way, as Roe noted, adding that the recipients often embellished the small gold attachment chain with precious stones or pendant pearls.[98]

The real world intrudes into the elaborate fantasies of Jahangir's allegorical paintings only in the depiction of art brought to the court by foreign merchants, ambassadors and his own nobles – German gold and silver vessels, a Chinese cup or Venetian decanter, and European textiles that may have been Brussels tapestries or French embroideries.[99]

Long after Jahangir's artists had stopped producing these complex paintings, their motifs continued to be used as a form of visual shorthand suggesting aspects of royalty. In paintings of Shah Jahan especially, they continued as pictorial clichés. European-style cherubs continue to shower gold or jewels from the heavens over the head of the emperor (Plate 109), and the lion and the lamb sit together in peaceful harmony that alludes to the Solomon-like attributes of a ruler in whose realm all natural hostilities are eradicated (Plate 118).[100]

141

Above | Plate 105 | PORTRAIT OF JAHANGIR
Signed by Balchand, c. 1615
Opaque watercolour and gold on paper
Detail of a page from an album c. 1750-1800 5 cm. x 4.1 cm.
Agha Khan collection M.140

Below | Plate 106 | PORTRAIT OF SHAH SHUJA'
Signed by Balchand, c. 1640
Opaque watercolour and gold on paper
Detail of a page from the St Petersburg album 3.6 cm. x 3.3 cm.
St Petersburg Branch of the Institute of Oriental Studies, Russian
Academy of Sciences: E. 14 folio 5 recto

THE KING OF THE WORLD

On his accession, Shah Jahan inherited Jahangir's remarkable library which included Akbar's equally remarkable manuscripts. During his reign, Shah Jahan wrote long inscriptions on the flyleaves of his greatest treasures, next to his father's similar annotations and the inspection notices made by many previous royal librarians.[101] A good calligrapher himself, Shah Jahan occasionally commented on the writing of famous practitioners in these volumes. Despite this clear interest, and his daily inspections of his artists' paintings when he resided in his different palaces, there is surprisingly little evidence of him commissioning illustrated manuscripts.[102] Most of the paintings seem to have been intended for albums, which also included works done for Jahangir that were given new floral borders.[103]

When he was still a prince, artists sometimes accompanied him on military campaigns, as suggested by Nanha's painting commemorating the great Mughal victory over the Rana of Mewar in 1614 (Plate 96). The artist has included himself, sketching the Rana as he bowed in submission (Plate 97).[104] Such great victories led Jahangir to give his son the title Shah Jahan (shah-i jahan, 'King of the World' in Persian) in 1617. At about the same time, and probably to mark the occasion, Abu'l Hasan painted a portrait that includes the new title written in minute gold letters above the prince's head. Strikingly, Shah Jahan is depicted with all the attributes of kingship (Plate 107): his head is encircled by the golden halo of monarchs, the jewel in his hand is a turban ornament that could only be worn by a ruler, and his royal necklaces of enormous pearls, spinels and emeralds are the equal of any depicted in portraits of Jahangir at the same time. The degree to which the prince may have influenced the artist

cannot be known, but this imperial magnificence combined with Abu'l Hasan's description of his subject as the 'blessed likeness of the *qibla* [direction of Mecca, to which Muslims turn when praying] and master of mankind,' suggests the aspirations that would ultimately lead Shah Jahan to rebel against Jahangir in 1622. Later, almost certainly after his accession, the painting was slightly extended and verses were added comparing him to Solomon and the kings of the *Shah Nama*, while proclaiming: 'There is no King of Kings other than him under heaven/ He is the royal rider on the piebald steed of the world'.[105]

Throughout the 1620s, as Jahangir's chronically fragile health deteriorated still further and Shah Jahan stayed away from the court, real power was held by others, notably Jahangir's wife Nur Jahan. When the emperor died near Lahore, Shah Jahan was at the opposite end of the empire in the Deccan, and Nur Jahan tried to secure the succession for her son Shahriyar. Her plans were thwarted by her brother Asaf Khan, whose support allowed Shah Jahan to reach Agra where his coronation was swiftly arranged on a suitably auspicious day in February 1628. Asaf Khan arrived in the city the following month, bringing Shah Jahan's sons from Lahore (Plate 56), and was given the highest office in the empire, that

143

Facing page | Plate 107 | SHAH JAHAN AS A PRINCE
HOLDING A TURBAN JEWEL
Signed '*Nader al-Zaman*' [Abu'l Hasan] c.1617
Opaque watercolour and gold on paper
Page 39 cm. x 26.7 cm. Painting 20.6 cm. x 11.5 cm.
Victoria and Albert Museum, London: IM.14-1925
Inscribed later by Shah Jahan: 'This is a good likeness of me in my
twenty-fifth year and it is the fine work of *Nader al-Zaman*,
the Wonder of the Epoch'

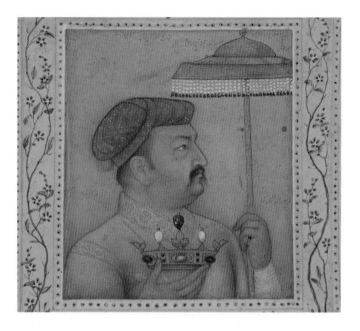

of Vakil. When Asaf Khan suggested a second, much grander coronation for the emperor, this was celebrated in the newly-constructed *Chehel Sutun* in August of the same year.

Accession paintings are not mentioned by Shah Jahan's historians, but were certainly produced. Asaf Khan's role as king-maker is alluded to in a miniature portrait dated to Shah Jahan's first regnal year, in which he holds a royal parasol and jewelled gold crown (Plate 108). In another small portrait, also painted by Abu'l Hasan in the same year, the emperor holds the royal seal, inscribed with his full array of imperial titles (Plate 22). A larger, allegorical painting by Bichitr depicts Akbar handing the crown directly to Shah Jahan, bypassing Jahangir (Plate 1).[106]

Many portraits of Shah Jahan depict him standing on a globe in the visual expression of his title, 'King of the World' (Plate 109). They were preserved in albums, accompanied by single portraits of his sons and closest friends. His leading courtiers are also portrayed, sometimes identified by the emperor in inscriptions probably added after he had been deposed and imprisoned by his son Aurangzeb, who took the title 'Alamgir ('World Seizer' in Persian), in 1658 (Plate 115).[107]

All Shah Jahan's albums were broken up, probably in the eighteenth century, and none can now be recreated in their entirety. One group of folios conventionally known as the 'Late Shah Jahan album', disguising the fact that the pages are dispersed across the world, is identified by their borders that follow the broad conventions of Jahangir's albums. They are filled with scrolls inhabited by animals and birds, with golden landscapes populated by figures occupied in various tasks, or by flowering plants (Plate 110). However, the experimentation of Jahangir's artists has disappeared, and the decoration has a rigid symmetry and frequent repetitiveness.[108] In the early twentieth century, some of these folios fell into the hands of a dealer in Paris, Georges Demotte who split their laminated layers to separate the paintings and

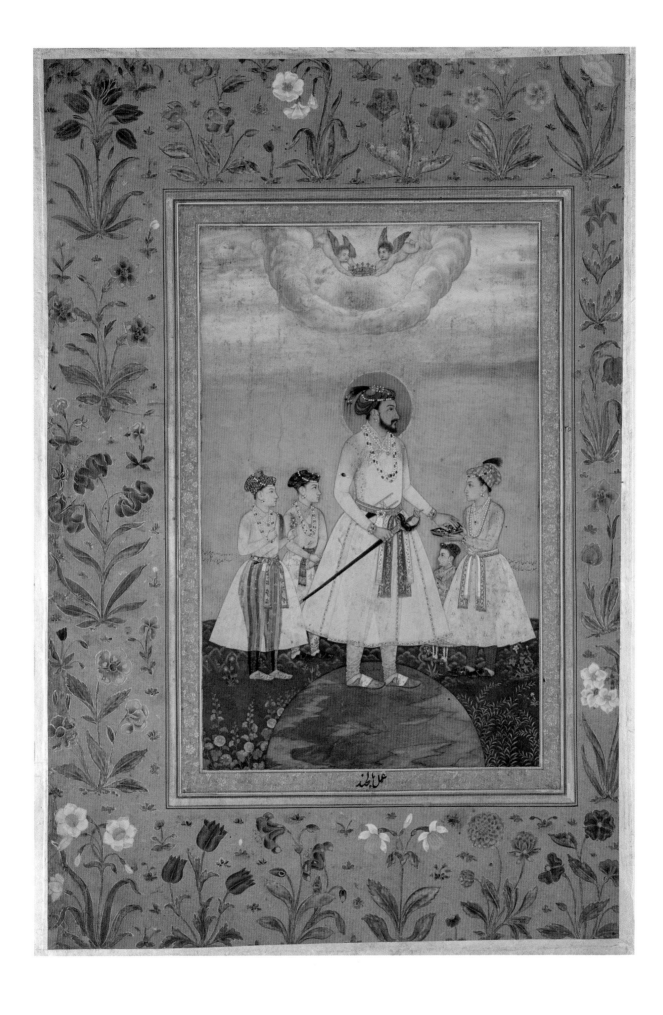

calligraphies, allowing him to sell them at a greater profit. He also seems to have replaced some of the central calligraphic panels with later pictures. A painting of women bathing in the moonlight may therefore be a later addition, but its borders provide a rare view of women attired in the dress and jewels of Shah Jahan's court (Plate 111).

More complicated compositions illustrate the *Padshah Nama*, the history of the reign. In the eighteenth century, probably at the court of Awadh, the manuscript was extensively refurbished and paintings added, but many original illustrations remain.[109] Shah Jahan is depicted in sumptuous palace assemblies sitting in his high *jharoka*, seemingly unaware of the crowd beneath (Plate 56). The emotionless formality of these scenes distances the emperor's personality as effectively as he physically separated himself from the throng in real life.

This official history emphasizes Shah Jahan's past glories. In an illustration that almost certainly depicts his return as a prince to the court from a military campaign in the Deccan in 1617, Shah Jahan's artist Murar shows Jahangir welcoming his son with a fond embrace (Plate 112).[110] But in standing up to greet him, Jahangir has left empty the symbolic seat of the King of the World in the *jharoka* towards which Shah Jahan now seems to move.

A very few paintings and manuscripts can be associated with other courtly patrons. Dara Shokuh was renowned for his scholarly interests, particularly philosophy and religion. He was a calligrapher whose work is seen in a detached folio from an album that was perhaps compiled for him, and which has a portrait of Babur on the other side (Plates 113 and 114) In AH 1051/1641-2 AD he gave his wife Nadira Banu an album of paintings and calligraphies that has survived in its entirety, and is unique for its many depictions of women (Plate 34).[111] It also includes studies of flowers done in the mannered style deriving from European herbal engravings, demonstrating the continuing influence

147

of the West on Mughal art. Some of the most significant portraits of Dara Shokuh were done by Jahangir's leading artist Govardhan, whose portrait had appeared in the borders of the Gulshan album (Plate 90) and whose long career continued well into Shah Jahan's reign. One of these is in very traditional style apart from its decorative oval frame that may have been added slightly later (Plate 116). The drawing of Dara Shokuh's brother Aurangzeb is by the much younger artist Lalchand, who came to prominence in the 1620s, but is an equally traditional preparatory sketch for a formal portrait and demonstrates the inherent conservatism of the reign (Plate 115).

The elite of the empire must often have patronised artists, but little can now be connected to particular individuals. A rare exception is an illustrated volume made for Zafar Khan, who belonged to an Iranian aristocratic family closely connected to the emperor, and whose son 'Inayat Khan abridged the *Padhshah Nama* for Shah Jahan. Zafar Khan was a famous patron of poets – though it was said that his liberality extended mainly to Iranians, rather than to those born in the empire, and that he was especially generous to those whose poems praised their benefactor.[112] An extremely able administrator, he was at different times governor of the provinces of Sind, Kabul, and Kashmir. Shah Jahan visited him in Kashmir in 1645 to inspect his new garden, and it was during this period that artists embellished painted scenes from Zafar Khan's life. These were used later as illustrations for a volume of his poems, written in his own hand (Plate 117).[113] In one, the refined atmosphere of his Kashmiri household is evoked. Musicians provide the accompaniment to a conversation taking place in the presence of poets and scholars, while a servant prepares a huqqa, and an old, bespectacled artist paints a portrait.

Although Shah Jahan seems not to have shared the profound interest that Akbar and Jahangir had in painting, his artists played an essential role at his court. Architecture was undoubtedly one of his greatest passions, and Shah Jahan's artists were crucial to its decoration (Plate 118). The illustrations to the *Padshah Nama* suggest that the walls of his palaces were painted with blossoming plants, complex allegorical pictures and purely ornamental patterns.[114] When a contemporary historian described Shahjahanabad, he singled out the Imtiyaz Mahal, or 'Place of Excellence' which was 'the exalted House of Government' and 'stood above the octagonal throne of the eighth sky in the perfection of its decorations and ornaments and in the infinite beauty of its paintings [*naqsh-u-nigar*]'. Thus, inside and outside, it had 'the lustre and colour of the promised Paradise', the most important theme of all in the arts of Shah Jahan's court.[115]

Facing page | Plate 112 | JAHANGIR RECEIVES PRINCE KHURRAM
ON HIS RETURN FROM THE DECCAN IN 1617
Signed by Murar c. 1640
Illustration to the *Padshah Nama* of Abdul Hamid Lahori
Opaque watercolour and gold on paper 30.8 cm. x 20.9 cm.
Royal Collection, Windsor Castle: RCIN. 1005025.k-1 folio 49A

150

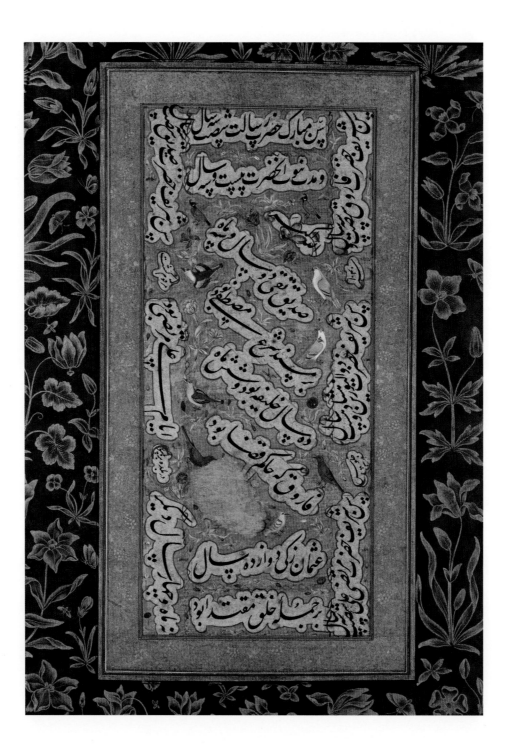

Plate 113 | CALLIGRAPHY
Probably written by Dara Shokuh
Burhanpur, dated regnal year 3 [AH 1040/1630-1 AD]
Ink, opaque watercolour and gold on paper
Page 40 cm. x 26.1 cm. Calligraphic panel 21.4 cm. x 96. cm.
Victoria and Albert Museum, London: IS.37a-1972

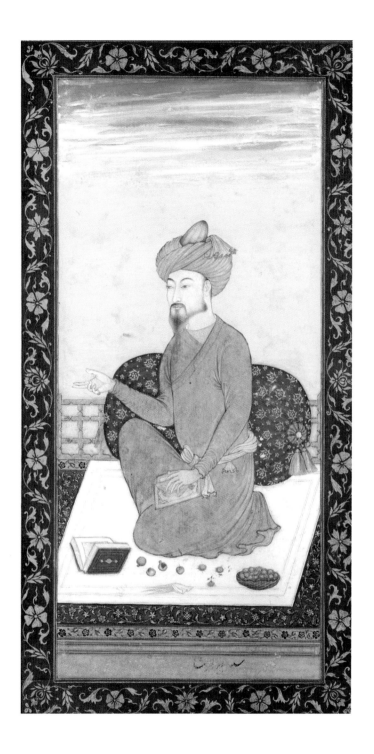

151

Plate 114 | PORTRAIT OF THE EMPEROR BABUR
c. 1630-40
Opaque watercolour and gold on paper
Page 40 cm. x 26.1 cm. Painting 21.4 cm. x 9.7 cm.
Victoria and Albert Museum, London: IS. 37-1972

Plate 115| PRINCE AURANGZEB
By La'lchand, c. 1640-45
Drawing and wash on paper with body colour, the borders painted with gold
Page 31.3 cm. x 20.1 cm. Drawing 16.7 cm. x 10.5 cm.
Chester Beatty Library, Dublin: In.41.3

Plate 116| PRINCE DARA SHOKUH
By Govardhan, c. 1635 the gold frame possibly c. 1650
Opaque watercolour and gold on paper
Page 40.9 cm. x 28.3 cm. Sold at Sotheby's London, 1999
Present whereabouts unknown

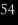

54

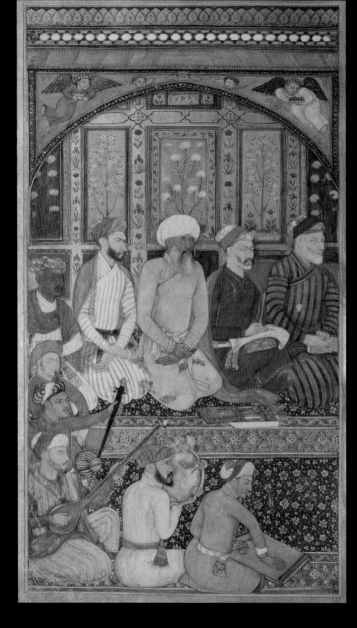

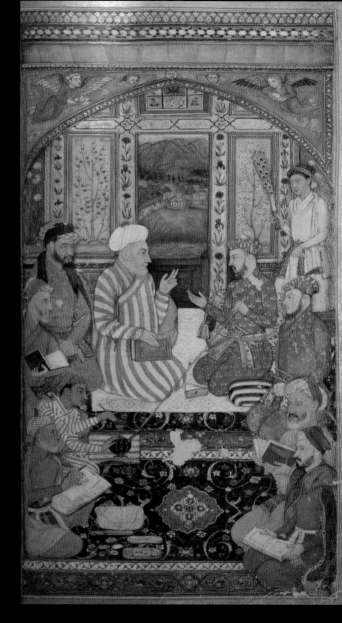

Plate 117 | ZAFAR KHAN AND HIS BROTHER IN THE COMPANY OF POETS AND SCHOLARS IN A GARDEN
Double page illustration, c. 1640-50 added to Zafar Khan's autograph copy of
his collection of poems [*Masnavi*] done in Lahore in AH 1073/1662 AD
Opaque watercolour and gold on paper
Royal Asiatic Society, London: MS. Persian 310, ff. 19v and 20r

Facing page | Plate 118 | JAHANGIR PRESENTS KHURRAM WITH A TURBAN ORNAMENT
Signed by Payag c. 1640
Illustration to the *Padshah Nama* of Abdul Hamid Lahori
Opaque watercolour and gold on paper, 30.6 cm. x 20.3 cm.
Royal Collection, Windsor Castle: RCIN. 1005025.k-1 folio 195a

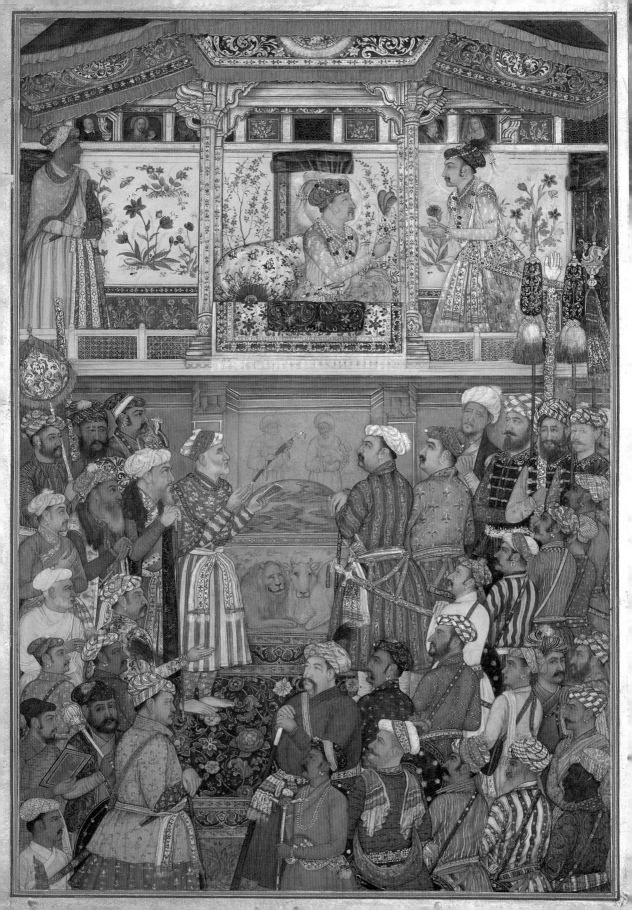

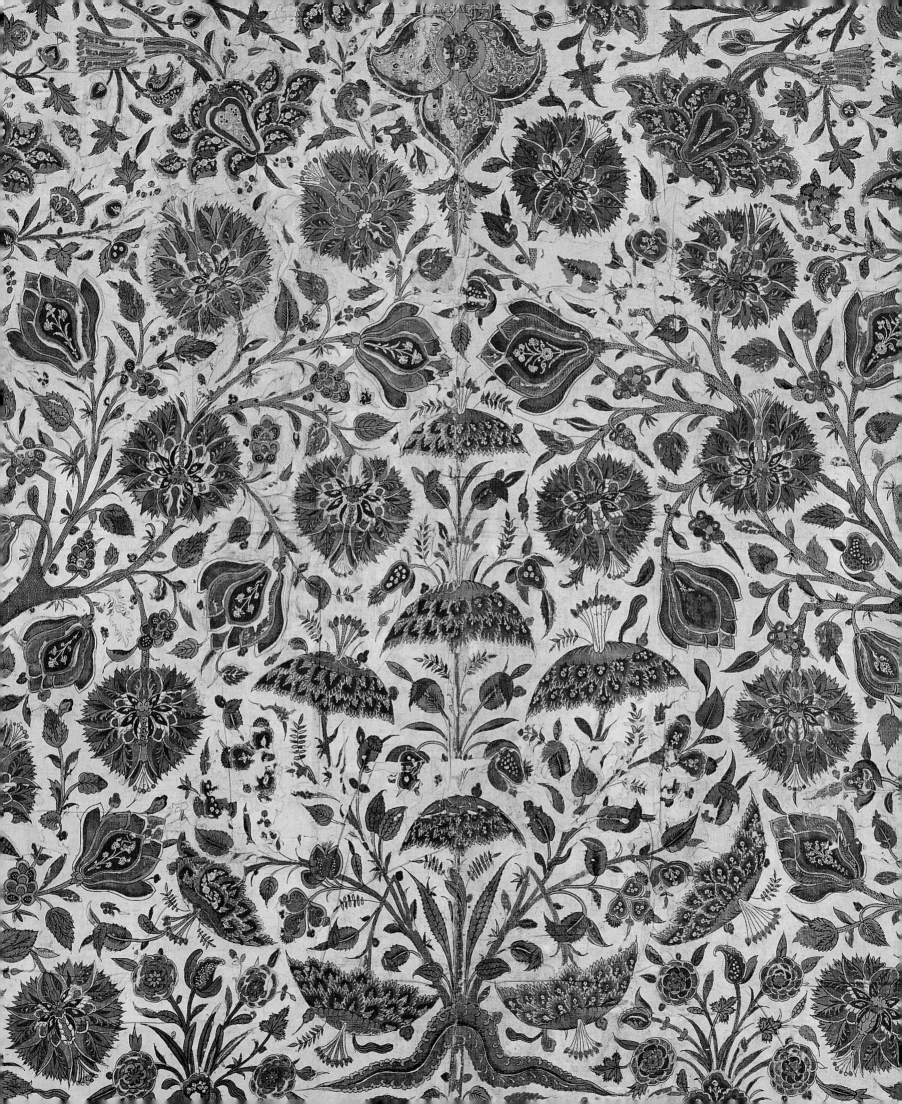

III

THE ROYAL WORKSHOPS AND
THE SKILLS OF HINDUSTAN

DETAIL OF FLOORSPREAD (see Plate 172)

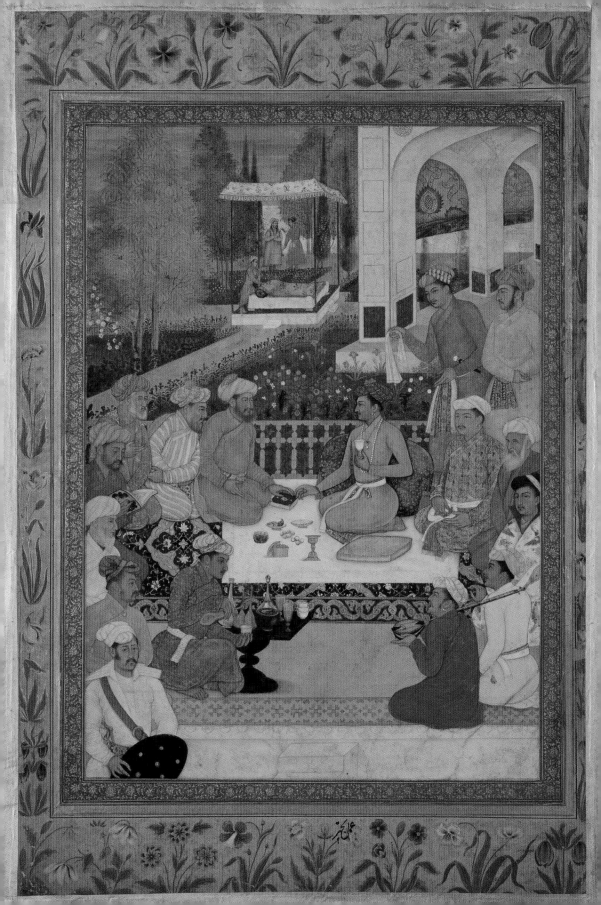

When Father Monserrate arrived in the Mughal court with his fellow Jesuits in 1580, he kept a diary to record some of the details of the exotic world he had entered. He observed the life of the court at close quarters while accompanying Akbar on a major military expedition to Kabul, lived at Fatehpur while the city was still under construction, and travelled to Agra as the tutor of the emperor's son Murad before returning to Goa in 1582. In Fatehpur, near the palace, he saw workshops housing painters and goldsmiths, and men making weapons, carpets, wall-hangings and other textiles.[1] The emperor, he noted, often went there to relax by watching his craftsmen work and sometimes joined in—Abu'l Fazl, the emperor's historiographer, added that Akbar particularly liked working with the armourers, and was an excellent gunmaker.[2] Monserrate visited the bazaar at Fatehpur that extended for more than half a mile and had 'an astonishing quantity of every description of merchandise'. He saw Agra's bazaar, full of precious stones, pearls, gold, silver and articles sent from the remotest parts of Europe.[3] The observant Jesuit marvelled at the 'great numbers of artisans, ironworkers and goldsmiths' in Agra, and saw in Lahore the vast array of arts produced in the city, as well as wares brought by merchants from all over Asia.[4]

Facing page | Plate 119 | PRINCE AND SCHOLARS IN A GARDEN
By Bichitr
c. 1615-20 with borders added during the reign of Shah Jahan
Opaque watercolour and gold on paper Page 39 cm. x 27.2 cm. Painting 27.9 cm. x 20 cm.
Chester Beatty Library, Dublin: In.07A.7

Father Monserrate's observations reveal some of the means by which the court was furnished with luxury goods. The royal workshops carried out direct commissions and Akbar, like Jahangir and Shah Jahan later, constantly encouraged the adoption of new techniques in all departments. Regional centres supplied other commodities which depended on local raw materials or natural resources. Large bazaars similar to those in Fatehpur, Lahore and Agra were found in all the great cities of the empire. Some, like Jahan Ara's tree-lined Chandni Chowk laid out in the new city of Shahjahanabad, were built by members of the royal family, and others by the aristocracy. All yielded substantial rental income for the empire.

Governors brought the specialities of their provinces to court, and fine goods from the rest of the subcontinent arrived with merchants and ambassadors. Chinese silk and porcelain, Iranian, Turkish and European textiles, Portuguese furniture, German metalwork and Venetian glass all found their way to Hindustan across international trade routes. These can often be identified in paintings (Plates 102, 103 and 119). Many were also sold at special bazaars set up in the palace. Akbar established the practice of holding monthly markets for the women of the royal household on what he called 'The Pleasant Day' (*Khush Ruz*) and men had their bazaars in the palace. At both, the emperor set fixed prices for particular goods while examining the strengths and weaknesses of the workshops which supplied them.[5] The Nowruz bazaar was particularly elaborate, providing a scintillating backdrop for the marriages that were often discreetly arranged here.[6]

160

Plate 120| PAIR OF EAR ORNAMENTS
Late 17th century Gold set with rubies
diamonds and emeralds 8.2 cm. x diameter 4.3 cm.
The al-Sabah collection
Kuwait National Museum: LNS 1809 Ja, b

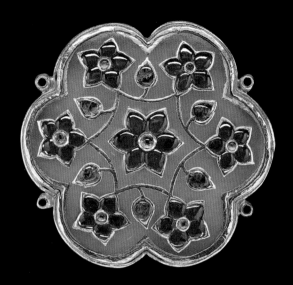

Plate 121 | JEWELLED MOUNT PERHAPS FOR A BELT
Second half of 17th century
Nephrite jade set with
rubies and emeralds in gold
Diameter 4.6 cm.
The al-Sabah collection
Kuwait National Museum: LNS 1186J

Plate 122 | THUMB RING
c. 1650
Nephrite jade set with emeralds and rubies in gold
Diameter 4.1 cm. x 3.2 cm.
Victoria and Albert Museum, London: 02522 (IS)

THE TREASURY OF PRECIOUS STONES

The twelve treasuries which lay at the heart of the efficient administration of the Mughal empire were the foundation of its economic stability. In Abu'l Fazl's survey of court institutions, they came second only to the royal household.[7] The treasury of precious stones was the most important, and its contents were purchased, acquired as plunder from vanquished enemies, or received as tribute. They were expertly examined by the treasurer and his jewellers as soon as they entered the store, and released whenever needed by the emperor or his goldsmiths.

The jewellers divided everything into three groups. The first consisted only of spinels, called in Persian *la'l*, short for *la'l-i Badakhshi*, 'the Badakhshan red [stone]'; the second included diamonds, rubies, sapphires and emeralds; and the third contained pearls. Almost everything came from outside the empire – the spinels were mined in Badakhshan, a province far to the north of Kabul, while most of the diamonds came from Golconda to the south, and the marvellous rubies described in ancient Sanskrit treatises as having the deep crimson colour of 'pigeon's blood' were from Burma.[8] Sri Lanka supplied sapphires and other stones, while emeralds were transported from Colombia across the world to Goa on Portuguese ships, which also brought pearls from the Gulf of Mexico and from the Persian Gulf fisheries.[9] The Portuguese dominated the eastern trade in precious stones in the late sixteenth and early seventeenth centuries because Goa provided complete freedom of trade as well as generous customs facilities. Portuguese jewel merchants regularly brought new treasures to the Mughal court[10] and artists often depicted the royal family examining precious stones (Plate 124).

162

Plate 123 | LIDDED PERFUME (*ARGCHA*) VESSEL
c. 1650-1700
Gold set with emeralds and diamonds, with champlevé enamel
9.1 cm. The State Hermitage, St Petersburg: V3-726
Sent to Russia from Iran by Nadir Shah's embassy in 1741

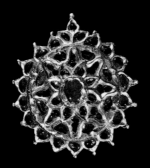

Plate 124 | SHAH JAHAN AND HIS SONS DARA SHOKUH AND
MURAD BAKSH (detail of Plate 109)

Plate 125 | EAR ORNAMENT
Mughal (or Deccan sultanates) late 17th century
Diamonds, rubies and emeralds set in gold
4.3 cm. x 3.9 cm.
The al-Sabah collection, Kuwait National Museum: LNS 290 J

Spinels were assessed according to the beauty of their deep, carmine red colour as also their size, lustre and transparency. They were by far the most valuable – 'first class' spinels were worth not less than 1000 *mohurs* (a Mughal gold coin not in general circulation, but used within court circles), compared with a minimum of 30 *mohurs* for all other stones deemed to be the best of their kind.[11] In placing such a high value on spinels, the Mughals followed Iranian convention rather than the Sanskrit gemmological traditions of most of the subcontinent. In these traditions, particular stones represented the planets of the Indian solar system, and complicated astrological considerations were involved when the jeweller placed them in a single auspicious setting in rings, pendants and other ornaments.[12]

In Iranian culture the spinel, like other precious stones, had its own very different but equally complex symbolism. It was seen primarily as a metaphor of sunlight, which was itself a metaphor of the divine in metaphysics, and of the sublime in art.[13] Persian poetry from its earliest beginnings demonstrates that spinels were closely associated with royal attire and were set into crowns and court regalia. Their place of origin is also frequently mentioned in verses that might suggest, for instance, a garden full of red anemones appeared to be jewelled with the spinels of Badakhshan.[14]

The finest stones owned by the Mughals were engraved with the emperor's titles, as they were at other courts under Iranian influence, and were often exchanged on occasions of outstanding importance. Akbar's specialist gem engraver Mawlana Ibrahim, whose family came from Yazd, inscribed them *la'l-i jalali* in a play on words deriving from the emperor's array of names, 'Jalal ad-Din Muhammad Akbar'. This can be understood both as 'spinel of Jalal' or 'glorious spinel'.[15] The emotional and dynastic value of each stone augmented with each change in ownership, as shown by a jewel originally given by Hamida Banu to Akbar on the birth of his first son. Jahangir notes in his memoirs that Akbar had worn the spinel for many years as a turban ornament and when he inherited it, he too wore it in his turban. When Shah Jahan returned to the court in 1617 after a military campaign in the Deccan, Jahangir rewarded him with the spinel not simply because of its beauty and its very high value (125,000 rupees) but because its history made it particularly auspicious and precious. An illustration in the *Padshah Nama* (Plate 118) may depict this occasion, though it was not the only large spinel given to Shah Jahan by Jahangir.

Jahangir, perhaps more than any other emperor, sought out spinels of great rarity that he wore in armlets and necklaces, or set in turban jewels. Shortly after 1615, his treasury received a spectacular addition. An envoy had taken a letter from Jahangir to Shah 'Abbas requesting spinels that had been donated to the shrine of Imam 'Ali, the cousin and son-in-law of the Prophet Muhammad, at Najaf, then within the Safavid empire. The religious authorities agreed to release them, including one engraved with a Timurid inscription, and they were despatched in a box of European manufacture to the delighted Jahangir.[16] The same envoy brought five more stones that Shah 'Abbas had intended to donate to the shrine of Imam Reza at Mashhad, but sent instead to the emperor.[17]

164

Facing page | Plate 126 | SHAH JAHAN AND
THE PROPHET KHIZR
c. 1640
Page from the St Petersburg album
Opaque watercolour and gold on paper
St Petersburg Branch of the Institute of Oriental Studies
Russian Academy of Sciences: E.14 folio 18 recto

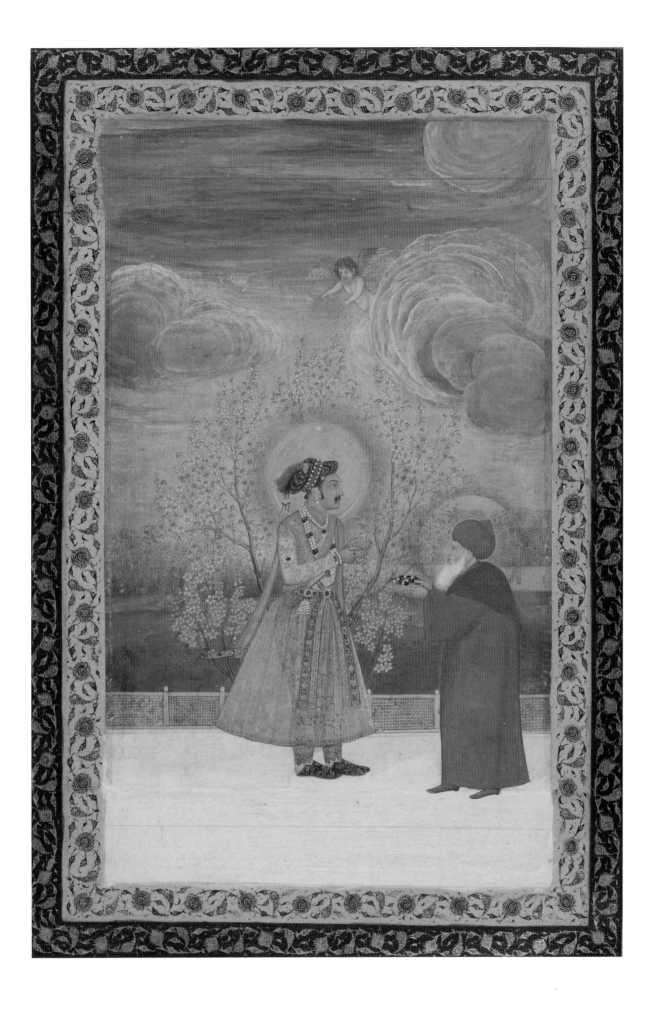

All these came to Shah Jahan on his accession and their provenance is perhaps alluded to in an allegorical painting in which a holy man bestows on him a royal rosary of spinels and large pearls (Plate 126), following a general theme in which similar figures are depicted presenting the emperor with different attributes of kingship or symbols of world rule. Shah Jahan himself is portrayed handing a royal spinel to his son and chosen successor, Dara Shokuh (Plate 24).

The most important spinel ever to enter the treasury was also connected with the Timurid ancestors of the Mughals. In 1621, Shah 'Abbas sent Jahangir a turban jewel (kalaki) set with a very large spinel engraved with the shah's name and the name and title of Timur's grandson, Ulugh Beg. This is almost certainly shown in a small portrait of Jahangir holding a turban aigrette of Iranian form which is very different from the Mughal jewels seen in contemporary paintings of the emperor and his sons (Plate 128). Within days of the arrival

of the spinel in 1621, Jahangir's best engraver, Sa'ida, was ordered to inscribe on it the emperor's title and the date. Very shortly afterwards, news arrived of Shah Jahan's victory over Malik 'Ambar of Ahmadnagar, a long-standing adversary of the Mughals whom Jahangir hated with passion, and the dynastic treasure was despatched to the prince. The stone in its intact state, though with two additional inscriptions recording its ownership by later rulers, suddenly reappeared in 2001 following its acquisition by Sheikh Nasser and Sheikha Hussah al-Sabah of Kuwait (Plate 127).[18]

Most of the diamonds in the second group of precious stones in the treasury came from the renowned Golconda mines, the major source in the world until the discovery of Brazilian diamonds in the early eighteenth century. Large diamonds were cut and polished so as to retain the maximum possible weight. The symmetry preferred in the West, which involves considerable wastage, was sacrificed by the Mughal

166

Plate 127| ROYAL SPINEL
Engraved with the titles of Ulugh Beg (before 1449 AD),
Shah 'Abbas of Iran (AH 1026 /1617 AD), Jahangir (AH 1030/1621 AD),
Shah Jahan (undated), 'Alamgir (AH 1070/1659-60 AD)
and Ahmad Shah Durrani (AH 1168 /1754-55 AD)
249.3 carats 4.8 cm. x 3.6 cm. x 1.8 cm.
The al-Sabah collection, Kuwait National Museum: LNS 1660 J

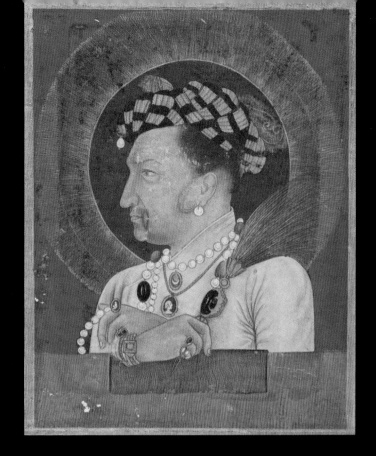

Plate 128 | JAHANGIR HOLDING A TURBAN JEWEL
c. 1625
Detail of a page from the St Petersburg album
Opaque watercolour, gold and silver on paper
5.8 cm. x 4.3 cm.
St Petersburg Branch of the Institute of Oriental Studies,
Russian Academy of Sciences: E.14 folio 4 recto

craftsmen. Exceptional skill was required in the Mughal atelier to cut diamonds, the hardest of all gems, in order to produce an extremely complex network of facets over the irregular shape, while at the same time bringing out the surface lustre and unique characteristics of each stone (Plates 129 and 130). This mastery can rarely be observed because loose stones were almost always re-cut if they reached the West, and those set into vessels and jewellery and preserved in museums are difficult to examine closely enough to appreciate them.

Diamonds in their natural octahedral form, such as the large stone set in the knop of a spoon probably made during Akbar's reign, were often left almost untouched (Plate 131). Very small crystals, like those in the rim of the bowl of the spoon, might be used to emphasise the outlines of objects and are almost invisible until they catch the light and suddenly sparkle. Other diamonds were split across their cleavage planes to produce flat slivers, and the thicker pieces might be chamfered at the edges to increase their lustre. The French jewel merchant Jean-Baptiste Tavernier, who visited India six times between 1631 and 1665, watched the diamond cutters at the Golconda mines and remarked: 'if the stone is clean they do not do more than just touch it with the wheel above and below, and do not venture to give it any form, for fear of reducing the weight. But if it has a small flaw, or any spots, or small black or red grit, they cover the whole of the stone with facettes in order that its defects may not be seen'.[19] Tavernier noted their great skill, adding that if a stone had 'a kind of knot, such as is seen in wood, the Indian diamond-cutters would not hesitate to cut such a stone, although our diamond-cutters in Europe would experience great difficulty in doing so, and as a general rule would be unwilling to undertake it', referring to what gemmologists call areas of 'differential hardness'.[20]

A small source of diamonds, however, was within the Mughal empire.[21] In 1618, Jahangir mentions that diamonds sent by the governor of Bengal from the Gogra mine, in a recently conquered part of Bihar, had been given to the court lapidaries for cutting.[22] One was engraved with the emperor's name, which was in itself a remarkable feat, but its most outstanding feature was its colour, which Jahangir describes as being like sapphire. Although nothing like it had ever been seen at court, the emperor's jewellers valued the blue diamond at only 3,000 rupees, but Jahangir adds that it would have been worth 20,000 rupees if clear and flawless.

The colour is still extraordinarily rare, but is found in the Wittelsbach diamond (Plate 133). Named after the ruling house of Bavaria which owned it in the eighteenth century, it can be traced with certainty to 1664, when Philip IV of Spain gave it to his young daughter, the Infanta Margareta Teresa, on her betrothal to the Emperor Leopold I of Austria.[23] It must therefore have come from India, though the precise source has yet to be determined. If it came from the Bihar mine, it would have been sent to the emperor who had first claim on any significant stone found, or traded, in his domains. The sophistication of its original cut allows the colour to change from pale to steel grey and through a range of greyish blue tones to deepest midnight blue depending on the direction of the light. It was recut after its sale in London in 2009 to eliminate minor chips to the edges, which reduced the weight from 35.56 carats to 31.06. This altered a stone that may have been cut at the Mughal court and represented a major landmark in the world history of diamond cutting.[24]

The other stones in this group, emeralds or the red and blue *yaqut* (meaning ruby and sapphire, both varieties of corundum) were also frequently exchanged at court. Any obvious imperfections were removed, and the stones were polished but not usually facetted. Large Colombian emeralds of intense deep green colour were highly valued at court. The natural hexagonal crystal was cut across to produce several flat stones, and the surface was then sometimes elaborately decorated by the emperor's gem-cutters (Plate 134).

Pearls were placed in the last category in the treasury. Single pearls might be presented to mark the birth

Plate 129| DIAMOND
Cut in the Deccan or at the Mughal court
17th century 24.8 carats 2 cm. x 1.6 cm.
The al-Sabah collection, Kuwait National Museum: LNS 2223 J

Plate 130| DIAMOND PENDANT (*TAWIZ*)
Cut in the Deccan or at the Mughal court
17th century or earlier 56.7 carats 3.3 cm. x 4.6 cm.
The al-Sabah collection, Kuwait National Museum: LNS 2156 J

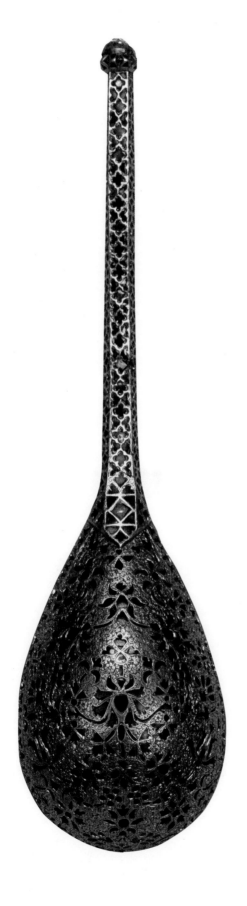

of children or at weddings, and paintings show that necklaces of very large pearls strung with rubies (or spinels) and emeralds were emblems of royalty worn, like turban jewels, only by the emperor and his sons. Jahangir pierced his ears in 1614 as a gesture of devotion to the great Sufi, Shaykh Salim Chishti, at whose tomb he had prayed for recovery during a serious illness, and put on pearl earrings.[25] He gave pearls from the treasury to everyone in his innermost circle to be worn in the same way, instantly setting a new fashion at court. Smaller pearls embellished jewellery, royal parasols and throne canopies, textiles and clothing. If depictions of women are to be relied upon, pearl necklaces, bracelets and earrings were worn in profusion and pearls provided a delicate weight to the borders of their fine muslin clothes (Plate 111). Specialists were employed in the treasury to bore the holes that allowed the pearls to be mounted in jewellery (Plate 120), strung on silk for necklaces or sewn on cloth.

170

Plate 131 | CEREMONIAL SPOON
c. 1600, Gold, chased and set with rubies
emeralds and diamonds 18.6 cm.
Victoria and Albert Museum, London: IM.173-1910

Plate 132 | SHAH JAHAN'S THUMBRING
c. 1628-58, Gold, set with diamonds
rubies and emeralds Length 4 cm.
Sent to Russia from Iran by Nadir Shah's
embassy in 1741
The State Hermitage, St Petersburg: V3-703

Plate 133 | THE 'WITTELSBACH' BLUE DIAMOND
Perhaps cut at the Mughal court during the reign of Jahangir or Shah Jahan
Weight: 35.56 carats
Sold at Christie's, 2009; since recut at the edges
reduced in weight to 31.06 carats
and renamed 'The Graff Wittelsbach diamond'

Plate 134 | CARVED HEXAGONAL EMERALD
c. 1590-1600 233.5 carats 5 cm. x 5.7 cm.
The al-Sabah collection, Kuwait National Museum: LNS 28 HS
Missing as a consequence of the Iraqi invasion of Kuwait in August 1990

Jewelled regalia and other symbols of power played a central role in Mughal court life, in keeping with the Iranian tradition that influenced it. The artisans who made them were singled out by Abu'l Fazl in his survey of the institutions of the royal household. A section of the *A'in-i Akbari* entitled, 'The workmen in encrusted wares' (*karpardazan-i morassa'-kar*)[26] listed those who made artefacts in plain gold or silver, and enamellers and inlayers as well as gem-setters. Jewelled objects are mentioned almost from the beginning of Mughal rule, but when the wealth of the empire grew, their importance increased. Under Jahangir and Shah Jahan they became extravagantly opulent.[27]

172

An English merchant provides precise details of the treasury in the early seventeenth century, corroborating the broad outline of its contents given by Abu'l Fazl in the 1590s.[28] William Hawkins arrived at Agra in 1609, where his knowledge of eastern languages allowed him to talk to the emperor without an interpreter and to befriend Nur Jahan's brother, Asaf Khan. He was given a stipend, married a Christian Armenian and lived at court until 1611. He mentions Jahangir's treasury of gold and silver coin, and another in which were kept diamonds and 'ballace rubies', meaning spinels ('ballace', or 'balas', is the altered form of Badakhshan). Of these alone, he remarked, there were two thousand, 'little and great, good and bad'. A third treasury contained 'the jewels wrought in gold', including jewelled hilts, hawking drums and a thousand saddles, as well as two thousand turban jewels and all kinds of gold and silver plates, including basins, cups and beakers (Plate 135). The emperor had 20 'kittasoles of state', using the Portuguese word 'quitasol', or sunshade, which may indicate that the inventory

originally came from the Jesuits. Hawkins adds that no one else in the empire would dare use this emblem of royalty.[29] There were five 'chaires of estate', two of gold and three silver, and 105 other chairs in gold and silver. There were over 100 wine 'vases', set with jewels and 500 wine cups, of which 50 were made from a single piece of ruby, emerald or other precious stone (Plate 136). The Englishman concludes that the emperor had so many necklaces of pearls and precious stones, and rings set with rubies, emeralds, diamonds or spinels, that only the treasurer knew exactly how many there were.

Father Monserrate had particularly noticed the gold ornaments and pearls worn by Akbar, but contemporary paintings suggest that his style was relatively restrained.[30] When foreign visitors saw Jahangir's wealth, they were astounded. Jacques de Coutre, a Flemish gem-cutter and jewel merchant, went from Goa to Agra in 1619 to chase a debt for pearls and precious stones. The merchant scrutinised the emperor with a professional's trained eye. Jahangir, he wrote, was covered with so many precious stones from all over the world that he looked 'like an idol', and had more jewels than all the monarchs of Europe put together.[31] Sir Thomas Roe's letters to the English East India Company reported Jahangir's insatiable appetite for precious stones and advised that jewels were the only things that they could be sure of selling at court.[32] His description of the emperor's resplendent appearance at the 1617 birthday weighing ceremony bears out his words.[33] The gold scales were set up in a garden, and Roe saw Jahangir 'clothed' in diamonds, rubies and pearls, with jewellery on his head, neck, breast, arms above the elbow and on the wrist, and one or two rings on every finger. The bedazzled ambassador describes rubies

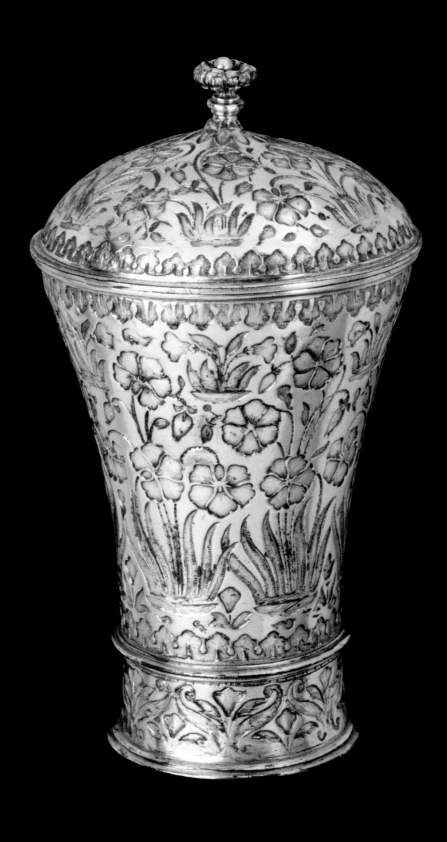

Plate 135 | BEAKER
Reign of Shah Jahan
Silver, chased and engraved
14.2 cm. x 8.3 cm.
Victoria and Albert Museum, London: IS.31-1961

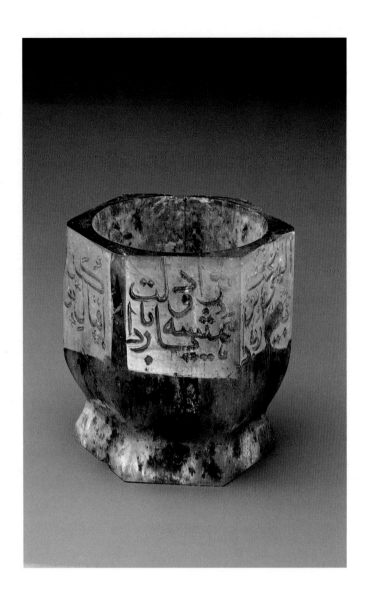

Plate 136 | CUP
Iran, 16th century (?)
Carved from a single emerald, inscribed with Persian verses
4.1 cm. x 4.3 cm. Weight 252 carats
The al-Sabah collection, Kuwait National Museum LNS 22 HS

Facing page | Plate 137 | DAGGER AND SCABBARD
Mughal, c. 1615-20
Hilt and scabbard gold, set with rubies, emeralds, diamonds,
glass, agate and ivory, blade steel overlaid with gold
Dagger 33.3 x 11.7 cm.
The al-Sabah collection, Kuwait National Museum: LNS 25 J

the size of walnuts and 'pearles such as mine eyes were amazed at'. The emperor's sword, shield and the throne nearby were similarly jewelled, and Roe later refers to the court as 'the treasury of the world'. This magnificence is reflected in contemporary portraits in which the details of jewellery and jewelled weapons are so clear that rare surviving artefacts can be compared closely with them.

One of Jahangir's daggers must have been made by his greatest goldsmiths and jewellers. Rubies, emeralds and diamonds are shaped with great precision to fit the rosettes, birds and blossoms cut out of the gold, and set so that they precisely follow the contours of the weapon (Plate 137). The larger rubies are placed at the centre of the rosettes and their petals, while most of the other stones are cut into small, flat slivers, except for the rows of small, natural diamond crystals in the edges of the hilt and scabbard. Similar daggers are depicted in portraits of Jahangir and Shah Jahan as a prince (Plate 107), strongly suggesting that the Kuwait dagger is a royal commission executed sometime between 1615 and 1620. A mount for a scabbard is of similar date (Plate 138). Here, a large diamond-set blossom is enclosed by ruby and emerald flowers on sinuous stems inlaid into a gold ground chased with minute flower heads. The stones are cut with such mastery that they have the fluidity of lines painted on a page, and the motifs closely resemble those on the golden grounds of contemporary manuscript illumination. A thumb ring with chased ornamentation on the gold surface was probably also made in the royal workshops at the same time (Plate 139).

The goldsmiths used highly refined gold called 'kundan' to set their stones. The purity and, consequently, the softness of the gold means that a molecular bond can be formed simply by applying pressure with tools. The stones can thus be secured without needing the relatively clumsy collets or claws of Western jewellery.[34] The technique, unique to the Indian subcontinent, was adopted at the Mughal court for all the jewelled artefacts made in the royal workshops, making it

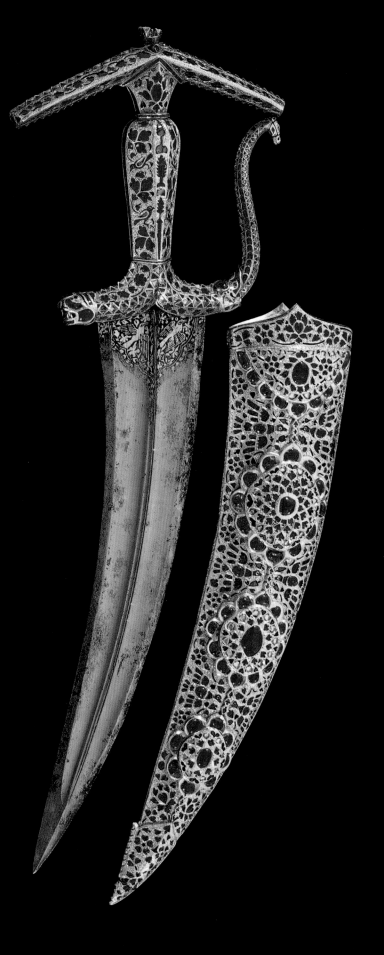

very likely that most of the goldsmiths, like the artists of the *Kitab Khana*, were indigenous craftsmen.

Royal weapons were the most common of jewelled insignia of power, and were frequently bestowed on favoured individuals.[35] A page from one of Shah Jahan's albums depicts some of them. Rustam Khan (Plate 140) came to the Mughal court from Ahmadnagar in the Deccan in 1630 and became an outstanding military commander. Shah Jahan rewarded his gallantry during the 1649 conquest of Qandahar with a superb robe of honour, a dagger and sword studded with gems from the royal storehouse, and a turban jewel. The portrait by Hunhar may record the occasion because Shah Jahan's note on the green background mentions the honorific title he gave Rustam Khan at the time. The general's weapons are extremely opulent. His dagger has an enormous facetted diamond in the pommel, and the hilt of the Mughal-style sword hanging from his belt is set with a large facetted emerald.[36] Small scenes in the borders illustrate the preliminary stages in the making of weapons for the court. At lower left, a man shows a clerk swords

and daggers of different forms with jewelled, enamelled or plain hilts. The clerk's status as a royal servant is suggested by his golden pen-case and his opulent earring set with two large pearls separated by a ruby, the form popularised by Jahangir and worn for decades afterwards. In the upper border, jewellers examine pearls and other stones taken out of a small wooden chest of the kind also used to store small jewelled items, including daggers.[37]

Not all jewelled artefacts were made in the palace workshops. When Shah Jahan was a prince he often lived away from the court and must have had his own craftsmen attached to the household. When he came to Fatehpur for Nowruz in 1619, Jahangir wrote that the prince gave him 'the precious things of the age, and rarities and curiosities of every country', including a huge spinel worth 40,000 rupees and six pearls together worth 33,000 rupees which had been bought in Gujarat by Shah Jahan's agents. The gifts, Jahangir recorded, also included 'a sword hilt made in my son's own goldsmith's shop. Most of the jewels had been cut to fit, and my son had paid attention to the minutest detail … it was worth 50,000 rupees'.[38]

Plate 138 | LOCKET FROM THE SCABBARD OF A DAGGER
c. 1615-20 Gold, engraved and set with diamonds, rubies and emeralds
Mughal (or Deccan sultanates), late 17th century
Diamonds, rubies and emeralds set in gold
4.3 cm. x 3.9 cm.
The al-Sabah collection, Kuwait National Museum: LNS XIX SH

Plate 139 | THUMB RING
c. 1620
Gold, set with rubies and emeralds, enamelled on the inside
3.7 cm. x Diameter 3 cm.
Victoria and Albert Museum, London: IM.207-1920
The enamelling on the inside is European in style

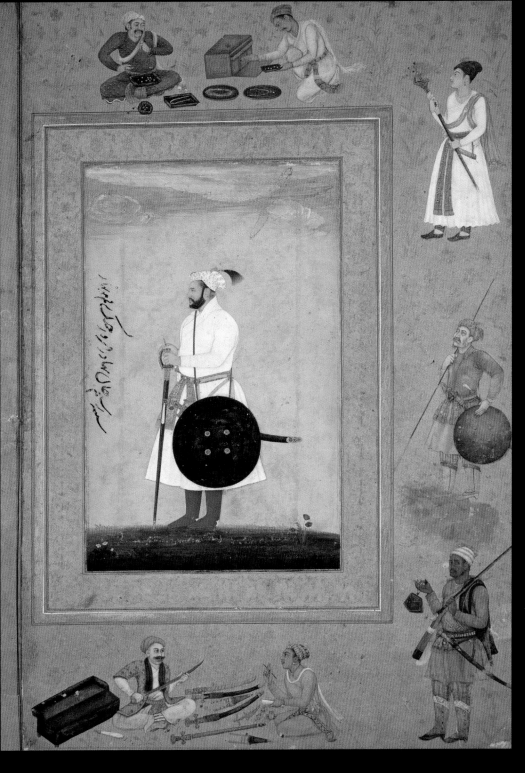

177

Plate 140 | PORTRAIT OF RUSTAM KHAN (D. 1658)
By Hunhar, c. 1650
Page from the 'Late Shah Jahan Album'
Opaque watercolour and gold on paper
Page 38 cm. x 26.6 cm. Painting 20.6 cm. x 13 cm.
Chester Beatty Library, Dublin: In 07B.35

THE TRADITIONS OF HINDUSTAN

In 1618, Jahangir and Nur Jahan visited Ahmadabad, capital of the Mughal province, or *subah,* of Gujarat. The city had long been famous for the unusual range and quality of its arts. In his detailed survey of the empire, Abu'l Fazl mentions its countless painters, seal engravers and other artisans, including the weavers who made sumptuous velvet and brocades and imitated the finest foreign cloth.[39] There was a lively trade in jewellery. Excellent swords and daggers were produced there. Its characteristic wooden boxes, inkstands, and other items covered in mother-of-pearl set into black composition, were collected by the Mughals and by foreign merchants who landed at Surat and went on to Ahmadabad (Plate 141). Agate vessels had been made in the Gujarati city of Cambay for centuries, and when the German traveller Johann Albrecht von Mandelslo arrived in the province in 1638 he described a thriving industry still producing agate, garnet and other hardstone vessels.[40] Cambay was also one of the several centres in western India where ivory-inlaid furniture was made. Local wares such as these were brought to Jahangir's palace for the regular market, which took place at night for the first time. The emperor bought quantities of jewelled artefacts and precious stones from shops that were brilliantly illuminated by lanterns, concluding that the event had been exceptionally splendid.[41]

Despite their extreme fragility, some sixteenth- and seventeenth-century Gujarati mother-of-pearl wares have survived. They share common designs, and their connection with the province is beyond doubt. Early in Jahangir's reign, a complete canopy studded with typical mother-of-pearl motifs was sent from Gujarat by its governor to be installed over the cenotaph of Shaykh Nizam al-Din Awliya at

Delhi. Wooden pillars in similar style remain in tombs near Ahmadabad, though their canopies have disappeared.[42] An exceptional signed and dated pen box was perhaps created for an aristocratic patron (Plate 143). Its intricate decoration combines Persian verses and geometrical designs drawn from the common stock of patterns, but also includes small figures whose distinctive faces are similar to those illustrated in contemporary manuscripts from western India, though unlike anything in Mughal art. Gujarat also produced small objects made entirely of mother-of-pearl, or of wood completely covered by these silvery shells with their tones of palest pink and green (Plate 144).

Abu'l Fazl mentions that Ahmadabad's woodworkers were also adept at making painted furniture. Edward Terry, Sir Thomas Roe's chaplain, elaborates on the historian's characteristically terse description. He notes that the artisans covered their wooden cabinets and bedsteads with 'a thick gum, then put their paint on, most artificially made of liquid silver, or gold, or other lively colours … and after make it much more beautiful with a very clear varnish put upon it'.[43] Terry also saw ivory-inlaid cabinets made in the province. Their high quality, and their decoration which includes the standard themes of princely entertainments and royal hunts, would have appealed to the Mughal court (Plates 142 and 145).

Gujarat was exceptional for the range of its *de luxe* products, but every province of the empire had its own specialities. Weapons were made in a number of centres which remained important until the nineteenth century. Lahore, for instance produced swords, daggers and armour of watered steel.[44] As in most craft production, different

178

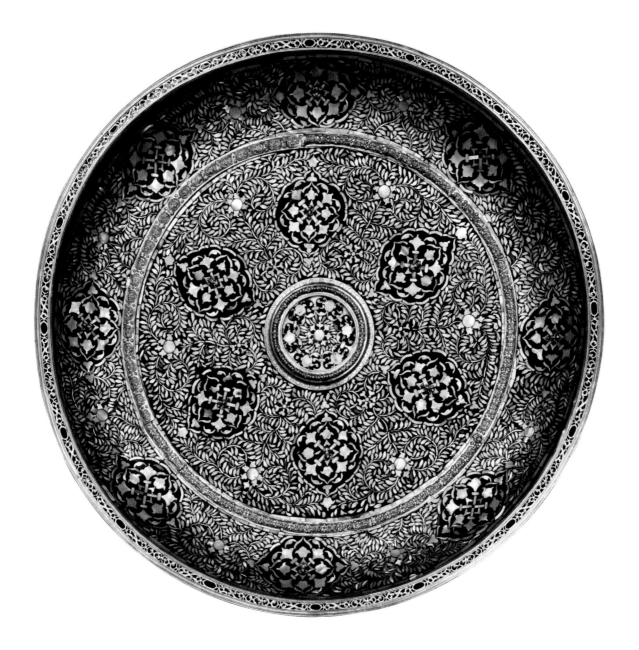

Plate 141 | BASIN
Gujarat, 16th century; the mounts by Elias Geyer, Leipzig c. 1600
Mother-of-pearl inlaid into lac over wood with gilt silver mounts
Diameter 60.1 cm.
Staatliche Kunstsammlungen Dresden, Grünes Gewolbe: IV.287

180

Plate 142 | CABINET
Gujarat or Sind, early 17th century
Wood inlaid with ivory
73.5 cm. x 65 cm.
Victoria and Albert Museum, London: IM.16-1931
Given by Mrs Beachcroft

practitioners would have been responsible for each stage in the manufacture which included forging, chiselling patterns into the steel, and applying gold decoration or gold-inlaid inscriptions recording the name of the owner. Other specialists, not necessarily in the same place, would make hilts of jewelled gold, ivory, and jade. Royal weapons such as the sword made for Dara Shokuh usually had gold-inlaid Persian verses naming the owner, and the date of completion (Plate 147). Others can be approximately dated by their decoration. The figures chiselled into the finely-watered steel blade of a

Plate 143 | PEN BOX
By Shaykh Muhammad
Gujarat, dated AH 995/1586-7 AD
Teak overlaid with mother-of-pearl on black lac,
the inside coated with red lac
8.7 cm. x 36.2 cm.
Freer Gallery of Art, Washington, D.C.: F.1986.58 a-c

dagger wear turbans of the kind seen in book painting of the late sixteenth century (Plate 147).[45]

The men who made weapons at court are mostly anonymous. Exceptions include Jahangir's master ivory carvers, Puran and Kalyan, who were entrusted with a rare piece of material (possibly fossil ivory from Siberia), which Shah Jahan gave his father in 1619. The hilts they made from it pleased Jahangir so much that he rewarded Puran with the extremely valuable present of an elephant, a robe of honour and a gold bracelet, and Kalyan with the honorific title *Aja'ib dast,* or 'astounding hand', a promotion and a bracelet inlaid with jewels.[46] These lavish presents suggest that the best craftsmen, like the best artists, enjoyed considerable wealth, in contrast to most of the artisans in the empire who are described in all three reigns as living in abject poverty.[47] The men who made the blades and scabbards for these special hilts are simply described by Jahangir as 'unique in the age' for

182

Plate 144 | BASIN
Gujarat, early 17th century; mounts London 1621-2
Mother-of-pearl with gilt silver mounts
8.5 cm. x 24 cm.
Victoria and Albert Museum, London: M.17-1968
Bequeathed by Mrs Hannah Gubbay

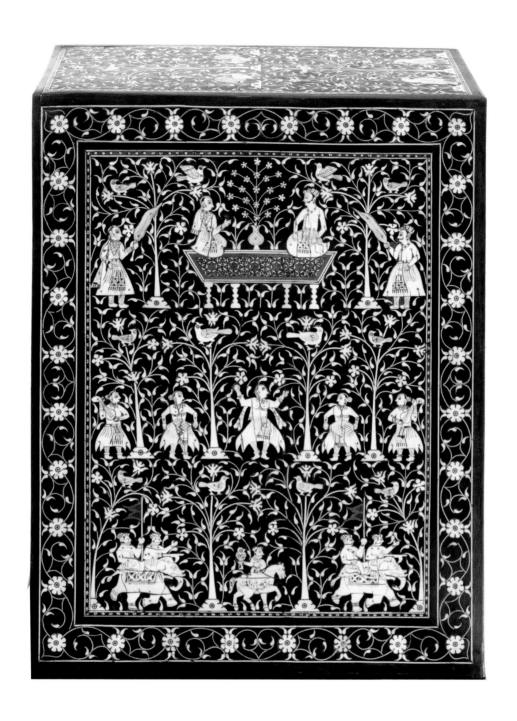

183

Plate 145 | CABINET (DETAIL OF TOP)
Gujarat or Sind, c. 1675-1700
Wood inlaid with ivory, 130 cm. x 64 cm.
Victoria and Albert Museum, London: IS.44-1972

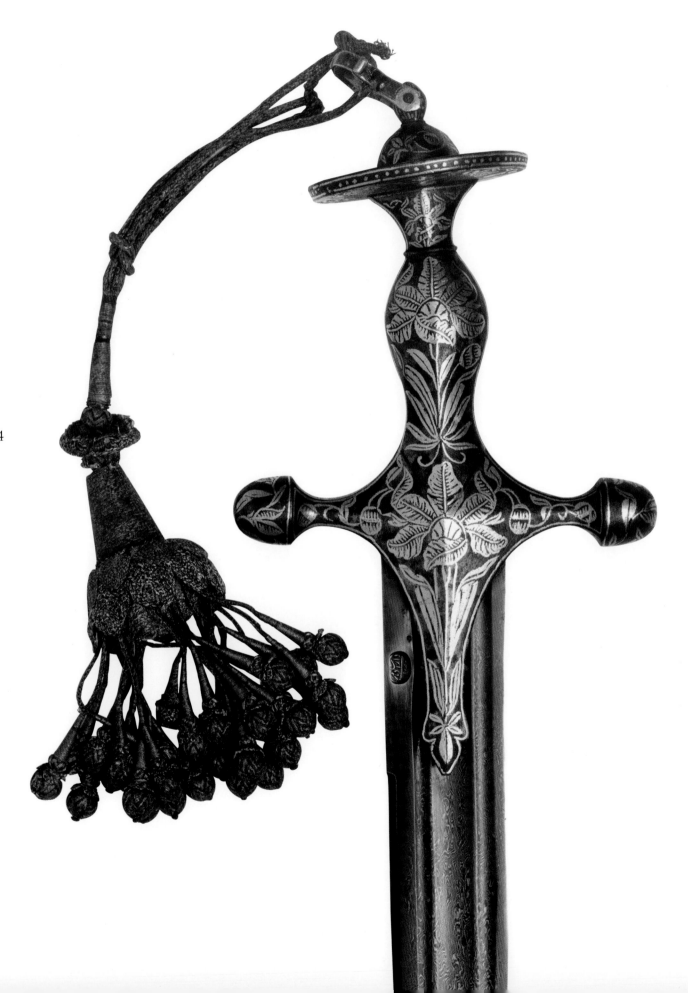

184

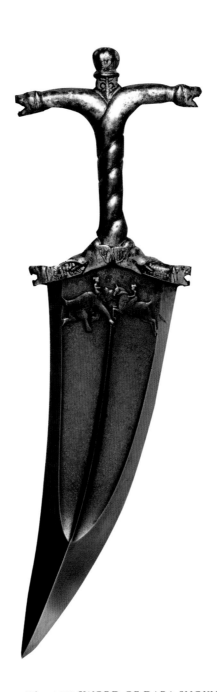

Facing page | Plate 146 | SWORD OF DARA SHOKUH
Dated AH 1050 / 1640-1 AD
Watered steel with gold overlaid decoration, the scabbard with enamelled gold mounts
91 cm. Victoria and Albert Museum, London: IS.214-1964
Given by the Right Hon. the Earl Kitchener of Khartoum
The back of the blade has a gold-inlaid inscription stating that the sword belonged to Dara
Shokuh, and a slightly damaged date that is probably AH 1050.

Plate 147 | DAGGER
c. 1590, Watered steel with gold overlaid decoration
31 cm. Victoria and Albert Museum, London: IS.86-1981

their skills, without any further details. However, two years later, Ustad Da'ud is named as one of the royal swordsmiths. A meteorite had fallen noisily and dramatically to earth in Jalandhar and Da'ud made two swords and a dagger by adding iron to the meteoritic material. The sword blades were apparently as sharp as steel and Jahangir added these unique weapons to his personal collection. He gave each of them a name, as was the Mughal custom – 'Lightning Nature' (*barqsirisht*) and 'Trenchant Sword' (*shamshir-i qati'*). The event was celebrated in verse by Sa'ida, the multi-talented Iranian who supervised the goldsmiths' department.[48]

Metal wares of great sophistication were made all over the subcontinent in a range of alloys and techniques. Craftsmen from all over Hindustan, and from Iran where outstanding metalwork was created in a vast range of types, would have found ready employment at the Mughal court. Two vessels demonstrate that their different traditions came together in all the arts of the court, just as they did in painting and architecture. In the first, the form and alloy are typically Hindustani, while the engraved decoration is Safavid. Its superb calligraphy, almost unseen on the inside, was in all likelihood done by one of Akbar's Iranian masters

Plate 148 | WATER VESSEL
c. 1600, Cast brass, engraved and filled with black composition
12.3 cm. x 15.4 cm., Victoria and Albert Museum, London: IS.21-1889
The exterior is engraved with invocations to the *Panj Ahl-e Beyt*, or
'Five Members of the House' of the Prophet; the interior is
engraved with Koranic verses

(Plate 148). The second, a wine bowl of typical Safavid shape, was made in Hindustan. Its pictorial decoration of a hunting scene populated by figures in both Iranian and in Mughal dress includes a spritely elephant with a howdah carrying what seems to be a royal cheetah (Plate 149).[49]

Glass was made long before the arrival of the Mughals, but was probably never a significant industry in Hindustan. Abu'l Fazl records that in Akbar's reign it was produced at Alwar, and mentions in passing that Bihar produced gilded glass. However, nothing earlier than the eighteenth century has so far been identified (Plate 150).[50] The court preferred the pure transparency of Venetian glass, particularly during the reigns of Jahangir and Shah Jahan when the trade is often mentioned in contemporary sources. Paintings of the period include characteristic Venetian forms such as the fluted glasses in a scene of a princely entertainment (Plate 119), and a wine glass with blue handles next to another princely figure sitting in a European-style chair (Plate 151). Glass was also imported from Iran but is difficult to identify in paintings because of the lack of information concerning its production.

Glazed tiles were produced in the empire, continuing a well-established tradition which also pre-dated Babur's invasion but was not indigenous. Tiles were a distinctive feature of Mughal architecture in the imperial cities and

Plate 149 | WINE BOWL
c. 1620-40, Copper, formerly tinned,
chased and with black composition
15.5 cm. x 34.5 cm.
CSMVS, Mumbai (formerly Prince of Wales Museum): 56.61

187

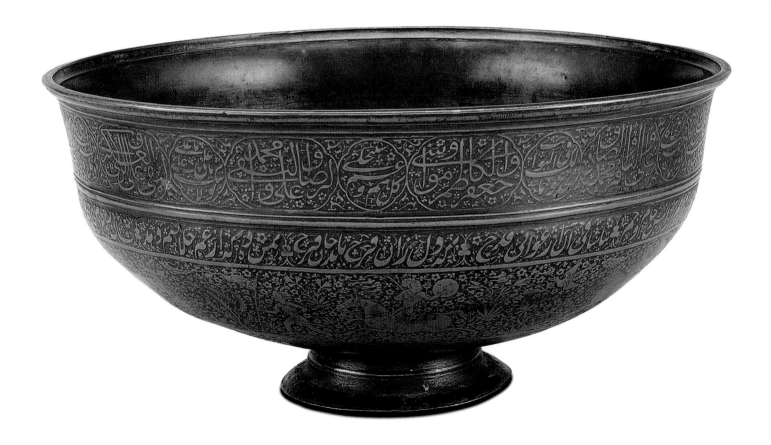

188

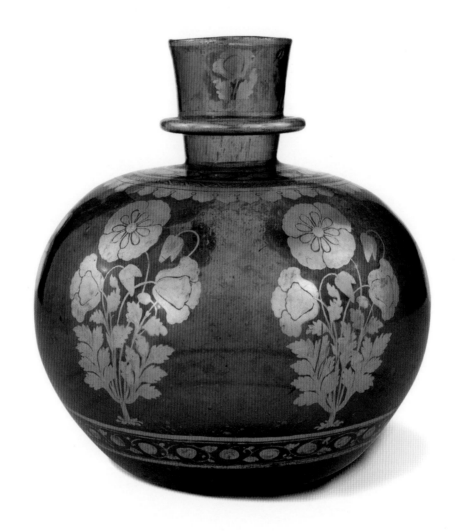

Plate 150| HUQQA BASE
c. 1700 Green glass with gilt decoration
19 cm. x 18 cm.
British Museum, London:1961.10-16.1
Bequeathed by Louis C.G. Clarke

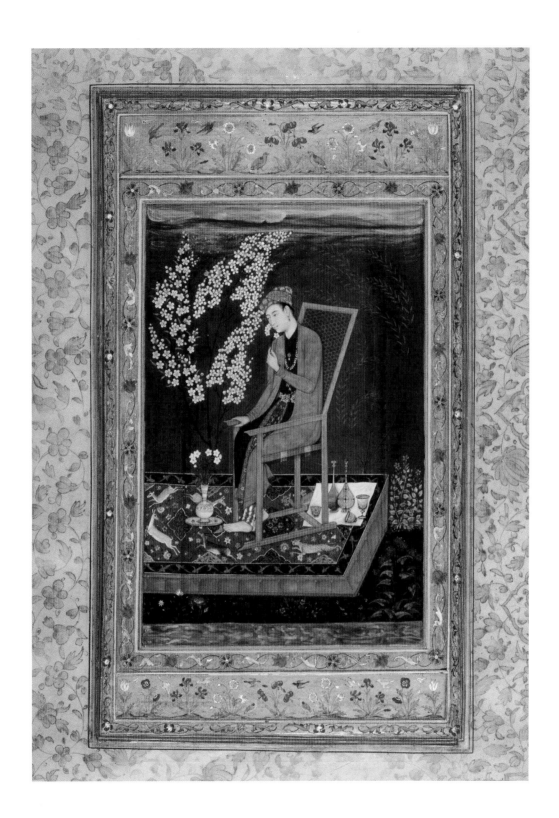

189

Plate 151 | A PRINCE IN A GARDEN
c. 1620-30, extended and borders added c. 1650
Opaque watercolour and gold on paper
Page 38.520-30, extended at the sides at a later date
38.5 cm. x 25.5 cm. Painting 17.2 cm. x 11.5 cm.
Bodleian Library, Oxford: Bod.Ms.Douce Or a.1 f. 45 b

the caravansarais along the major routes in the north.[51] Some fragments of monochrome tiles remain on Akbar's monuments at Fatehpur, and pictorial tile mosaics on the brick walls of Lahore fort depicting many different subjects are believed to date from Jahangir's reign (Plate 15). They include a pair of fighting camels inspired by a painting done by the great Iranian master, Behzad, which had been acquired by Akbar (Plate 152). It had been copied by 'Abd us-Samad, and Jahangir's artist Nanha made his own copy which was preserved in the Gulshan album next to Behzad's original.[52] It also appears in a carpet of about 1620, raising intriguing questions that cannot be answered with any certainty about the role played by the artists of the *Kitab Khana* in supplying designs for use in other media.[53]

Other tiles, including a rare example that may date from Jahangir's reign (Plate 154), and most of those decorating monuments constructed during Shah Jahan's reign (Plate 155), were produced using a different technique. They all have polychrome painted designs, the colours of which are prevented from running into each other by the application of a dry line (*cuerda seca*) of manganese mixed with a greasy substance which evaporates on firing, leaving a fine dark outline to each colour. Pre-Mughal monuments in Panjab are decorated with glazed tiles, and tiles probably continued to be made under Mughal rule in cities of the province such as Multan. The adoption of the *cuerda seca* technique prevalent in Safavid Iran makes it likely that Iranian specialists were involved.

Another architectural embellishment of Shah Jahan's reign demonstrates the constant ability of Mughal craftsmen to copy foreign techniques. The men who began to use the technique perfected in Florence of inlaying into marble small pieces of semi-precious stones (*pietra dura*) may conceivably have been taught by a European lapidary working in the royal workshops, such as the anonymous maker of an alabaster portrait of Shah Jahan (Plate 157).[54] The emperor has been given European features, but the jewellery is authentically rendered and there are traces of Mughal-style gold decoration on the textile covering the balcony.

The Florentine technique inspired Shah Jahan's craftsmen to inlay the marble monuments of his reign with a delicacy that had not been seen before. It was used in the tombs of Jahangir (Plate 158) and Mumtaz Mahal (Plates 157 and 159), and in all the most important chambers of the white marble palace structures at Akbarabad and Shahjahanabad. Uniquely, authentic panels made in Florence are combined with Mughal *pietra dura* decoration on the wall of the heavily symbolic *jharoka* in the emperor's new capital (Plate 19).[55]

192

Plate 154 | TILE
Reign of Jahangir, Glazed earthenware
20.5 cm. x 20.5 cm. (maximum)
Victoria and Albert Museum, London: IS.68-1898

Plate 155 | TILE
Reign of Shah Jahan, Glazed earthenware
19.2 cm. x 19.7 cm.
Victoria and Albert Museum, London: IS.25-1887

194

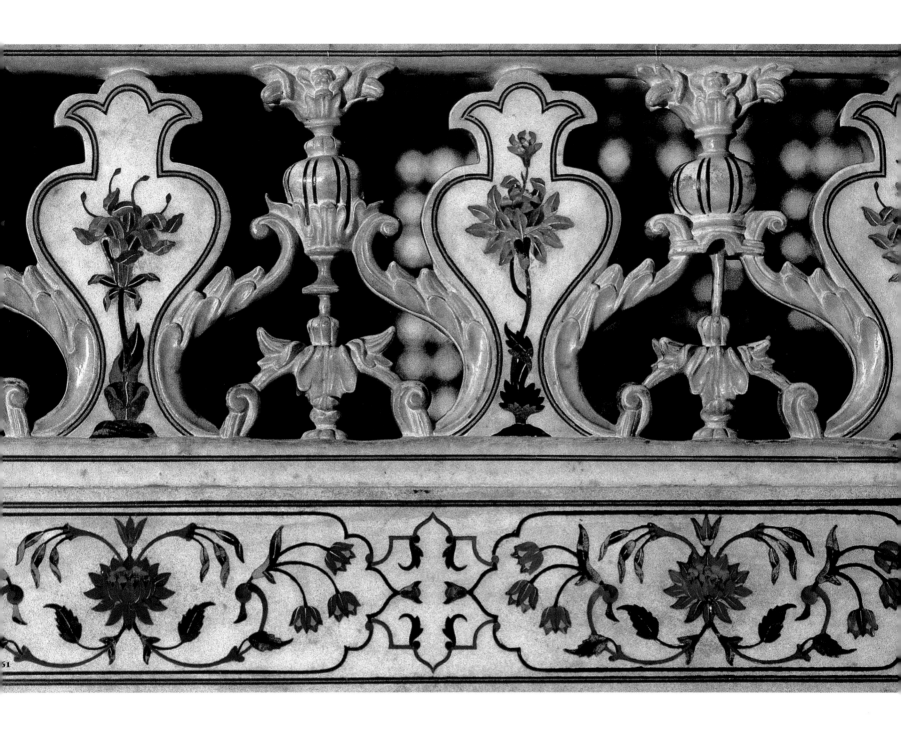

Facing page|Plate 156| PORTRAIT OF SHAH JAHAN
By a northern European artist probably in Mughal royal service, c. 1650
Carved alabaster with traces of polychrome and gold decoration
11.5 cm. x 8.4 cm.
Rijksmuseum, Amsterdam: 12249

Plate 157| DETAIL OF PLATE 159

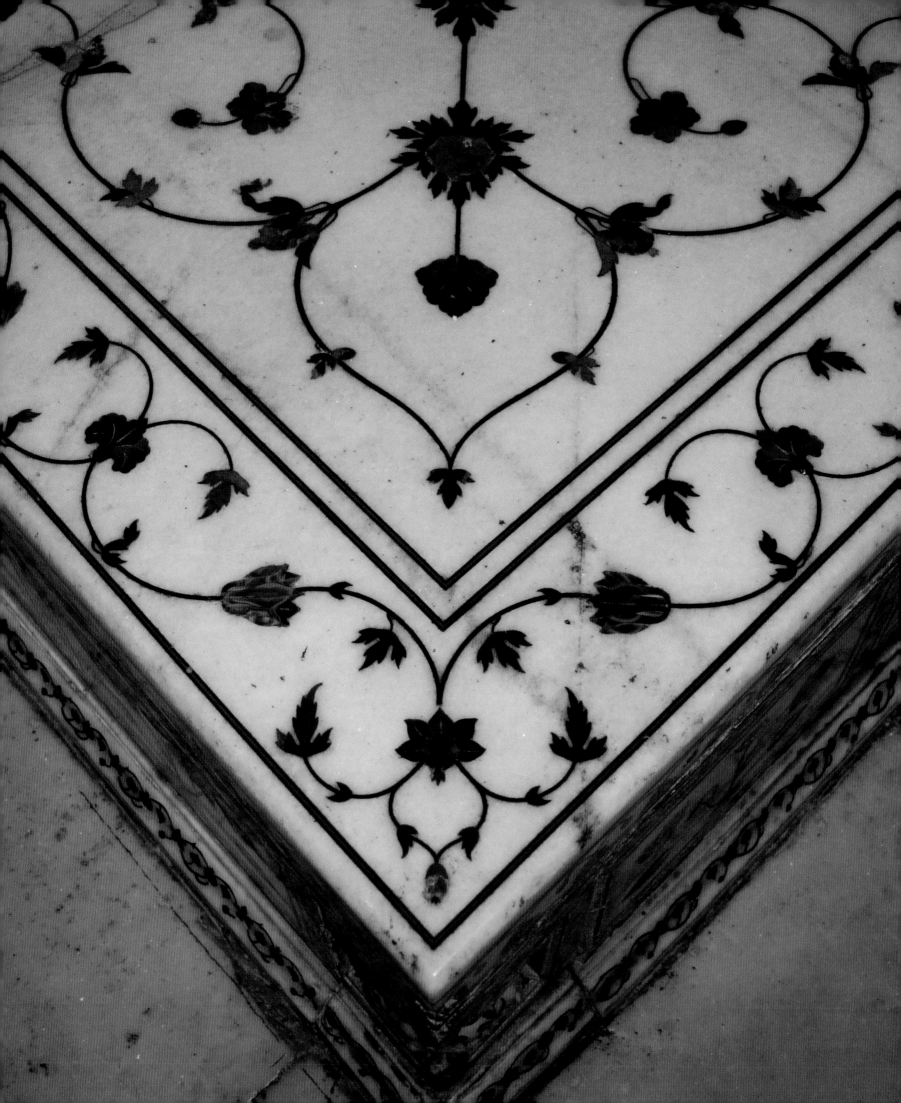

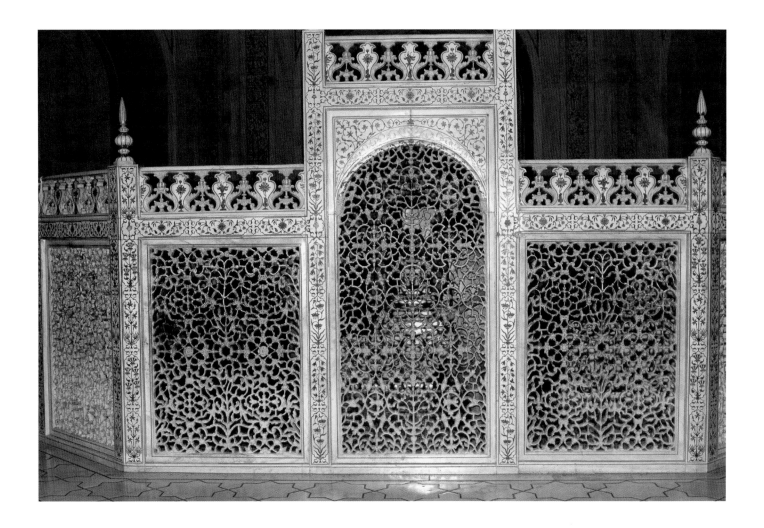

197

Facing page | Plate 158 | DETAIL OF THE PLINTH OF JAHANGIR'S CENOTAPH
Shahdara, Lahore

Plate 159 | PIERCED MARBLE SCREEN ENCLOSING THE TOMB
OF MUMTAZ MAHAL, TAJ MAHAL
Agra

198

The Indian subcontinent at all times was renowned for its textiles and every region had its own specialities, produced for all levels of the local market or for export.[56] Under the Mughals, existing techniques were improved, new industries introduced and workshops established at court and in some provincial centres. However, because of their inherent fragility and the ravages caused by the monsoon and by insects, almost nothing is left of the vast amount of sumptuous embroideries, gold and silver brocaded silk, printed and painted cotton, fine muslin, velvet and carpets used by the Mughals.

A central part of court ceremonial was the presentation of robes of honour called *khil'at*, and the storehouse for cloth and garments acquired by the royal household was particularly important. During Akbar's reign, 1000 complete outfits were made for the emperor every year, with 120 always kept ready to be worn or given away. Once these and all the other items acquired through purchase, tribute or gift entered the store, they were meticulously catalogued. The year, month, day or even the time of day when they arrived was carefully recorded, and certain items were given a higher valuation if they arrived on particular days. Price and weight determined their place in a hierarchical ranking, as did their colours in a wide range including white, gold and crimson, the mauve hue of certain parrots and the blue of Chinese porcelain. The predilection of the court for specific colours is reflected in the advice given by merchants to their colleagues concerning what would sell easily. Thus, when the English trader William Edwardes writes to the English settlement in Surat in 1614, he advises against despatching 'sad colours of any sorts ... for they

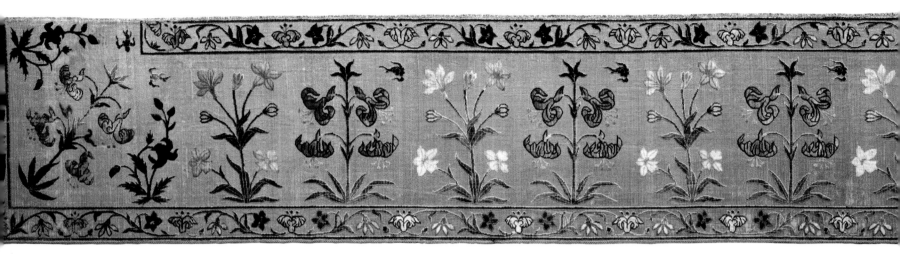

delight altogether in light colours,' and to send instead 'greens of all sorts' and 'Venice reds'.[57]

For much of the time, the court wore white diaphanous muslin. Fine muslin was made in Rajasthan and the Deccan, but the best came from Dacca. This softly draping, extremely lightweight cloth had been known in Ancient Rome as *nebula*, meaning mist, vapour or clouds, and *venti textiles*, or 'woven winds'.[58] In India it is generally called *malmal* or, when subtly patterned in the loom, *jamdani*, and to the Mughals it was also known as *ab ravan*, or 'running water'.[59]

Akbar had eleven different forms of robe or coat in his wardrobe, but very occasionally donned European clothes which had probably been given to him by his envoys on their return from Goa in 1578.[60] The following year, in the first meeting between Akbar and the Jesuits, Father Monserrate describes him wearing a scarlet cloak with gold fastenings, and ordering his sons to put on similar cloaks and Portuguese hats in honour of their guests.[61]

Plate 161 | FRAGMENT OF A FLOORSPREAD
Reign of Shah Jahan
Silk velvet and silver-wrapped thread
35 cm. x 265 cm.
Victoria and Albert Museum, London: 320a-1898

Winter, or residence in the cooler provinces of the empire, required quilted or fur-lined robes of the kind listed by Abu'l Fazl in his description of the royal wardrobe, as well as woollen shawls. Shawls of exquisite softness had been made in Kashmir for centuries, and the industry must have been well established by the 1540s when Shah Tahmasp requested Kashmir shawls to be sent to Iran for the exiled Humayun.[62] The kingdom was conquered by the Mughal armies in 1586 and Akbar quickly turned his attention to making improvements in these shawls woven from the fine hair of Tibetan goats. He modified the terminology used, adopting the Hindi designation *paramnaram*, meaning 'very soft', for the cloth, and ordered experiments to be made in dyeing so that the choice could be extended from the natural colours of the wool and the few dyes already added to white wool.[63] He set new fashions in wearing shawls, and may have worn garments made of shawl cloth.[64] Thereafter Kashmiri shawls, lengths of shawl cloth, and sashes (*patkas*) woven from the same fabric were included in the exchange of luxurious textiles between the emperors and the aristocracy. Paintings done under Akbar, Jahangir and Shah Jahan suggest that the shawls worn at court were monochrome, though they were later embellished with woven or embroidered patterns of increasing complexity.[65]

199

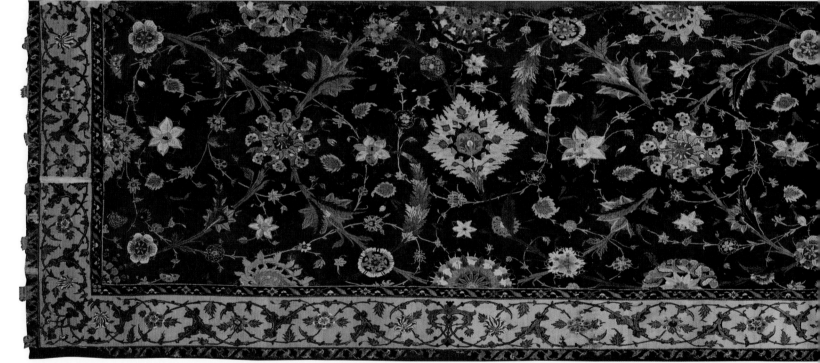

Plate 162 | FRAGMENTARY CARPET
Kashmir or Lahore c. 1620-25
Pashmina
Museu Calouste Gulbenkian, Calouste Gulbenkian Foundation, Lisbon: T 72

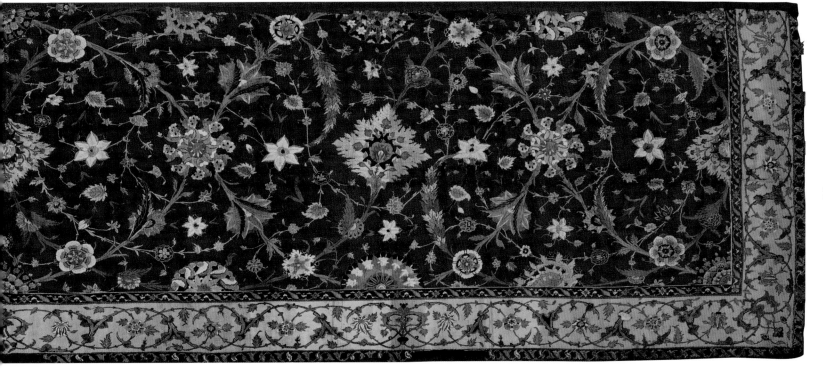

201

However, nothing predating the late seventeenth century has survived (Plate 163).

Akbar encouraged technical innovation in textiles perhaps even more energetically than he did in any other area of artistic production for the court. With his encouragement, skilled practitioners settled in the empire to improve both the products of the imperial workshops and those of renowned centres such as Lahore, Agra, Fatehpur and the cities of Gujarat.[66] As a result, Abu'l Fazl claims the finest cloth made outside Hindustan could be replicated by the royal craftsmen.

Contemporary sources, whether court histories or the letters of merchants whose business it was to understand local products, name many different kinds of woven, printed or embroidered textiles, many of which can no longer be identified.[67] Ahmadabad and Surat were famous for their woven silks, including some costing eight to forty rupees a piece that were 'very soft, decorated all over with flowers of different colours' and exported to south-east Asia.[68]

Large items such as screens, tents, their awnings and linings, were stored in the *Farrash Khana*. A catastrophic fire in 1579 destroyed all these items made from 'gold cloth,

European velvet, woollen cloth, Damask silk, satin and brocade, brocaded carpets'.[69] Carpets were also stored here. The most highly regarded carpets came from Iran, but Akbar encouraged their production in court workshops in Lahore, Agra and Fatehpur, intending that they should be of equal quality. By the 1590s, Abu'l Fazl reports that 'the carpets of Iran and Turan are no longer thought of'. Production in these Hindustani cities continued under Jahangir, though Lahore seems to have emerged as the major centre and continued to supply Shah Jahan's court.[70]

The rare surviving carpets from Akbar's reign are conceived like pictures on a page, or pictorial patterns tooled on the leather bindings of books. In one, a winged beast with an elephant's head clutches small elephants in the paws of its lion-like legs, in its trunk and in the knot of its tail (Plate 166). This is the *gaja-simha* which represents sovereignty, attacked here by the equally mythical bird of Persian literature known as the *simorgh* (Plate 165).[71] The scene is also inhabited by animals of the hunt, and includes a cart carrying a royal cheetah and a house where a mother plays with a small child near her cooks and servants. Its overall meaning is no longer

202

Plate 163 | FRAGMENT OF A SHAWL BORDER
Kashmir c.1650 Pashmina
Jagdish and Kamla Mittal Museum of Indian Art, Hyderabad: 81.2

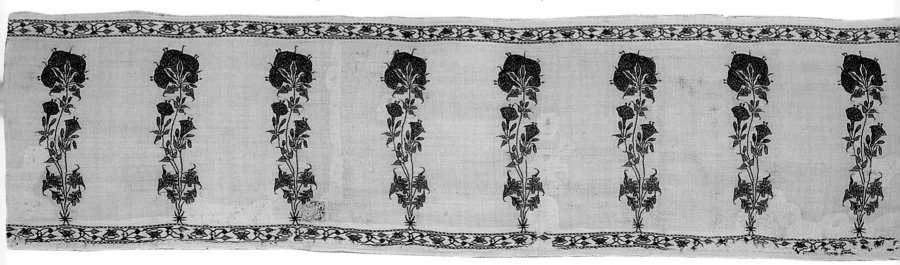

apparent. The ground is filled with the flowering plants of early Mughal painting and leaping animals of the kind found in the golden designs of manuscript borders. Other carpets draw on classical Iranian designs which slowly evolve during Jahangir's reign (Plates 161 and 170) until the floral styles of Shah Jahan's reign predominate.

The artists of the *Kitab Khana* would probably have supplied designs to the artisans of the royal workshops for use in all media, but there seems to be a particularly close relationship between the art of the book and the patterns used in carpets and figured textiles (Plate 170 a,b,c,d).

Certain garments produced in the royal workshops were restricted to particular ranks. A painting of a royal falconer shows him wearing a beautiful *jama* that may represent one of these (Plate 53).[72] The animals, which may have been woven or embroidered, are remarkably similar to those in a hunting scene painted by Mansur in the 1590s (Plates 50 and 51). They also relate to the designs ornamenting a throne in a portrait of Jahangir done jointly by Mansur and Manohar (Plate 167). The verses framing the painting specify that the likeness (*shabih*) of Jahangir is by Manohar, while the throne is almost certainly designed by Mansur.[73] It is decorated with small studies of birds and animals (Plate 52), subjects in which he was an acknowledged master, and with the scrolling patterns of manuscript illumination in which he also specialised. Whether or not the throne (perhaps of painted and gilt wood?) was ever made cannot be known.

All the centres of textile production which were improved during Akbar's reign continued to flourish under Jahangir and Shah Jahan. Governors returning to court made customary offerings to the emperor which usually included textiles made in their provinces. Occasionally, specific details are provided. When the governor of Malwa was received at Shah Jahan's court in 1638, for instance, he gave 2000 bolts of the expensive '*do-dami*' cloth with flowered designs for which Malwa was famous, and which was then of better

quality than ever before. Shah Jahan wore it in summer, and his historian records that a single garment cost 40 rupees if the cloth was plain, and 80 rupees if it had coloured flowers.[74] Shah Jahan had his own textiles workshop in Ahmadabad, perhaps established when, still a prince, he was governor of Gujarat. His weavers sent valuable textiles of unspecified nature from Gujarat to court, then at Fatehpur, for Nowruz in 1619,[75] and when the German traveller Johann Albrecht Mandelslo reached the province in 1638, he noticed that one of its newest products was a very fine fabric of silk mixed with cotton embellished with, gold flowers. Within the empire, this was reserved exclusively for Shah Jahan, though he allowed foreigners to buy it to take abroad.[76] The remarkable hunting coat was almost certainly made by Gujarati embroiderers who were renowned for their fine work in chain stitch (Plates 36 and 168).

Tavernier provides some details concerning commercial textiles he saw during his visits made between the 1630s and 1650s. Burhanpur, one of the most important cities in the empire because of its strategic position near the Deccan, though largely ruined when he saw it, produced fine woven cotton. Its textile trade was very significant, with 'transparent muslins' exported to Iran, Turkey, Poland and other countries. When the same cloth was dyed in different colours 'and ornamented with flowers', it was worn by Indian women as veils and scarves. Some cotton was plain white apart from stripes of gold or silver running along the entire length, and ends brocaded in 'a tissue of gold, silver, and of silk with flowers'. The skill of the weavers was such that 'there is no reverse, one side being as beautiful as the other'.[77] Tavernier perhaps refers here to waist sashes (*patkas*) that were a key element of the *khil'at* and often demonstrated the most sophisticated skills of weavers and embroiderers (Plates 169 and 171). Painted and printed cottons were also made in Burhanpur, but the Mughals would have acquired the cotton covers and hangings produced in court workshops on

Plate 164 | BINDING OF THE *KHAMSA* OF NEZAMI
c. 1595 Leather, tooled, gilt and lacquered 30 cm. x 20 cm.
British Library, London: Or. 12208
Bequest of C.W. Dyson Perrins
The text copied in 1593-5 by Abd al-Rahim

205

Plate 165 | ELEPHANTS AND *SIMURGH*
c.1600-1610 Drawing with watercolour wash
28.1 cm. x 19.2 cm.
Victoria and Albert Museum, London: IM.155-1914

Plate 166 | CARPET
Lahore c. 1590-1600
Wool with cotton warp and weft 243 cm. x 154 cm.
Museum of Fine Arts, Boston: 93.1480
Gift of Mrs Frederick L. Ames, in the name of
Frederick L. Ames, 1893

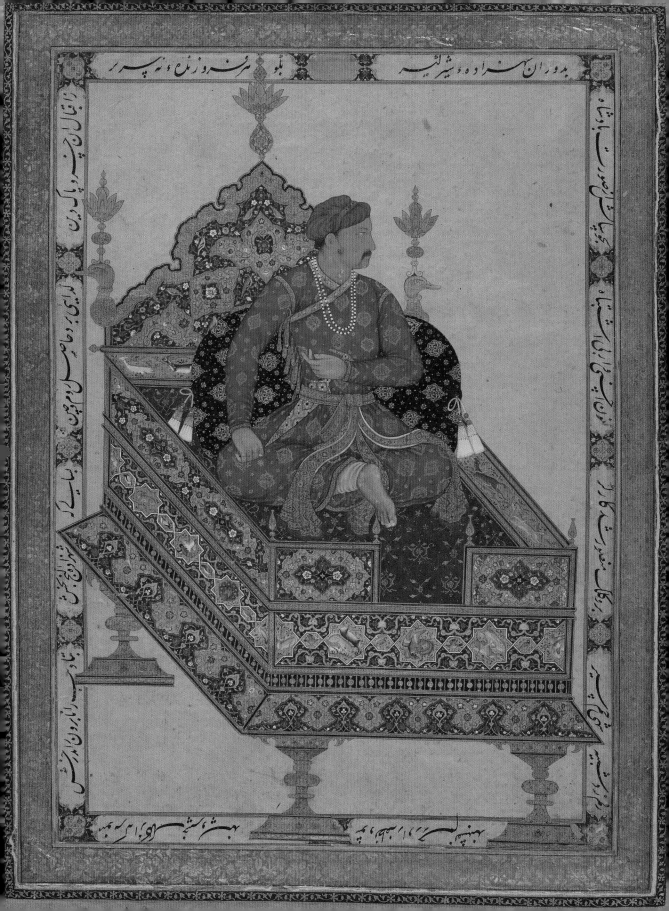

207

Facing page | Plate 167 | SALIM ENTHRONED
By Manohar and Mansur
1599 or 1600 Page from the St Petersburg album
Opaque watercolour and gold on paper 27.2 cm. x 19.5 cm.
St Petersburg Branch of the Institute of Oriental Studies
Russian Academy of Sciences: E.14 folio 3 recto

Plate 168 | RIDING COAT (DETAIL)
Gujarat, reign of Jahangir
Satin embroidered with silk
Victoria and Albert Museum, London: IS.18-1947

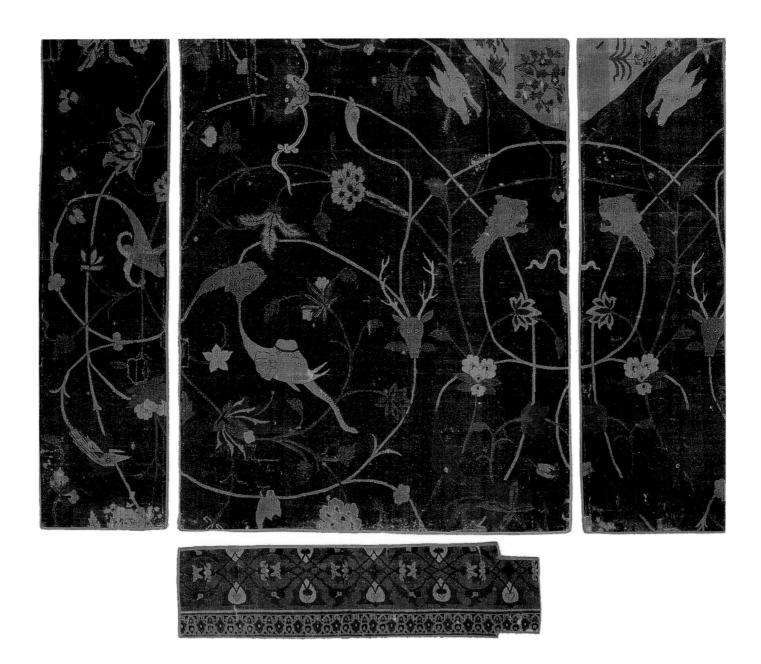

209

Facing page | Plate 169 | SASH (*PATKA*)
Gujarat, late 17th century Silk, cotton and metal-wrapped silk yarn

Plate 170 (a,b,c,d) | FRAGMENTS FROM A CARPET
Lahore, c. 1610-20
Wool with silk warp and weft
103 cm. x 85 cm.; 103 cm. x 27.5 cm.; 103 cm. x 32.5 cm.; 80 cm. x 20 cm.
Musee des Arts Decoratifs, Paris: A5212A, A5212B, A5212C and A5212D

the Coromandel Coast, where the finest pieces were reserved for the exclusive use of the ruler and sent as gifts to other kings (Plate 172).

Abu'l Fazl's description of the royal wardrobe singles out the gold brocades and silks of the Iranian cities of Kashan, Yazd and Herat, and textiles of Bursa in Western Anatolia, Khotan, and Europe.[78] Velvet had been used by Babur long before his conquest of Delhi and was a *de luxe* fabric throughout the Mughal period, used to make robes, saddle cloths and cushions, as well as tent and wall-hangings. In Akbar's reign, European velvet was extensively imported via Jeddah and Aden to Cambay. Iran was a major source, but from the end of the sixteenth century it was also made at Ahmadabad and Lahore. The Safavid-style velvets seen in paintings of Shah Jahan's court could therefore have been made within the Mughal empire.

Velvet adorned the court on every great occasion. Small panels covered the *jharoka* balustrade (Plate 23), while larger pieces were used as wall-hangings, floorspreads (Plate 161) and as canopies. For the inauguration of Shahjahanabad in 1648, the imperial factory in Gujarat supplied velvet for the canopy erected in front of the new *Chehel Sutun* worth one lakh (100,000) rupees, the same value a single precious stone might have had.[79]

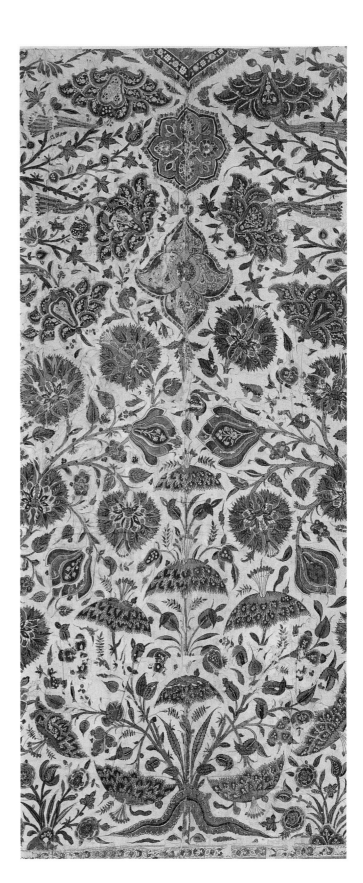

211

Facing page | Plate 171 | SASH (*PATKA*)
Gujarat, late 17th century Silk, cotton and metal-wrapped silk yarn
Bharat Kala Bhavan, Varanasi

Plate 172 | PART OF A FLOORSPREAD
South-east India, probably Petaboli,
Andhra Pradesh, for the Golconda court
Cotton, painted and dyed Warp 238 cm. x Weft 135.5 cm.
Tapi collection: 98.1834

MUGHAL JADE

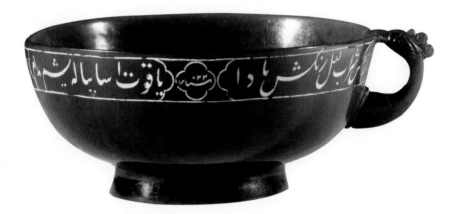

Most foreign visitors to the court mention the alacrity with which Mughal craftsmen copied any new forms or techniques they came across. New materials were adopted in the royal workshops with equal facility and skill.

When William Hawkins described the Mughal treasury, he mentioned that jade was in the treasury of precious stones, presumably uncut, and that some of Jahangir's drinking cups were made of jade.[80] The nephrite jade used for Mughal vessels, jewellery and hilts throughout the seventeenth century was never found in the subcontinent. Yet, by the early years of Jahangir's reign, this exceptionally difficult material which cannot be carved, and must be abraded

to create form and ornamentation, had been mastered to perfection. A dated wine cup provides a clue as to how this remarkable innovation came about. The verses incised on the cup using diamond drills name Jahangir, leaving no doubt that this was commissioned by him (Plate 173). They also have a direct connection with Sa'ida, the supervisor (*darogha*) of the court goldsmiths, because the multi-talented Iranian used them again in the lines he composed in celebration of the weapons made by Ustad Da'ud from the meteorite.[81] Sa'ida was an exceptional calligrapher who was able to engrave his beautiful writing on a minuscule scale on precious stones, as he did on the Timurid spinel sent to Jahangir by Shah 'Abbas (Plate 127). When Shah 'Abbas sent Jahangir another

Plate 173| WINE CUP OF JAHANGIR
Probably made by Sa'ida-ye Gilani
Dated regnal year 8, AH 1022/ 21 February-6 August 1613 AD
Nephrite jade, the incised inscriptions filled at a later date with white
composition 3.8 cm. x 8.8 cm.
Victoria and Albert Museum, London: IM.152-1924
Given by the Royal Asiatic Society

Facing page| Plate 174| WINE TANKARD
Made for Ulugh Beg, perhaps in Herat c. 1425-50, the handle
probably made at the Mughal court by Sa'ida-ye Gilani
who added the inscription dated
AH 1022 /1613-14 AD
Nephrite jade Height 14.5 cm.
Calouste Gulbenkian Museum, Lisbon: 328

dynastic Timurid possession in AH 1022/1613-4 AD, the royal goldsmith was again entrusted with the delicate task of adding the emperor's own titles (Plate 174). The white jade tankard had been owned by Ulugh Beg, as the band of calligraphy encircling its neck states, and Sa'ida added not only a new inscription to its rim, clearly in the same hand as the inscriptions on the spinel, but perhaps also a new handle which is made from a slightly whiter jade than the body of the vessel.[82] The jaws of the dragon grip the rim at the precise point where the inscription begins, and seem to utter the words of the Koranic formula: 'God is Great' (*Allahu Akbar*).[83]

Sa'ida's expertise combined with his role as supervisor of the most important imperial workshop suggests that the swift adoption of jade for royal artefacts in the early seventeenth century was due to his influence. The new material was worked with the same bow-drills used by Indian lapidaries for centuries to make agate, rock crystal and carnelian.[84] Jade objects could therefore also be made for the emperor by others in the royal workshops, most of whom remain anonymous.[85] Some vessels, like the delicate perfume phial of white jade dated to the last year of Jahangir's life, copied the forms of nature (Plate 175) and in a drawing that departs radically from the magnificence of most of his portraits, Jahangir is depicted holding a lobed cup in the form of a half gourd (Plate 176). Nothing like it

214

Plate 175 | JAHANGIR'S PERFUME PHIAL
Dated AH 1036 / 1626-7 AD
White nephrite jade with silver mounts
6.2 cm. x 1.5 cm.
CSMVS, Mumbai (formerly Prince of Wales Museum): 66.18

Plate 176 | PORTRAIT OF JAHANGIR
HOLDING A WINE CUP
c. 1620, Drawing on paper, 10.4 cm. x 5.4 cm.
Los Angeles County Museum of Art: M. 83.1.5
From the Nasli and Alice Heeramaneck Collection
Museum Associates Purchase

Plate 177 | WINE CUP DECORATED WITH FLOWERS
Reign of Shah Jahan White nephrite jade
13.3 cm. x 8.2 cm.
Victoria and Albert Museum, London: IS.02561

Plate 178 | WINE CUP OF SHAH JAHAN
Dated regnal year 31, AH 1067 / 1657 AD
White nephrite jade 18.7 cm. x 14 cm.
Victoria and Albert Museum, London: IS.12-1962
Purchased with the assistance of the Art Fund, the Wolfson Foundation,
Spink & Son and an anonymous benefactor

has survived from his reign, but similar jade cups were made in Shah Jahan's workshops (Plate 177).[86] His greatest jade wine cup was completed just before the cataclysm caused by his illness that led to him being deposed and imprisoned by his son Aurangzeb, who had two of his brothers assassinated and took the title 'Alamgir when he became emperor in 1658 (Plate 178). The serenely curving animal-head handle is inspired by Mannerist designs, demonstrating the continuing influence of Europe on the art of the court.[87] The lobed body of the cup is inscribed so discreetly with the emperor's title that it went unnoticed for decades after the cup reached the West, and it is unsigned, leaving no clue as to the identity of the master who made it.[88]

Mughal jade was also embellished with precious stones and used for jewellery, vessels and the hilts of weapons (Plate 180).

216

Plate 179 | DADO PANEL FROM THE TAJ MAHAL
White marble inlaid with *pietra dura* decoration

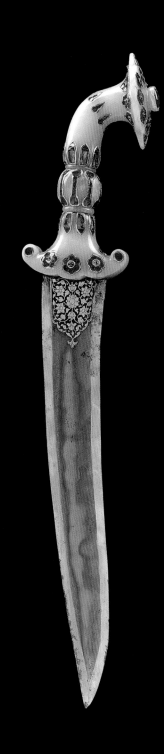

Plate 180| DAGGER
Mughal (or Deccan sultanates), mid-17th century
Hilt of white nephrite jade set with rubies and emeralds in gold,
the blade watered steel overlaid with gold in two colours
39.5 cm. x 9.3 cm.
The al-Sabah collection, Kuwait National Museum: LNS 2221 J

ENAMELLING

Enamelling was one of the greatest arts of Shah Jahan's court. However, this technique of fusing glass onto metal seems to have been unknown in the empire before the end of the sixteenth century. It was almost certainly introduced as a result of contact with Europe.[89] In his survey of the court institutions written in the 1590s, Abu'l Fazl refers to the presence of enamellers in the royal workshops and mentions in passing that the royal guns sometimes had mounts of enamelled gold.[90] Akbar's craftsmen may have learned enamelling when they were sent to Goa in 1575 with specific instructions to learn new techniques – a Father Duarte de Sande who met them there reported 'they have learned almost all our crafts'.[91] Indian goldsmiths had been employed by the Portuguese in Goa from the early sixteenth century, and some had even travelled to Lisbon where they would have seen, and in all likelihood learned, enamelling.[92] By 1606, Goa was full of goldsmiths, lapidaries and artisans of all kinds from Italy, Portugal and other Western countries, as the French traveller Pyrard de Laval reports.[93] Some of them must have been there five years earlier, when Akbar's second delegation arrived with orders 'to gain sure and certain knowledge of the sort of rare objects that are held in high esteem in Portugal, and the means, style and fashion of the nobles'.[94] Any skilled craftsmen they came across were to be invited to the court, with assurances that they would be offered anything they needed and could leave whenever they wished.

When Sir Thomas Roe came to the Mughal empire in 1616, Mughal enamellers must have been highly accomplished. He reported to the English factors in 1618 that the price of enamel as a raw material had fallen, but would still yield a reasonable profit if of good quality. Most significantly, he added that if red enamel was 'very fine', it would sell at twice the price of gold – of all the colours enamelled on gold, translucent red is the most difficult to achieve. The Portuguese, Roe added, had been sending enamel to the court from Goa for the past two years and sold the red raw material at 45 shillings an ounce, and blue, white and green at 18 shillings an ounce.[95] At the same time, the English factors outside the capital reported there was no market at all for enamel, suggesting that it was used only in the royal workshops. A cup and cover for *argcha*, the solidified perfume sometimes given to visiting ambassadors in jewelled or enamelled gold cups, may have been made in Jahangir's reign (Plate 182). The small flower heads of its highly unusual design are reminiscent of the details copied by Mansur from Western botanical engravings (Plate 100 and detail, p.82).

By the reign of Shah Jahan, enamel was widely used to embellish gold artefacts made in the royal ateliers. Sa'ida made an enamelled throne over nine months in 1652 which was valued at five lakh rupees,[96] Jahan Ara Begum presented her father with an enamelled bedstead worth 40,000 rupees to mark his 65th lunar birthday in 1655,[97] and Shah Jahan regularly bestowed enamelled saddles, daggers and swords, containers for *pan* and perfume, and many more items, to the other members of his family, to the aristocracy and to visitors to his court.

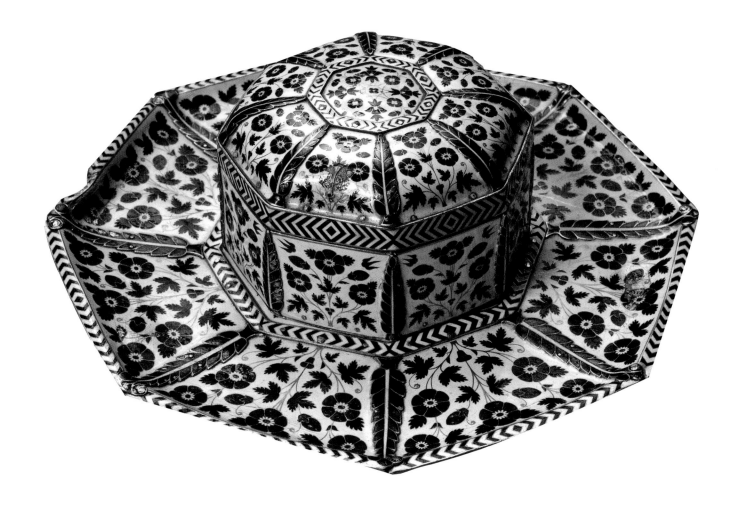

219

Plate 181 | *PAN DAN* (CASKET FOR *PAN*) AND STAND
Reign of Shah Jahan
Enamelled gold
Casket 15.2 cm. wide Stand 33 cm. diameter
State Hermitage, St Petersburg: V3-706 and 707

220

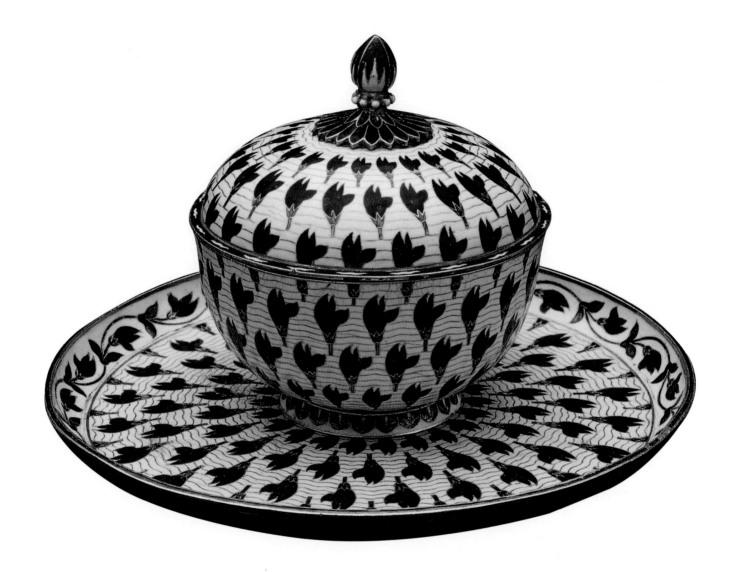

Plate 182 | LIDDED CUP AND SAUCER
PROBABLY FOR *ARGCHA*
c. 1620-30, Gold with champlevé and painted enamel
Cup: 7.8 cm. x 7.2 cm. Saucer: Diameter 12.9 cm.
The al-Sabah collection, Kuwait National Museum: LNS 2191-C
Formerly in the collection of the Marquis of Bute

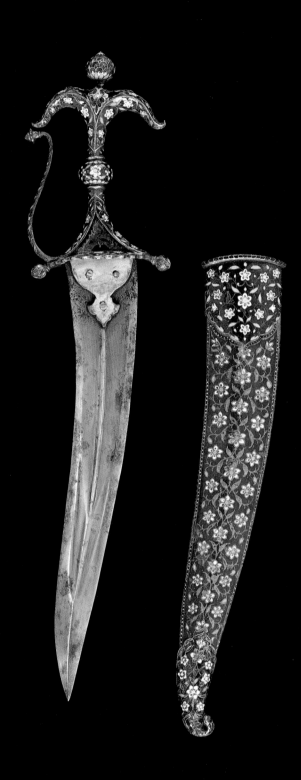

Plate 183| DAGGER AND SCABBARD
Mughal (or Deccan sultanates) mid-17th century
Hilt of white nephrite jade set with rubies and emeralds in gold,
the blade watered steel overlaid with gold in two colours
39.5 cm. x 9.3 cm.
The al-Sabah collection, Kuwait National Museum: LNS 2221 J

THE GOLDSMITHS' ATELIER AND THE IRANIAN MASTER

The virtuoso craftsmen of the goldsmiths' atelier were directed by a master whose skills were even more remarkable than their own. Sa'ida, the Iranian engraver, enameller and lapidary from Gilan, arrived at the Mughal court at an unknown date. He was admired in Jahangir's reign as a poet.[98] His name is mentioned several times in Jahangir's memoirs, a rare accolade, and first appears in 1616 when the court was at Ajmer. The emperor had travelled outside the city to a beautiful valley that he visited regularly, to inspect newly completed pavilions next to a fountain and natural reservoir. His entourage included poets who had been ordered to compose celebratory poems, and Jahangir singled out the verses of Sa'ida, referring to him as the 'Chief Goldsmith'. Sa'ida held the same post under Shah Jahan, when the court historian Muhammad Saleh provided an unusual insight into the personality of the leading Mughal artist. After describing Sa'ida's unique mastery of different techniques and arts, including gem engraving (*hakkaki*) and calligraphy, the historian added 'he is extremely good company, a fine conversationalist, and a modest man with a sense of propriety'. Jahangir, he went on, had given him the eulogistic name 'Bi Badal Khan', or 'Prince Peerless'.[99] Other sources mention that he had his own mansion in Agra and, like the cultivated Mir Sayyid 'Ali whose house had been near his fellow Iranians at Fatehpur, lived in an elite Iranian quarter.[100] The distinctive dress of Iranian aristocrats at the Mughal court is depicted by Abu'l Hasan, himself the son of an Iranian immigrant, in his paintings in the borders of a page from the Gulshan album (Plate 184). Sa'ida's major commissions from Shah Jahan include a golden screen with inscriptions traced in translucent green enamel erected around the tomb of the emperor's wife in Agra in 1632, as well as his enamelled throne.[101] The screen was later replaced with one of marble (Plate 159).

A very few of the goldsmiths and jewellers under his supervision were Europeans. Augustin Hiriart, a Protestant goldsmith and enameller from Bordeaux, arrived in Hindustan via London and Iran in about 1613.[102] He too has the distinction of being mentioned in Jahangir's memoirs. In 1619, Jahangir's father-in-law I'timad ad-Daula invited the emperor and the ladies of the royal household to his mansion for Nowruz. The centrepiece of his lavish offerings was a throne made by a '*farangi*' to whom Jahangir gave the name Hunarmand, meaning 'the artist'. Augustin was a metal engraver, enameller and jeweller. His throne was supported by four lions, cost 450,000 rupees and took three years to complete.[103] Augustin himself adds more details in a letter written from Lahore in 1625. Its domed canopy supported by twelve columns was covered with 4000 stones. He had made artificial ones for the model, but the final version had stones of inestimable value taken from the abundant supplies in the treasury. Jahangir, he writes, 'has a great number of pearls and it is certain that he also has more large diamonds and large rubies than all the princes of the universe'. A contemporary painting depicts Jahangir on a similar throne, though its gold canopy is decorated with European *putti* rather than precious stones (Plate 185).

Hunarmand's throne would have been inherited by Shah Jahan on his accession, when jewelled and plain gold thrones that may have looked like those in a painting by Bichitr were brought out of the treasury for the celebrations

222

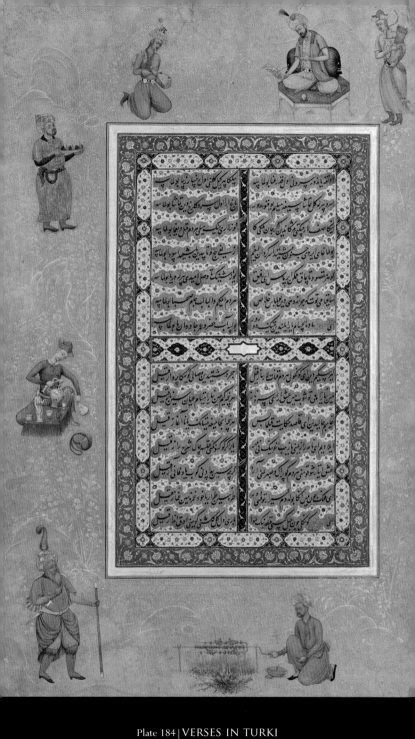

Plate 184 | VERSES IN TURKI
by Sultan Husawn Bayqara
Calligraphy Iran or Hindustan second half of 16th century Borders Mughal, signed by
Abu'l Hasan, c. 1620-30 Page from the Gulshan album
Ink, opaque watercolour and gold on paper
Golestan Palace Museum, Tehran; Manuscript No. 1663, folio 217

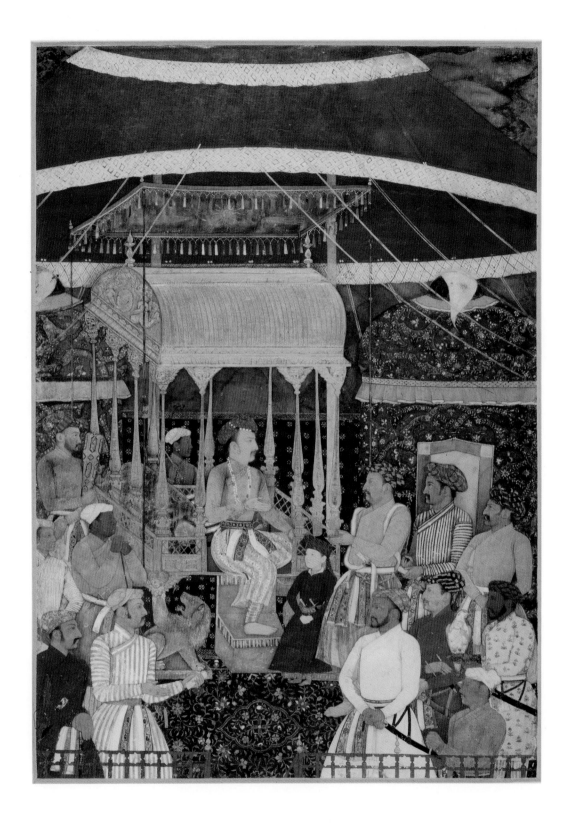

Plate 185 | JAHANGIR SEATED ON A THRONE OF EUROPEAN DESIGN
c.1620-25
Opaque watercolour and gold on paper
Keir Collection, Richmond

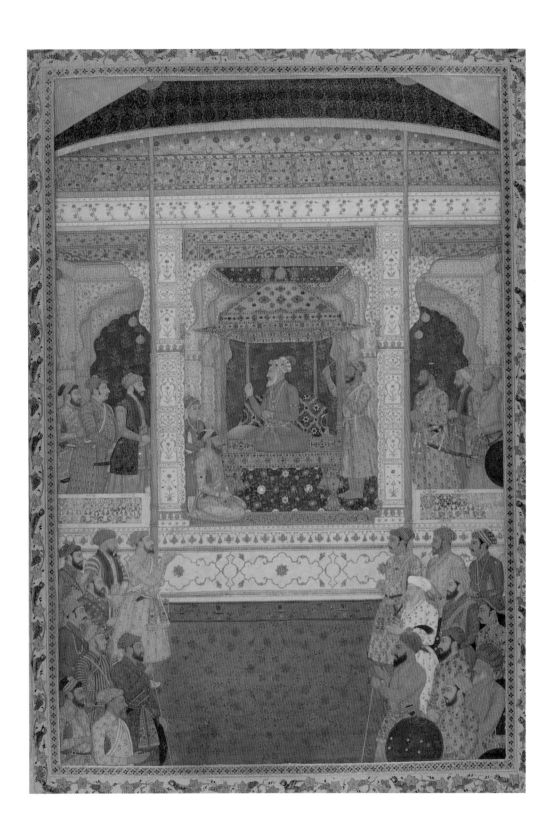

225

Plate 186| SHAH JAHAN ON THE JEWELLED THRONE
c. 1635 Opaque watercolour and gold on paper
Page from the St Petersburg album 25.5 cm. x 23.5 cm.
St Petersburg Branch of the Institute of Oriental Studies
Russian Academy of Sciences: E.14, f. 25 recto

(Plate 1). However, before the end of the year Shah Jahan had commissioned a new one. The most extravagantly sumptuous, technically brilliant throne ever made for the Mughal emperors was entrusted to the royal goldsmiths under Sa'ida's supervision. It took them seven years to complete the commission (Plate 186).[104] Its jewelled gold canopy, supported by twelve jewelled gold pillars, was fringed with pearls. Two peacocks, encrusted with precious stones and enamelled, were perched on the canopy. Persian verses enamelled in emerald green ran around the base of the throne, and its sides were completely covered with specially selected diamonds, spinels, rubies, emeralds and pearls. Some of the diamonds were of European cut and could have been either imported or cut at court – Augustin had cut a 100-carat diamond for Jahangir, and Shah Jahan employed a Dutch diamond cutter called Abraham de Duyt for at least twelve years.[105] Some of the stones had come from the personal treasury of Shah Jahan who was a great connoisseur in this field, and their total value was recorded as being 86 lakh of rupees. The court historians list the exact number of emeralds, rubies and other gems set into the throne, but only one stone is singled out – the Timurid spinel engraved by Sa'ida (Plate 127).

The throne which was first brought to the court at Nowruz in 1635 was always displayed on grand occasions such as the emperor's birthday weighing ceremony or the anniversary of the coronation. Its most spectacular appearance was at the inauguration of Shahjahanabad when it was placed in the Hall of Public Audience. Three thousand labourers took nearly a month to install the velvet canopy woven in Gujarat

over a courtyard in front of the *Chehel Sutun* that could hold over 1000 people.[106] The moment when the emperor took his seat on the Jewelled Throne, as it was called at the time, marked the culmination of the inauguration celebrations of the city, and the creators of the royal city received their rewards at the foot of the throne.

In Shahjahanabad, the court poets wrote, fountains sprinkled water like diamond drops, and water as clear as crystal flowed between plants with flowers red as ruby and leaves the colour of emeralds. The artefacts made for the court, adorned with blossoming plants set with real rubies and emeralds, translated these images literally. Architectural decoration, with its red blossoms and green flowers inlaid into white marble or painted onto white walls, inspired similar designs in translucent green and red on white enamel, just as the blossoms carved in relief in the marble on the friezes of Taj Mahal are reproduced in white jade on wine cups. According to Tavernier, the ornamentation of the royal thrones was matched exactly with the jewelled daggers worn at court, and the hangings and carpets of the court supplied their own variations on the universal floral theme, with gently swaying flowers woven into the patterns of robes and sashes. The harmony in court design was as deliberate as the formal symmetry of Shah Jahan's greatest monument, the mausoleum he built for his wife Mumtaz Mahal.[107]

Within his new city, Shah Jahan created a world untainted by poverty or disease. Its floral perfection was proclaimed by the verse written on the walls of the Hall of Private Audience in the heart of the palace:

If there is Paradise on earth, it is this, it is this, it is this.

Facing page | Plate 187 | ARCHED NICHE, TAJ MAHAL
Agra

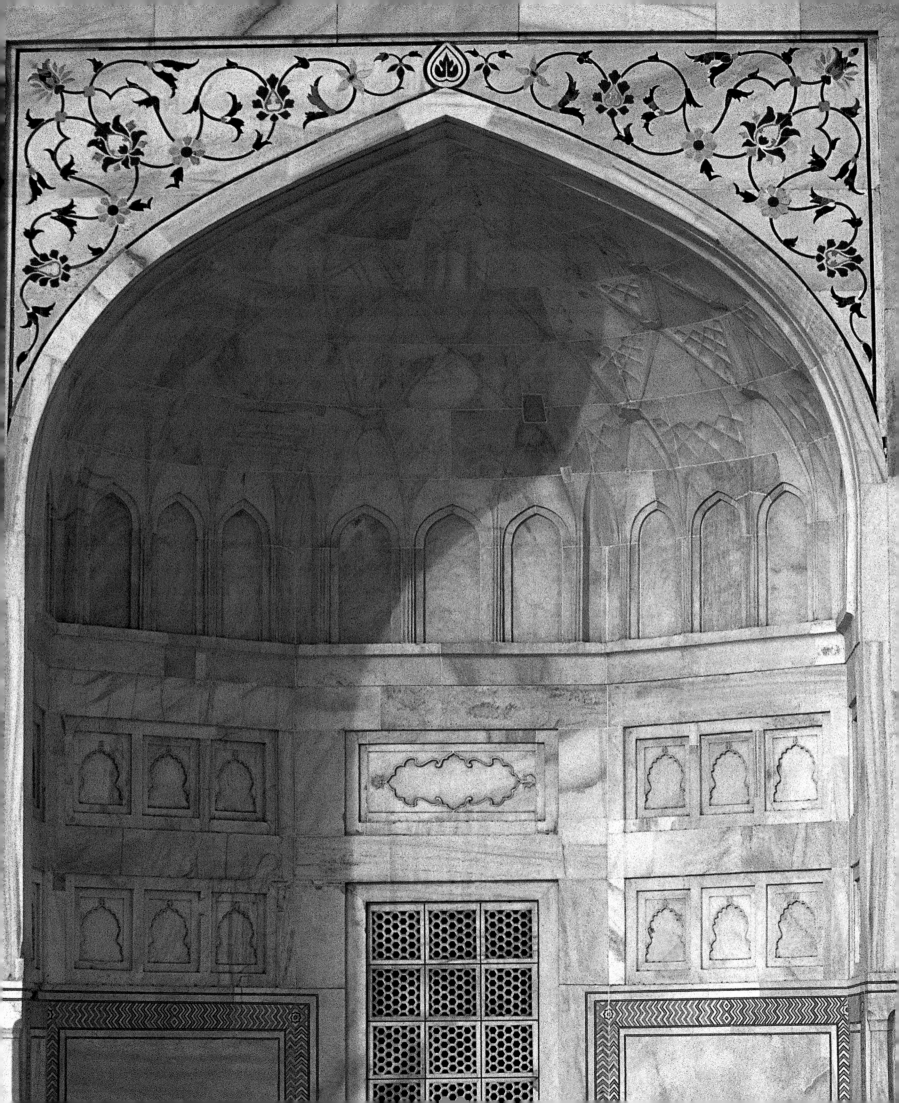

Facing page | Plate 188 | WALL HANGING OR TENT PANEL
Reign of Shah Jahan Woven silk 213.3 cm. x 91.4 cm.
Bharat Kala Bhavan, Varanasi: 10/33

Plate 189 | DETAIL OF JAHANGIR'S CENOTAPH
Shahdara, Lahore

NOTES

THE CITY AND THE ROYAL ENCAMPMENT

1 Begley and Desai, 1990, pp.408-9; Blake, 1991, p.31

2 Blake, 1991, p.31

3 Begley and Desai, 1990, pp.408-9; Blake, 1991, pp.56 and 75

4 Abu'l Fazl, quoted in Richards, 1995, p.28.

5 Thackston, 1996, pp.390, 392

6 Much has been written on the construction of this city. For a succinct overview, see Asher, 1992, pp.51-67. For detailed studies of different aspects of the site, see Smith, 1896-8; Rizvi and Flynn, 1975; Brand and Lowry, 1985; and the collected papers edited by Brand and Lowry, 1987.

7 On the construction of the tomb, which was not completed until almost a decade after Shaikh Salim Chishti's death, see Asher, 1992, pp.56-8 and Koch, 1991, pp.56-60. On the pillar, see Asher, ibid., pp. 63-4 and Koch, ibid., p.60.

8 *See* Rizvi and Flynn, 1975, frontispiece, for an example of pictures on the wall in the Khwabgah; p.48 for the reference to tiles; pp.55-6 for references to the poems and Appendix A for the original poems in Persian.

9 Asher, 1992, pp.66-7. For a detailed analysis of the various regional influences on the architecture of the city, *see* Ebba Koch, in Brand and Lowry, 1987, pp.121-48.

10 Asher, 1990, pp.43-7; Lowry, 1987; Beveridge, 1977, vol. III, p.569; Blochmann, vol. I, p.465, Hoyland, p.96.

11 *See* Blochmann and Phillott, 1977, vol.I, *A'in* 72 'The Manner in which His Majesty Spends His Time', pp.162-5.

12 Moosvi, 1994, pp.60-4 for a translation from Badauni's contemporary unofficial history of Akbar's reign, the *Muntakhabu't Tawarikh*, written from the perspective of a disapproving eyewitness.

13 *See* Alvi, 1978, p.38.

14 Thackston, 1999, p.145

15 Begley and Desai, 1990, pp.25-6 for the first order. For a detailed discussion of the construction and significance of the *Chehel Sutun*, see Koch, 2001, pp.229-54.

16 Begley and Desai, 1990, pp.567-73

17 Blake, 1991, p.92 for the name of the setting; see Koch, 2001, pp.61-129, for a major study of the Shahjahanabad *jharoka*, and the first analysis of the relationship between the Florentine and Mughal *pietre dure*. For the significance of the hoopoe, and its relation to jewellery in Jahangir's reign in particular, *see* Melikian-Chirvani, 2004, pp.23-4 and caption for pl.21.

18 Blake, 1991, for a comprehensive account of the city and its later history; Asher, 1992, pp.191-204 for a survey of the palace buildings of Shahjahanabad; see also Y.D. Sharma, 1974. Blake, 1991, p.43, gives the total cost of the palace and the individual cost of its most important structures.

19 Banerjee and Hoyland, 1993, p.209

20 Blake, 1991, pp.92-3

21 Thackston, 1999, p.xiv

22 Begley and Desai, 1990, p.xix

23 'Abd us-Samad, for instance, regularly seems to have done special Nowruz paintings, completed in a day and a half: *see* Rajabi, 2005, pp.420 and 421 for two of these works dated 1551 and 1552, preserved in the Gulshan album.

24 Thackston, 1999, pp.107-8

25 Beveridge, 2003, vol.I, p.616

26 Foster, ed., 1967, pp.138 and 142

27 Foster, ed., 1967, pp.138 and 143-5; cf. Thackston, 1999, p.189.

28 Blochmann and Phillott, 1977, vol.I, pp.78-83

29 Begley and Desai, 1990, pp.62-3

30 Blochmann and Phillott, 1977, vol.I, pp.276-7

31 Begley and Desai, 1990, p.96 (their translation of *la'l* as 'rubies' corrected here to 'spinels').

32 Begley and Desai, 1990, pp.309-10 and 312-4, 317-8

33 Begley and Desai, 1990, pp.90-3

34 Lal, 2005, pp.128-37 and pp.202-5; Hoyland p.75

35 Foster, 1967, pp.320-1

36 Blochmann and Phillott, 1977, vol.I, pp.45-7

37 This identification has plausibly been suggested by Das, 1998, p.119.

38 Blochmann and Phillott, 1977, vol. I, pp.308-20

39 Quoted by Irving Finkel, 2006, p.69.

40 Finkel, ibid., p.63

41 Blochmann and Phillott, 1977, vol.I, pp.313-5

42 Blochmann and Phillott, 1977, vol.I, pp.309-10

43 Correia-Afonso, 1980, pp.81-2; Banerjee and Hoyland, 1993, pp.197-8

44 Blochmann and Phillott, 1977, vol.I, p.308

45 Andrews, 1999, II, pp.1277-82 for a slightly adapted version of Blochmann and Phillott, 1977, vol.I, *A'in* 19, pp.52-4.

46 Banerjee and Hoyland, 1993, p.79

47 Andrews, 1999, vol. II, p.883

48 Andrews, 1999, vol. II, p.1280

49 Blochmann and Phillott, 1977, vol.I, pp.55-7

50 Foster, 1967, pp.325-6

51 Habib, 1992, p.4

52 *See* Andrews, 1999, chapter 3 'Akbar' for a full description of his encampment. See also Habib, 'Akbar's Technology', pp.4-5.

53 Begley and Desai, 1990, p.5

54 Thackston, 1999, pp.282-4

55 When Akbar appeared at the strategic fort of Gaugran, for example, in 1561 during the campaign against Baz Bahadur of Mandu, its governor immediately came out and presented him with the keys to the fort (*see* Stronge, 2002, pp.67-8 and pl.43, p.64).

56 Blochmann and Phillot, 1977, vol.I, pp.297-300 for the care of cheetahs ('leopards' in the translation) and pp.123-39 for the series of regulations concerning elephants in the royal stables.

57 Blochmann and Phillott, 1977, vol.I, pp.304-8

58 Blochmann and Phillott, 1977, vol.I, pp.292-3

59 Richards, 1995, pp.94-5

60 Asher, 1992, pp.102-3; Thackston, 1999, p.69

61 Thackston, 1999, p.75

62 Thackston, 1999, p.273

63 Andrews, 1987, pp.151-2

64 Andrews, 1999, II, p.1156

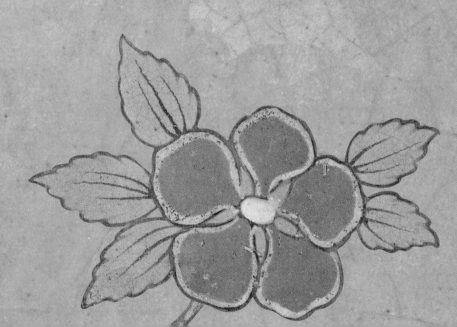

THE MUGHAL 'HOUSE OF BOOKS'

1 Beveridge, 1977, vol.I, pp.518-21

2 Mohiuddin, 1971, p.38

3 Ellen Smart, 'Akbar: Illiterate Genius', in Joanna Williams, ed., *Kaladarsana*, Delhi, 1981, pp.99-108

4 *See* Beveridge, 1977, vol.III, p.125

5 Blochmann and Phillott, 1977, vol.I, p.110; Beveridge, vol.I, p.520

6 Banerjee and Hoyland, 1993, p.201

7 Blochmann and Phillott, 1977, vol.I, p.109

8 This wealth of information has been relatively little studied. An exception is the major survey done by Seyller, 1997.

9 On his poetry, see Na'imuddin, 'Some unpublished verses of Babur' and Alam, 1998, pp.317-8.

10 Wilkinson, *Shah-Nameh*, *see* pp.1-3 for details of the manuscript's royal Mughal owners.

11 Beveridge, 1977, vol.I, pp.309-10

12 *See* Arnold, 1930, for the first monograph on this *Zafar Nama* manuscript now in the Johns Hopkins Library, Baltimore; see also Natif, 2002, p.213 for a full bibliography.

13 *See* Richards, 1995, pp.9-12 for a succinct account of Humayun's life, and Moosvi, 1994, p.7.

14 *See* Chandra, 1976, pp.171-3.

15 For the few facts known about Mir Sayyid 'Ali and the corpus of work that can be definitely seen as his work, and bibliography, see Melikian-Chirvani, 1998. As he notes, the date of their arrival in Kabul based on a letter shown to a historian by 'Abd us-Samad himself, seems preferable to the slightly different dates cited elsewhere.

16 *See* Melikian-Chirvani, 2007, cat.174, pp.436-7 for the translation (into French) of the verses and an enlarged detail of the artist's signature.

17 Canby, 1994, includes images of the minute signatures of the artists who overpainted the faces in Jahangir's reign, identified by John Seyller.

18 For his life, *see* Naik, 1966.

19 *See* Verma, 1994, for the lists of works by, e.g., Bhim Gujarati, Dev Jiv Gujarati, Haydar Kashmiri, Ibrahim Lahori, Kesav Gujarati, and others.

20 *See* Naim's translation in Chandra, 1976, pp.182-4

21 *See* Porter, 1994, chapter 9 on workshop practice in Iran, obviously relevant to Hindustan; also Haq, 1931 for the personnel of 'Abdur Rahim's smaller, but very important library; Seyller, 1999, chapter II for the same information, and his chapter V for a survey of the manuscripts associated with this patron.

22 *See* Porter, 1994, chapter 3, on the layout and composition of Mughal manuscripts.

23 *See* Beach, 1992, pp.231-2, for Akbar's early manuscripts; the conversion of the date of the colophon of the *Anvar-i Suhayli*, AH 22 Rabi' II 978, should be corrected to 23 September 1570 AD (see Natif, 2008). See also Das, 2005, p.111, note 2. See Losty, 1982, cat.56, pp.86-7 for the *DuwalRaniKhizr Khan*.

24 A major reappraisal of the Cleveland Museum of Art's *Tuti Nama* (Seyller, 1992), demonstrated that the manuscript was substantially refurbished in Akbar's *Kitab Khana*. It cannot, therefore, be seen as demonstrating the transition between the pre-Mughal and early Mughal styles.

25 A less probable tradition claims they also include aspects of the life of another Hamza, a 9th century revolutionary figure from Sistan (Pritchett, 1991, pp.2-3).

26 Beveridge, 1977, vol.II, pp.342-3; *see* also Pritchett, 1991, p.5

27 The dates c.1562-77 were first suggested by Chandra, 1976, pp.66-7; Seyller, 2002, suggested a slightly earlier date on the basis of a supposed date on a page identified as

an early volume, though this is questionable (*see* Mclikian-Chirvani, 1998, p.50 note 7).

28 Chandra, 1976, pp.183-4

29 Chandra, 1976, especially pp.66-9

30 Blochmann and Phillott, 1977, vol.I, p.114

31 Chandra, 1976, p.183, and Das, 'Daswant: His Last Drawings in the *Razmnama*', in Das, 1998, for a survey of his work and bibliography. The *Razmnama* was completed in 1586.

32 *See* Seyller, 2002, for all known pictures, many reproduced in colour.

33 *See* Brand and Lowry, 1985, pp.63-4 for a list of manuscripts produced at Fatehpur. However, most of Akbar's manuscripts were produced in Lahore, after the court moved there in 1585, and in Agra after it moved again in 1598. The production of the *Shah Nama* is mentioned by both Abu'l Fazl and Badauni.

34 Rizvi, 1975, pp.203-22

35 Das, 2005, p.10 provides the names of some of the Hindu scholars.

36 Rizvi, 1975, p.211

37 *See* Das, 2005, pp.12-14 for a concise account of this manuscript, with bibliography.

38 Das, 2005, p.14

39 Rizvi, 1975, p.219

40 *See* Naik, *passim*, and Haq, 1931, for his library, and Seyller, 1999, for a monograph on the manuscript, now disbound and in the Freer Gallery of Art, Washington.

41 *See* Beach, 1987, chapter III, on the Lahore manuscripts, including the small volumes of poetry. See also Schmitz and Desai, 2006, pp.79-83 for a *Divan* of Hafez illustrated in Lahore, and other Mughal copies of the same *Divan*.

42 Rizvi, pp.223-98 for a comprehensive survey of Akbar's historical commissions.

43 Rizvi, 1975, pp.220-1

44 Beveridge, 1977, vol.III, p.862

45 Rizvi, 1975, pp.240-2

46 Rizvi, 1975, pp.242-8

47 *See* Stronge, 2002, pp.36-47. Seyller, 1990, was the first to draw attention to the replacement of original text panels, but concluded this showed the illustrations had been done for a different history, now missing. This seems unlikely for a work that, had it existed, would have been copied many times for the court and been mentioned by other historians.

48 Abu'l Fazl reported that Akbar selected the scenes for the illustrated copies of the *Chingiz-nama*, *Zafar Nama*, *Razm Nama*, *Ramayana*, *Nal Daman*, *Kalila wa Dimna*, '*Iyar-i Danesh*, and others, as well as the *Akbar Nama* (*see* Chandra, *Tuti-nama*, p.184).

49 Beveridge, 1977, vol.III, pp.321, 598, 779

50 Chandra, 1976, p.23

51 *See* Stronge, 2002, pp.58-85

52 Blochmann and Phillott, 1977, vol.I, p.33 note, and especially pp.376-9; Beveridge and Prashad, 2003, vol. II, pp.951-7.

53 *See* Mohiuddin, 1975, p.38.

54 Quoted in Rizvi, 1975, pp.197-8. See also Flores and Vasconcelos de Saldanha, 2003, p.50.

55 *See* Brand and Lowry, p.63.

56 Melikian-Chirvani, 1998, pp.31-2

57 Quoted in Mittal, 1985, p.244.

58 *See* Koch, in Seyller, 2002, p.30.

59 Foster, ed., 1985, p.163

60 *See* von Leyden, 1982, pp.11-26 for a discussion of Mughal playing cards.

61 Blochmann and Phillott, 1977, vol. I, pp.319-20

62 The best translation of this famous passage from the *A'in-i Akbari* is by Professor Naim in Chandra, 1976, pp.182-4.

63 *See* Flores and Vasconcelos de Saldanha, 2003, for previously unpublished documents of this period, and Bailey, 1999, p.114.

64 Bailey, 1999, p.114

65 Banerjee and Hoyland, 1993, pp.27-8

66 Bailey, 1999, p.115; Correia-Afonso, 1980, p.58

67 Banerjee and Hoyland, 1993, p.176

68 Correia-Afonso, 1980, p.85

69 *See* Beach, 1965, for the first detailed study of the precise European sources used by Mughal artists.

70 *See* Skelton and Stronge in Crill and Jariwala, eds, 2010 for examples of pre-Mughal and early Mughal paintings of individuals.

71 Bailey, 1999, p.124

72 O'Malley, p.392. This took place in 1602, during Salim's brief reconciliation with his father. Echoes of Salim's European commissions may be found in one of his albums of the period: see Wright, 2009, pp.54-67.

73 Richards, 1993, pp.55-6

74 For Salim's disturbed character at this time, *see* Alvi, 1978, p.32; for the manuscripts see Leach, 1995, vol.I, pp.155-89 and Das, 2009.

75 Das, 2009, p.58

76 Das, 1978, pp.40-1

77 *See* Melikian-Chirvani, 2007, cat. 179, pp.444-5 for a painting of Saint Jerome copied from an engraving, an enlarged detail of Nadira Banu's signature, translation (in French) and bibliography; and cat. 178, p.443, for her other work.

78 Ruqiya Banu's painting is reproduced in Rajabi, 2005, p.461.

79 Eslami, 2003 for a concise survey of the literature on the album; for the minor discrepancies in the conversion of the *hijra* dates by different authors, *see* Stronge, in Wright, 2009, pp.79-80. The pages held in Berlin were published by Kuhnel and Goetz, 1926.

80 *See* Beach, 1965 and 1980.

81 *See* Porter, 1994, chapter 2 'Decorated Papers' for the ingredients used to dye papers in Iran and Hindustan.

82 Eslami, 2003

83 These margins were first published by Goddard, 1936, who slightly misread the name of Govardhan and identified the figure holding the portfolio as Jahangir, though he bears little resemblance to the emperor. This was corrected by later authors. For Abu'l Hasan's birth, see Das, 1978, pp.40-1.

84 *See* Desai, 1999, p.76.

85 An important exception is 'Munim Jahangiri', who signed the inkpot made for Jahangir dated AH 1028/1618-19 AD now in the Metropolitan Museum of Art, New York (*see* The Indian Heritage, 1982, cat. 352, p. 117). No further details are known about this craftsman in royal service.

86 *See* Stronge, 2002, pl.88, p.123 for an independent prototype and pl. 87, p.122, for its inclusion in a durbar scene.

87 Thackston, 1999, p.271

88 Thackston, 1999, pp.267-8

89 I am extremely grateful to Henry Noltie of the Royal Botanical Gardens in Edinburgh for his comments on Mansur's study. He notes that the identification as *Tulipa Linata* is nevertheless not definitive, as is the case with almost all flowers depicted in Mughal art, which provide a general idea of a plant rather than a botanically accurate specimen, unless copied directly from a Western herbal or florilegium.

90 *See* Stronge, 2008, pp.96-8; see also Koch, 2009, p.307.

91 *See* Stronge in Wright, 2008, pp.99-101.

92 The pictures have been discussed extensively: first published by Richard Ettinghausen in 1961, significant later studies include those by Robert Skelton, Asok Das, Milo Beach, Ebba Koch and Gauvin Bailey, 2001; see Bailey for a full bibliography.

93 Blochmann, vol.I, pp.2-3; *see* also Stronge, 2002, pp.151-3.

234

94 Bailey, 2001, p.53

95 Translation by A.S. Melikian-Chirvani; the verses are in *Hajaz* metre.

96 Ettinghausen, 1961, text facing pl.14; Bailey, 2001, p.47.

97 Beach, 1978, nos 32, 64

98 Foster, 1967, pp.244-5. *See* also Das, 1978, pp.18-19.

99 Ettinghausen, 1961, text facing pls13 and 14. He suggests an Italian tapestry as the source of the textile in the painting of Jahangir with Shah 'Abbas; I am grateful to Antonia Brodie, former curator of textiles at the V&A, for showing me closely similar designs in late sixteenth-century Brussels tapestries and French embroideries. All could have made their way to the Mughal court.

100 A point made by Bailey, 2001, p.56.

101 *See* Seyller, 1997, who includes many illustrations of these flyleaves. *See* also pp.246-7, p.249 and note 22.

102 Blake, 1991, p.93; Koch, 2001, p.131, provides the translation of a passage from Shah Jahan's historian Qazwini.

103 *See* Wright, 2009, for a survey of albums associated with Shah Jahan as a prince and as emperor.

104 It is probable that the artist Hashim was with Shah Jahan during his Deccan campaigns in the 1620s, when he painted sensitive portraits of Muhammad 'Adil Shah and of Jahangir's hated enemy Malik 'Ambar (Stronge, 2002, pp.160-5).

105 The inscription and the verses are translated and analyzed in Melikian-Chirvani, 2004, pp.18-20, who points out that the prince is given all the attributes of an emperor without it being explicitly stated.

106 Its companion page, depicting Timur handing the crown to Babur in the presence of Humayun, is in the V&A (often illustrated, but *see* e.g., Stronge, 2002, pl.112, p.150).

107 Leach, 1995, vol.I, p.389

108 *See* Wright, 2009, pp.107-39.

109 This was first suggested in Losty, 1982, p.100. The major monograph on the manuscript (Beach and Koch, 1997), accepts them all as being of the reign of Shah Jahan, the marked differences in style being explained as the work of different artists. Given the similarity of some paintings in the manuscript with 18th-century paintings from Lucknow, in particular those illustrated by Beach in Beach and Koch, pp.123-8, it is difficult not to conclude that many *Padshah Nama* pictures are later additions.

110 Beach and Koch, 1997, p.165

111 Falk and Archer, 1981, no.68 (only the pictures are reproduced, without their borders); *see* also Wright, 2009, p.473. Seyller, 1997, pp.294-5 gives the date as AH 1056/1646-7 AD.

112 Desai, pp.101-2

113 Losty, 1982, cat.83, p.101

114 *See* Koch in Beach and Koch, 1997, pp.136-7 for a discussion of the allegorical paintings depicted on the walls beneath the *jharoka* in the illustrations to the *Padshah Nama*.

115 I am greatly indebted to A.S. Melikian-Chirvani for this translation of Muhammad Saleh Kanbu's *Shah-Jahan Nama*, vol.III (edited by Ghulam Yazdani, Lahore, 3 vols., 1960-7), p.32, lines 23-8.

1 Banerjee and Hoyland, 1993, p.201

2 Correia-Afonso, 1980, pp.56, 36-7; Blochmann and Phillott, 1977, vol.I, pp.119-20

3 Banerjee and Hoyland, 1993, pp.31, 35-6

4 Banerjee and Hoyland, 1993, pp.36 and 159

5 Blochmann and Phillott, 1977, vol.I, p.287

6 Bada'uni, quoted by Blochmann and Phillott, 1977, vol.I, p.213.

7 Blochmann and Phillott, 1977, vol.I, pp.12-15

8 Spinel has various colours and sources. For the Badakhshani source of the red spinels favoured at the Mughal court, following Iranian convention, *see* Melikian-Chirvani, 2001.

9 Other traders would also have brought these pearls to the court: *see* Tavernier, 1977, vol.II, pp.84 -96 for a mid-17th century description of the fisheries, the Portuguese role in selling pearls from Goa and the taste for large pearls from the Gulf of Mexico in the courts of the subcontinent.

10 Vassallo e Silva, 1995, p.54

11 Tavernier (Ball, 1977, vol.I, p.15) mentions transactions made at court using these coins. Silver coins were used for general commerce.

12 *See* Untracht, 1997, pp.304-311 for the 'nine-stone' (*navratna*) setting of traditional Hindu jewellery.

13 For the definitive monograph on the meaning of spinels in Persianate culture, see Melikian-Chirvani, 2001.

14 As quoted by Vesel, 1985, pp.150-3.

15 Blochmann and Phillott, 1977, vol.I, p.55

16 Islam, 1979, vol.I, p.178

17 Islam, 1979, vol.I, p.179

18 It was first published by Keene and Kaoukji, 2001, cat.12.1, pp.134-5. See Melikian-Chirvani, 2001, pp.98-102 for a detailed discussion of the spinel's historical significance and references in contemporary Persian sources.

19 Ball, 1977, vol.II, p.44

20 Ball, 1977, vol.II, p.46. I am grateful to Joanna Whalley for explaining this property of diamond.

21 Balfour, 1987

22 Thackston, 1999, p.277

23 It was sold at Christie's (*The Wittelsbach Diamond*, Christie's London, Wednesday 10 December 2008, lot 212) with information on its history mainly taken from Balfour, 1987.

24 It has been assumed the cut is European (see Droschel, Evers and Ottomeyer, 2008, pp.359-60: I am extremely grateful to Alan Hart for showing me this article). However, as Manuel Keene (2001, p.128) observes, the skills of 'cutters in the East' are regularly ignored. Souren Melikian (*International Herald Tribune* column, September 4, 2009) has suggested the diamond was cut at the Mughal court by Sa'ida.

25 Thackston, 1999, p.161. Hindu members of the court can, however, be seen in paintings wearing earrings in pierced ears before this date, following well-established tradition.

26 Translated in Jarrett and Sarkar, vol.III, p.346 as 'Workmen in Decorative Art'.

27 *See* Melikian-Chirvani, 2004, for a survey of jewelled objects at the Mughal court to the end of Shah Jahan's reign.

28 Foster, 1985, pp.60-121 for Hawkins and his Indian journey. The treasury is described on pp.101-3.

29 As suggested by Foster, 1985, p.101, n.5.

30 Banerjee and Hoyland, 1993, p.198

31 Quoted by Vassallo e Silva, 2004, p.44.

32 Foster, 1967, p.498

33 Foster, 1967, p.412

34 Abu'l Fazl includes a slightly garbled description of the technique (Jarrett and Sarkar, 1978, vol.III, p.345-6) in his survey of the indigenous traditions of Hindustan. *See* Untracht, 1997, pp.366-7, and Keene in Crill, Stronge and Topsfield, 2009, pp.190-202 for explanations of the technique by practitioners.

35 *See* Melikian-Chirvani, 2004.

36 *See* Stronge, in Wright, 2008, pp.190-1 for a fuller description of Rustam Khan's jewellery and weapons.

37 *See* Wright, 2008, p.190 fig.82 for jewelled daggers stored in an ivory-inlaid chest depicted in another border of the 'Late Shah Jahan album' (Wright, 2009, cat. 60).

38 Thackston, 1996, p.297, 'ruby' corrected here to 'spinel', following *la'l* in the Persian text.

39 Jarrett and Sarkar, 1978, vol.II, pp.246-7

40 Mandelslo, 1719, p.240

41 Thackston, 1999, p.273

42 *See* Digby, 1986, for the pioneering work on this subject, and José Jordão Felgueiras in Vassallo e Silva, ed, 1999, pp.129-53 for many additional objects and sources. See also Jaffer, 2009, cats.5, 10, 11-14 for pieces in the V&A.

43 Quoted by Jaffer, 2009, p.25.

44 Jarrett and Sarkar, 1978, vol.II, p.317 for the metals found in the subah of Lahore.

45 *See* Welch, 1985, cat.10 for a portrait of Akbar's favourite musician Tansen, who carries a similar dagger in his sash.

46 Thackston, 1999, p.308

47 *See* for example the comments made by Pelsaert (Moreland and Geyl, 1925, p.60) and Mandelslo (1719, p.195).

48 Melikian-Chirvani, 1999, pp. 87-9

49 Blochmann, 1977, vol.I, p.55 for Iranian masters and their style of engraving calligraphy on metal. *See* Melikian-Chirvani, 1994, for a full description of the wine bowl and its inscriptions, and the same author's entry in *The Indian Heritage*, 1982, cat.489 on the V&A vessel.

50 Both centres are mentioned by Abu'l Fazl, see Jarrett and Sarkar, 1978, vol.II, pp.164, 192.

51 *See* Gonnella.

52 Reproduced in Semsar and Emami, 2000, pp.260-1.

53 *See* Mittal, 1986, for one of the few studies of this aspect of Mughal design.

54 As suggested convincingly by Ebba Koch, 2001, note 32, pp.76-7.

55 Asher, 1992, pp.173-4 for Jahangir's tomb. *See* Koch, 2001, pp.61-129.

56 *See* Murphy, 1979, for a survey of the textiles of Bengal from early times to the 19th century as an indication of the range of production in one region.

57 Letter from Thomas Kerridge, Ajmer, 20 March 1614 (William Foster, ed, *East India Company Records*, 1614, p.17).

58 Murphy, 1979, p.63

59 Tavernier (Ball, 1977, vol.II p.6 n. 2) provides the Mughal term; see also Murphy, 1979, and Cohen in Wright, 2009, pp.185-6.

60 *See* Cohen in Wright, 2009, note 3, pp.186-7 for a brief discussion of the difficulties in identifying precisely what the names of these robes designate, not least because their meaning changes over time.

61 Banerjee and Hoyland, 1993, p.28

62 Chandra, 1954, p.7 for early sources on the industry in Kashmir, and Rizvi and Ahmed, 2009, pp.148-63 for the Mughal period including the trade with Iran.

63 *See* Chandra, 1954, p.10 for terminology and dyeing, and also Habib, 1992, p.6. During the dyeing experiments it was discovered that *tus* wool would not take red colour.

64 Rizvi and Ahmed, pp.150-1

65 *See* Cohen in Wright, 2009, pp.180-1 for an analysis of the shawls depicted in paintings in the collection of the Chester Beatty Library.

237

66 Blochmann and Phillott, 1977, vol.I, pp.93-4

67 *See* Raychaudhuri in Raychaudhuri and Habib, eds, 1982, pp.261-73 for textile production in general in the Mughal empire, and p.270 for a brief note on the 'bewildering variety of names for the different types of textiles'. Habib, 1982, provides a glossary of textile terms in the Appendix, pp.69-70.

68 Ball, 1977, vol.II, pp.2-3

69 Brand and Lowry, 1985, p.114, quoting the translation of a passage written by the historian Arif Qandahari.

70 On Mughal carpets, *see* Walker, 1997 (especially pp.6-12 for carpet production under Akbar, Jahangir and Shah Jahan).

71 *See* Walker, 1997, pp.37-45 for a discussion of the relationship between manuscripts and carpet design, and specifically the *gaja-simha* motif seen on this carpet, in Mughal painting and also on inlaid woodwork (*see* eg Levenson, 2007, pp.122-2).

72 Blochmann and Phillott, 1977, vol.I, p.94

73 *See* Brend, 2008, for the complete Persian inscriptions with translation. The date of the painting is provided by a chronogram in the verses, converted by Brend to AH 1008/1599-1600 AD.

74 Begley and Desai, 1990, p.220

75 Thackston, 1999, p.297

76 Mandelslo, 1719, p.79

77 Ball, 1977, vol.I, pp.34, 42

78 Blochmann and Phillott, 1977, vol.I, pp.98-99

79 Begley and Desai, 1990, pp.407-8

80 Foster, 1985, pp.102-3

81 Melikian-Chirvani, 1999, pp.96-100 for a full discussion of this wine cup, and the first identification of Sa'ida as the master who made it.

82 Melikian-Chirvani, 1999, pp.105-13

83 Melikian-Chirvani, 1999, p.109

84 Chandra, 1939, and Skelton, 1972

86 Eg Teng Shu-p'ing, 2004, pp.250-1 for others in Taipei, and *The Indian Heritage*, 1982, cat. 355a, for a cup of Shah Jahan dated 1647-8.

87 Skelton in Keverne, 1991, p.286

88 The cup was acquired in the 19th century by the great collector of Mughal hardstones, Colonel Charles Seton Guthrie (Skelton, 1978, p.2).

89 *See* Stronge in Levenson, 2007, pp.114-5.

90 Jarrett and Sarkar, vol.III, p.346. Enamelled guns are mentioned in Blochmann and Phillott, 1977 vol.I, p.121.

91 Carvalho in Trnek and Vassallo e Silva, 2001.

92 Vassallo e Silva, 1996, pp.17-19

93 De Castro, 1998, p.581

94 Akbar's *farman* to the Viceroy of Goa was issued at Burhanpur on 29 March 1601: *see* Flores and Vasconcelos Saldanha, 2003, p.78.

95 Foster, 1967, pp. 479, 488

96 Begley and Desai, 1990, p.463

97 Begley and Desai, 1990, p.506

98 For the life and work of Sa'ida-yi Gilani, *see* Melikian-Chirvani, 1999, pp.83-140.

99 Melikian-Chirvani, p.84

100 Desai, 2003, p.86

101 Stronge, 2004, p.64

102 Augustin's letters were first published by Sir E.D. Maclagan in 1916: *see* Stronge, 2004 for full bibliography on the artist.

103 Stronge, 2004, p.57

104 *See* Stronge, 2004, pp.62-5 for the throne and its representations in paintings, none of which exactly correspond to the detailed descriptions given by Shah Jahan's historians or by European observers.

105 Prakash, 1984, pp.137, 139. *See* also Stronge, 2004, p.56.

106 Blake, 1991, p. 31, and Begley and Desai, 1990, p.407.

107 *See* Koch, 2006, for the most complete monograph on the Taj Mahal.

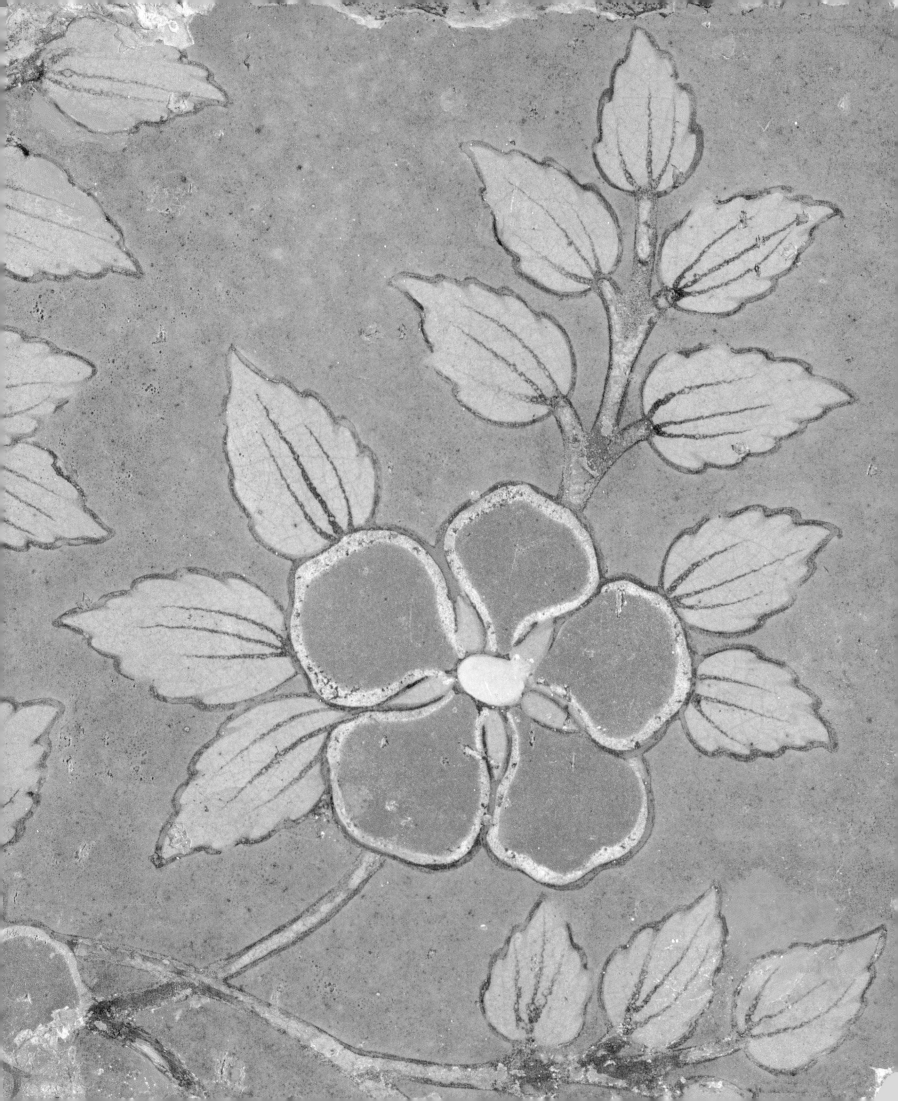

BIBLIOGRAPHY

Alam, Muzaffar, 'The Pursuit of Persian: Language in Mughal Politics', *Modern Asian Studies*, Cambridge, vol.32, no.2, 1998, pp.317-49

Alvi, Azra, ed., *Ma'asir-i Jahangiri: A Contemporary Account of Jahangir by Khwaja Kamgar Husaini*, New York, 1978

Alvi, M.A., and A. Rahman, *Jahangir – The Naturalist*, New Delhi, 1968

Andrews, Peter Alford, 'The Generous Heart or the Mass of Clouds: The Court Tents of Shah Jahan', *Muqarnas*, vol.4, Leiden, 1987, pp.149-65

Andrews, Peter Alford, *Felt Tents and Pavilions: The Nomadic Tradition and its Interaction with Princely Tentage*, London, 1999

Ansari, Muhammad Azhar, *The Social Life of the Mughal Emperors 1526-1707*, Allahabad, 1974

Arnold, Sir Thomas, *Bihzad and his Paintings in the Zafarnamah*, London, 1930

Asher, Catherine, *Architecture of Mughal India*, (The New Cambridge History of India), I:4, Cambridge, 1992

Aziz, Abdul, *The Imperial Treasury of the Indian Mughuls*, Delhi, 1972

Bailey, Gauvin Alexander, *Art on the Jesuit Missions in Asia and Latin America, 1542-1773*, Toronto, 1999

Bailey, Gauvin Alexander, 'The End of the "Catholic Era" in Mughal Painting: Jahangir's Dream Pictures, English Painting, and the Renaissance Frontispiece', in *Marg* [Magazine], vol.53, no.2, December 2001, pp.46-59

Balfour, Ian, *Famous Diamonds*, London (3rd edition), 1997

Ball, Valentine, trs and ed., *Travels in India by Jean-Baptiste Tavernier, Baron of Aubonne*, second edition edited by William Crooke, 2 vols, New Delhi, 1977

Banerjee, S.N., and John S. Hoyland, eds, *Commentary of Father Monserrate*, Jalandhar, 1993

Barnes, Ruth, Steven Cohen and Rosemary Crill, *Trade, Temple & Court: Indian Textiles from the Tapi Collection*, Mumbai, 2002

Beach, Milo Cleveland, *Early Mughal Painting*, Asia Society [New York], 1987

Beach, Milo Cleveland, *Mughal and Rajput Painting*, (The Cambridge History of India), I:3, Cambridge, 1992

Beach, Milo Cleveland, 'The Gulshan Album and Its European Sources', *Bulletin of the Museum of Fine Arts, Boston*, vol.332, 1965, pp.63-91

Beach, Milo Cleveland, 'The Mughal painter Abu'l Hasan and some English sources for his style', *The Journal of the Walters Art Gallery*, vol.38, 1980, pp.6-33

Beach, Milo Cleveland and Ebba Koch with translations by Wheeler M. Thackston, *King of the World: The Padshahnama: An Imperial Mughal Manuscript from the Royal Library, Windsor Castle*, London and Washington, 1997

Begley, W.E. and Z.A. Desai, *Taj Mahal: The Illumined Tomb: An Anthology of Seventeenth-Century Mughal and European Documentary Sources*, Cambridge, Massachusetts, Seattle and London, 1989

Begley, W.E. and Z.A. Desai, eds, *The Shah Jahan Nama of 'Inayat Khan: An Abridged History of the Mughal Emperor, as Compiled by His*

Royal Historian, translated by A.R. Fuller, Delhi, New York and Oxford, 1990

Beveridge, H. (trs) and Baini Prashad (revised, annotated, and completed), *The Maathir-ul-Umara ... by Nawwab Samsamuddaula Shah Nawaz Khan and his son 'Abdul Hayy* (second edition), 2 vols, The Asiatic Society Kolkata, 2003

Blake, Stephen P., *Shahjahanabad: The Sovereign City in Mughal India 1639-1739*, Cambridge, 1991

Blochmann, H. trs and ed., *The A'in-i Akbari by Abu'l-Fazl 'Allami*, second edition revised by Lieut Col D.C. Phillott, vols1&2, New Delhi, 1977

Brand, Michael and Glenn D. Lowry, *Akbar's India: Art from the Mughal City of Victory*, New York, 1985

Brand, Michael and Glenn D. Lowry, eds, *Fatehpur-Sikri*, Mumbai, 1987

Brend, Barbara, *The Emperor Akbar's Khamsa of Nizami*, London, 1995

Brend, Barbara, 'Dating the Prince: A Picture in the St Petersburg Mughal Album', *South Asian Studies*, vol.XXIV, London, 2008, pp.91-6

Canby, Sheila, ed., *Humayun's Garden Party. Princes of the House of Timur and Early Mughal Painting*, Mumbai, 1994

Castro, Xavier de and Bouchon, Geneviève, eds, Voyage de Pyrard de Laval aux Indes orientales (1601-1611), Paris, 1998 (2 vols)

Chadour-Sampson, Beatriz and Nigel Israel, eds, *Jewelled Arts of Mughal India, Jewellery Studies*, London, vol.10, 2004

Chandra, Moti, 'The art of cutting hardstone ware in Ancient and Modern India', *Journal of the Gujarat Research Society*, vol. I., no. 4, Bombay, October 1939, pp. 71-85

Chandra, Moti, 'Kashmir Shawls', *Prince of Wales Museum Bulletin*, No. 3, 1954, pp. 1-24 plus plates

Chandra, Pramod, *The Tuti-Nama of the Cleveland Museum of Art*, Codices Selecti, Facsimile vol.LV, Commentarium vol.LV, Austria, 1976

Correia-Afonso, John, *Letters from the Mughal Court: The First Jesuit Mission to Akbar (1580-1583)*, Mumbai, 1980

Crill, Rosemary, Susan Stronge, and Andrew Topsfield, eds, *Arts of Mughal India: Studies in Honour of Robert Skelton*, Ahmadabad and London, 2004

Crill, Rosemary and Kapil Jariwala, eds, *The Indian Portrait*, London, 2010

Das, Asok Kumar, *Mughal Painting During Jahangir's Time*, Calcutta, 1978

Das, Asok Kumar, ed., *Mughal Masters: Further Studies*, Mumbai, 1998

Das, Asok Kumar, *Paintings of the Razmnama: The Book of War*, Kolkata, 2005

Das, Asok Kumar, 'Salim's *Taswir Khana*' in Neelum Saran Gour ed., *Allahabad: Where The Rivers Meet*, Mumbai, 2009

Desai, Ziyaud-Din.A., 'Studies in Indian Art and Culture: Some Avoidable Presumptions and Speculative Theories', *Marg*, vol.51, no.1, September 1999, pp.75-86

Desai, Z.A., *Nobility under the Great Mughals: Based on the Dhakhirat ul-Khawanin of Shaikh Farid Bhakkari*, New Delhi, 2003

Digby, Simon, 'The mother-of-pearl overlaid furniture of Gujarat: The holdings of the Victoria and Albert Museum', in Robert Skelton *et al*, eds, *Facets of Indian Art*, London, 1986, pp.213-22

Eslami, Kambiz, 'Golšān Album', in E. Yarshater, ed., *Encyclopaedia Iranica* vol.11, 2003, pp.104-8

Ettinghausen, Richard, *Paintings of the Sultans and Emperors of India In American Collections,* New Delhi, 1961

Flores, Jorge and Vasconcelos de Saldanha, António, *Os Firangis na Chancelaria Mogol. Cópias Portuguesas de Documentos de Akbar (1572-1604)/The Firangis in the Mughal Chancellery. Portuguese Copies of Akbar's Documents (1572-1604)*, New Delhi and Lisbon, 2003

Foster, William, ed., *Early Travels in India, 1583-1619*, New Delhi 1985

Foster, William, ed. *The Embassy of Sir Thomas Roe to India, 1615-1619*, Kraus Reprint Limited, 1967

Gittinger, Mattiebelle, *Master Dyers to the World: Technique and Trade in Early Indian Dyed Cotton Textiles*, Washington, D.C., 1982

Godard, Yedda A., 'Les Marges du Murakka' Gulshan', *Athar-é Iran*, Annales du Service Archéologique de l'Iran, tome 1, 1936, pp.11-33

Godard, Yedda A., 'Un album de portraits des princes timurides de l'Inde', *Athar-é Iran*, Annales du Service Archéologique de l'Iran, tome 2, 1937, pp.179-277

Gonnella, Julia, 'Tiles', *Grove Art Online*, Indian subcontinent, section VIII, 5: Ceramics

Goswamy, B.N. and Rahul Jain, *Patkas: A Costume Accessory in the Collection of the Calico Museum of Textiles*, Ahmadabad, 2002

Gupta, Parmeshwari Lal, *Coins*, New Delhi, (third edition), 1991

Habib, Irfan, *An Atlas of the Mughal Empire*, Delhi, 1982

Habib, Irfan, 'Akbar and Technology', *Social Scientist*, vol.20, nos9-10, September-October 1992, pp.3-15

Haq, M. Mahfuzul, 'The Khan-i Khanan and His Painters, Illuminators and Calligraphists', *Islamic Culture*, vol.5, 1931, pp.621-30

Irwin, John and Hall, Margaret, *Indian Embroideries*, Mumbai, 1973

Irwin, John and Hall, Margaret, *Indian Embroideries*, Volume II, Historic Textiles of India at the Calico Museum, Bombay, 1973

Irwin, John and Margaret Hall, *Indian Painted and Printed Fabrics*, Volume I, Historic Textiles of India at the Calico Museum, Bombay, 1971

Islam, Riazul, *A Calendar of Documents on Indo-Persian Relations (1500-1750)*, Karachi, 1979

Ivanov, A.A., et al., *Oriental Jewellery from the collection of the Special Treasury, the State Hermitage Oriental Department*, St Petersburg, 1984

Jaffer, Amin, *Luxury Goods from India: The Art of the Indian Cabinet-maker*, London, 2002

Jarrett, Colonel H.S., *The A'in-i Akbari by Abu'l-Fazl 'Allami*, vol.III, revised second edition corrected and annotated by Sir Jadunath Sarkar, New Delhi, 1978

Keene, Manuel with Salam Kaoukji, *Treasury of the World: Jewelled Arts of India in the Age of the Mughals*, London, 2001

Keene, Manuel, 'The *kundan* technique: The Indian jeweller's unique artistic treasure', in Rosemary Crill, Susan Stronge and Andrew Topsfield, eds, *Arts of Mughal India: Studies in Honour of Robert Skelton*, Ahmedabad and London, 2004, pp.190-202

Koch, Ebba, 'The Architectural Forms' in Michael Brand and Glenn D. Lowry, eds, *Fatehpur-Sikri*, Mumbai, 1987, pp.121-48

Koch, Ebba, 'Influence on Mughal Architecture' in George Michell, ed., *Ahmadabad*, Mumbai, 1988, pp.168-85

Koch, Ebba, *Mughal Architecture*, Munich, 1991

Koch, Ebba, *Mughal Art and Imperial Ideology: Collected Studies*, New Delhi, 2001

Koch, Ebba, *The Complete Taj Mahal and the Riverfront Gardens of Agra*, London, 2006

Koch, Ebba, 'Jahangir as Francis Bacon's Ideal of the King as Observer and Investigator of Nature', *Journal of the Asiatic Society*, London, Third Series, vol.19, part 3, July 2009, pp.293-338

Kühnel, Ernst and Hermann Goetz, *Indian Book Painting from Jahangir's Album in the State Library in Berlin*, Berlin, 1926

Lal, Ruby, *Domesticity and Power in the Early Mughal World*, Cambridge, 2005

Leach, Linda York, *Mughal and other Indian Paintings from the Chester Beatty Library*, Dublin, 1995, 2 vols

Levenson, Jay A., ed., *Encompassing the Globe: Portugal and the World in the 16th and 17th Centuries. Reference Catalogue*, Washington, D.C., 2007

Lightbown, R.W., 'Oriental Art and the Orient in late Renaissance and Baroque Italy, *Journal of the Warburg and Courtauld Institutes*, vol.XXXII, 1969

Losty, Jeremiah P., *The Art of the Book in India*, London, 1982

Losty, Jeremiah P., 'The "Bute Hafiz" and the development of border decoration in the manuscript studio of the Mughals', *The Burlington Magazine*, vol.CXXVII, December 1985, pp.855-70

Losty, Jeremiah P., 'Shah Jahan Period', in *Oxford Dictionary of Art*, Indian sub., VI, 4 (i): Mughal painting styles

Lowry, Glenn D., 'Humayun's Tomb: Form, Function, and Meaning in Early Mughal Architecture', *Muqarnas*, vol.4, Leiden, 1987, pp.133-48

Lowry, Glenn D. and Milo Cleveland Beach, *An Annotated and Illustrated Checklist of the Vever Collection*, Seattle and London, 1988

Maclagan, Sir Edward, *The Jesuits and the Great Mogul*, London, 1932

Mandelslo, Johann Albrecht von, *Voyages celebres et remarquables…*, Leiden, 1719

Malekandathil, Pius and Jamal Mohammad, eds, *The Portuguese, Indian Ocean And European Bridge Heads*, Lisbon, 2001

Markel, Stephen, 'Western Imports and the Nature of Later Indian Glassware', *Asian Art*, vol.VI, no.4, Fall 1993, pp.35-59

Melikian-Chirvani, Assadullah Souren, 'The Iranian Style in North Hindustan Metalwork', in Françoise 'Nalini' Delvoye, *Confluence of Cultures: French Contributions to Indo-Persian Studies*, New Delhi and Tehran, 1995, pp.54-81

Melikian-Chirvani, A.S., 'Sa'ida-ye Gilani and the Iranian Style Jades of Hindustan', *Bulletin of the Asia Institute*, Michigan, New Series, 1999, vol.13, pp.83-140

Melikian-Chirvani, A.S., 'The Red Stones of Light in Iranian Culture. I. Spinels', in *Bulletin of the Asia Institute*, Michigan, New Series, vol.15, 2001, pp.77-110

Melikian-Chirvani, A.S., 'The Jewelled Objects of Hindustan', in Beatriz Chadour-Sampson and Nigel Israel, eds, *Jewellery Studies*, vol.10, London, 2004, pp.9-32

Mittal, Jagdish, 'Indian painters as designers of decorative art objects in the Mughal period', in Robert Skelton et al., eds, *Facets of Indian Art*, London, 1986, pp.243-52

Mohiuddin, Dr Momin, *The Chancellery and Persian Epistolography under the Mughals. From Babur to Shah Jahan (1526-1658)*, Calcutta, 1971

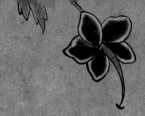

Monserrate, Father Antonio, *Commentary on his Journey to the Court of Akbar*, translated by J.S. Hoyland, London, 1922

Moosvi, Shireen, *Episodes in the Life of Akbar: Contemporary Records and Reminiscences*, New Delhi, 1994

Naik, Chhotubhai Ranchhodji, '*Abdu'r-Rahim Khan-i-Khanan and his Literary Circle*, Ahmadabad, 1966

Na'imuddin, Sayyid, 'Some Unpublished Verses of Babur', *Islamic Culture*, vol. XXX, no.1, 1956, pp.44-50

Nath, R., *Colour Decoration in Mughal Architecture (India & Pakistan)*, Jaipur, 1989 (second revised edition)

Natif, Mika, 'The *Zafarnama* [Book of Conquest] of Sultan Husayn Mirza' in Colum Hourihane, ed., *Insights and Interpretation. Studies in Celebration of the Eighty-fifth Anniversary of the Index of Christian Art*, Princeton University Press, 2002

Natif, Mika, 'The SOAS *Anvār-i Suhaylī*: the journey of a "Reincarnated" manuscript', in Gülru Necipoğlu and Julia Bailey, eds, *Frontiers of Islamic Art and Architecture: Essays in celebration of Oleg Grabar's Eightieth Birthday, Muqarnas* vol.25, 2008, pp.331-58

Okada, Amina, trs. Deke Dusinberre, *Imperial Mughal Painters*, Paris, 1992

Okada, Amina and Jean-Louis Nou, trs. Eleanor Levieux, *A Jewel of Mughal India: The Mausoleum of I'timad ad-Daulah*, Milan, 2003

Pal, Pratapaditya, ed., *Master Artists of the Imperial Mughal Court*, Mumbai, 1991

Payne, C.H., *Akbar and the Jesuits: An Account of the Jesuit Missions to the Court of Akbar by Father Pierre du Jarric, S.J.*, London, 1926

Payne, C.H. trs., *Jahangir and the Jesuits: With an Account of the Travels of Benedict Goes and the Mission to Pegu. From the Relations of Father Fernão Guerreiro, S.J.*, London, 1930

Porter, Yves, *Painters, Paintings and Books: An Essay on Indo-Persian Technical Literature, 12-19th century*, New Delhi, 1994

Prakash, Om, *The Dutch Factories in India 1617-1623*, New Delhi, 1984

Prakash, Om, *Bullion for Goods. European and Indian Merchants in the Indian Ocean Trade 1500-1800*, New Delhi, 2004

Pritchett, Frances W., *The Romance Tradition in Urdu. Adventures from the Dastan of Amir Hamzah*, New York, 1991

Rajabi, Mohammad-Ali, *Masterpieces of Persian Painting*, Tehran, 2005

Raychaudhuri, Tapan and Habib, Irfan, eds, *The Cambridge Economic History of India volume I: c.1200-c.1750*, Cambridge University Press, 1982

Rezavi, Syed Ali Nadeem, 'Mughal Wall Paintings: A Case Study of Fathpur Sikri', *Proceedings of the Indian History Congress*, Mysore, 2003

Riboud, Krishna, ed., *In Search of Themes and Skills: Asian Textiles*, Mumbai, 1989

Richards, John F., *The Mughal Empire*, (The New Cambridge History of India), I.5, Cambridge, 1995

Rizvi, Janet and Monisha Ahmad, *Pashmina: The Kashmir Shawl and Beyond*, Mumbai, 2009

Rizvi, Saiyid Athar Abbas, *Fatehpur Sikri*, Archaeological Survey of India, Calcutta, n.d. [1972]

Rizvi, S.A.A., *Religious and Intellectual History of the Muslims in Akbar's Reign*, New Delhi, 1975

Rizvi, S.A.A. and Vincent John Adams Flynn, *Fathpur-Sikri*, Mumbai, 1975

Semsar, Mohammad-Hasan and Karim Emami, *Golestan*

Palace Library: A Portfolio of Miniature Paintings and Calligraphy, Tehran, 2000

Seyller, John, 'Codicological aspects of the Victoria and Albert Museum *Akbar Nama* and their historical implications', *Art Journal*, vol.XLIX, no.4, 1990, pp.379-87

Seyller, John, 'Overpainting in the Cleveland *Tuti-nama*,' *Artibus Asiae*, vol.LII, 3/4, 1992, pp.283-318

Seyller, John, 'The Inspection and Valuation of Manuscripts in the Imperial Mughal Library', *Artibus Asiae*, vol.LVII, 3/4, Zurich and Washington, D.C., 1997, pp.243-349.

Seyller, John, *Workshop and Patron in Mughal India: The Freer Ramayana and other Illustrated Manuscripts of 'Abd al-Rahim*, *Artibus Asiae* vol.XLII, 42, Zurich and Washington D.C., 1999

Seyller, John with Wheeler M. Thackston, Ebba Koch, Antoinette Owen, and Rainald Franz, *The Adventures of Hamza*, Washington, D.C., 2002

Siddiqi, W.H., *Rampur Raza Library: Monograph*, Rampur, 1998

Skelton, Robert, 'Islamic and Mughal Jades', in Keverne, Roger, ed., *Jade*, London, 1991

Skelton, Robert, 'Imperial Symbolism in Mughal Painting', in Priscilla Soucek, ed., *Content and Context of Visual Arts in the Islamic World*, London, 1988, pp.177-87

Skelton, Robert, 'The Relations between the Chinese and Indian jade carving traditions', in Watson, W., ed., *The Westward influence of the Chinese arts from the 14th to the 18th century*, Colloquies on Art and Archaeology in Asia, No. 3, London, 1972, pp. 98-112

Smart, Ellen S. and Dale C. Gluckman, 'Cloth of Luxury: Velvet in Mughal India', in Krishna Riboud, ed., *In Quest of Themes and Skills: Asian Textiles*, Mumbai, 1989, pp.36-47

Smith, Edmund W., *The Moghul Architecture of Fathpur-Sikri*, Archaeological Survey of India, New Imperial Series, vol.XVIII, Allahabad, 1896-8

Smith, Vincent, 'The Treasure of Akbar', *Journal of the Royal Asiatic Society*, London, April 1915, pp.231-43

Soudavar, Abolala with a contribution by Milo Cleveland Beach, *Art of the Persian Courts. Selections from the Art and History Trust Collection*, New York, 1992

Stronge, Susan, 'The Myth of the Timur Ruby', *Jewellery Studies*, London, vol.7, 1996, pp.5-12

Stronge, Susan, *Painting for the Mughal Emperor: The Art of the Book 1560-1660*, London, 2002

Stronge, Susan, 'The Sublime Thrones of the Mughal Emperors of Hindustan', in Beatriz Chadour-Sampson and Nigel Israel, eds, *Jewellery Studies*, vol.10, London, 2004, pp.52-67

Stronge, Susan, 'Far from the Arte of Painting', in Rosemary Crill, Susan Stronge and Andrew Topsfield, eds, *Arts of Mughal India: Studies in Honour of Robert Skelton*, Ahmedabad and London, 2004, pp.129-37

Teng, Shu-p'ing, 'On the Eastward Transmission of Islamic-style Jades during the Ch'ien-lung and Chia-ch'ing Reigns', *National Palace Museum Bulletin*, Taipei, vol.37, no.2, September 2004, pp.25-138

Thackston, Wheeler M., translator, editor and annotator, *The Baburnama. Memoirs of Babur, Prince and Emperor*, New York and Oxford, 1996

Thackston, Wheeler M., translator, editor and annotator, *The Jahangirnama. Memoirs of Jahangir, Emperor of India*, Washington, D.C. and Oxford, 1999

Topsfield, Andrew, ed., *The Art of Play: Board and Card Games of India*, Mumbai, 2006

Topsfield, Andrew, *Paintings from Mughal India*, Oxford, 2008

Trnek, Helmut, and Nuno Vassallo e Silva, eds, *Exotica: The Portuguese Discoveries and the Renaissance Kunstkammer*, Lisbon, 2001

Untracht, Oppi, *Traditional Jewelry of India*, London, 1997

Vassallo e Silva, Nuno, *A Herança de Rauluchantim / The Heritage of Rauluchantim*, Lisbon, 1996

Vassallo e Silva, Nuno, 'Jewels and Gems in Goa from the Sixteenth to the Eighteenth Century', in Susan Stronge, ed., *The Jewels of India*, Mumbai, 1995, pp.53-62

Vassallo e Silva, Nuno, 'Jewels for the Great Mughal: Goa a Centre of the Gem Trade in the Orient', in Beatriz Chadour-Sampson and Nigel Israel, eds, *Jewellery Studies*, vol.10, London, 2004, pp.41-51

Verma, Som Prakash, 'Miniatures of the Tarikh-i-Khandan-i-Timuria an illustrated manuscript of Akbar's court', *Roopa-Lekha*, New Delhi, vol.XLIII, Nos1&2, pp.56-60

Verma, S.P., *Mughal Painters and Their Work*, New Delhi, 1994

Verma, S.P., ed., *Flora and Fauna in Mughal Art*, Mumbai, 1999

Vesel, Ziva, 'Sur la terminologie des gemmes: *yaqut* et *la'l* chez les auteurs persans', *Studia Iranica*, t.14, fasc.2, Paris, 1985, pp.147-55.

Victoria and Albert Museum, *The Indian Heritage: Court Life and Arts Under Mughal Rule*, London, 1982

Von Leyden, Rudolf, *Ganjifa: The Playing Cards of India*, London, 1982

Walker, Daniel, *Flowers Underfoot: Indian Carpets of the Mughal Era*, New York, 1997

Welch, Stuart Cary, Annemarie Schimmel, Marie L. Swietochowski and Wheeler M. Thackston, *The Emperor's Album: Images of Mughal India*, New York, 1987

Weis, Friederike, 'The Impact of Nadal's *Evangelicae Historiae Imagines* on Three Illustrations of the *Akbar Nama* in the Victoria and Albert Museum', *Indo-Asiatische Zeitschrift*, vol.6/7, 2002-3, pp.95-117

Wilkinson, J.V.S., *The Shah-Nameh of Firdausi: The Book of the Persian Kings*, Oxford, 1931

Wright, Elaine, *Muraqqa': Imperial Mughal Albums from the Chester Beatty Library*, Alexandria, Virginia, 2008

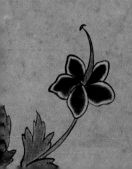

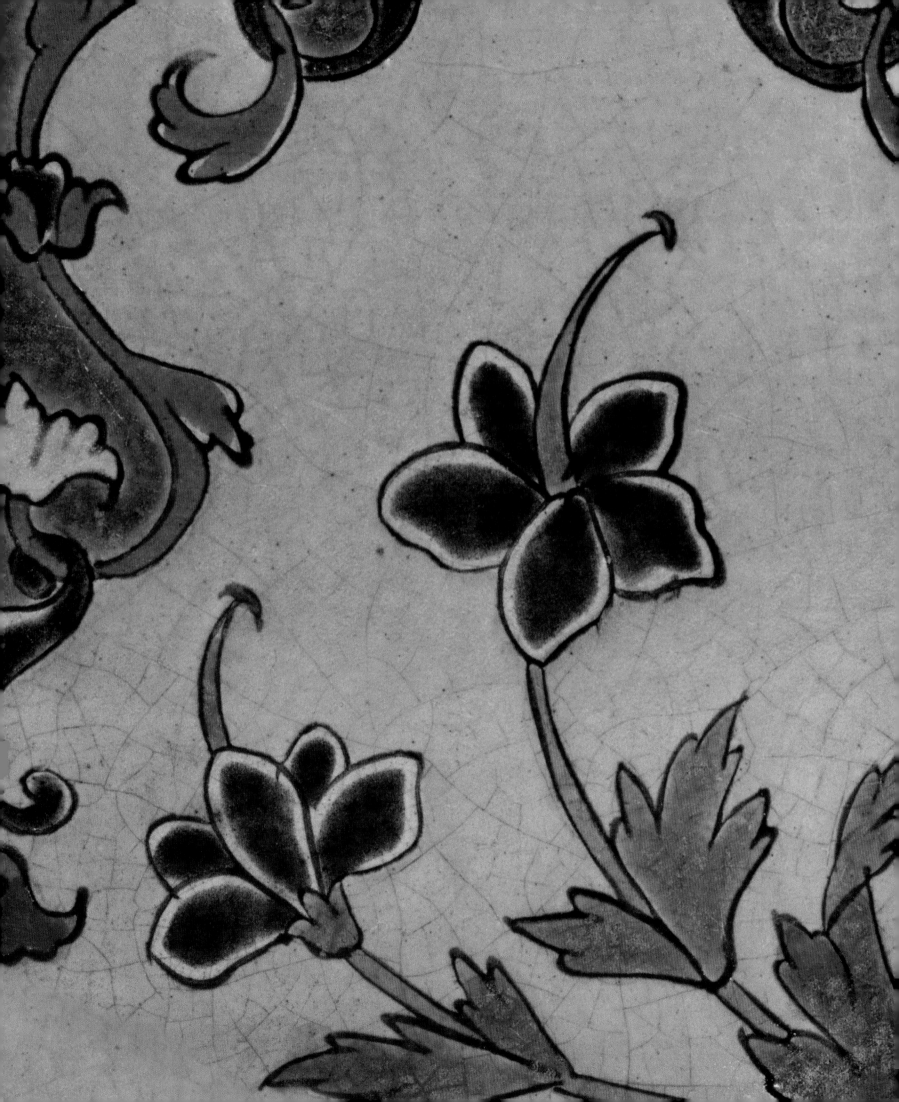

INDEX

248

249

250

PHOTO CREDITS

ISBN: 978-81-7436-696-2

© This edition Roli & Janssen BV 2010
Published in India by
Roli Books in arrangement with
Roli & Janssen BV, The Netherlands
M-75, Greater Kailash-II Market
New Delhi 110 048, India.
Phone: ++91-11-40682000
Fax: ++91-11-29217185
Email: info@rolibooks.com
Website: www.rolibooks.com

Project Editor: Priya Kapoor
Editor: Neelam Narula
Design: Sneha Pamneja
Layout: Naresh L Mondal

Printed and bound in Singapore